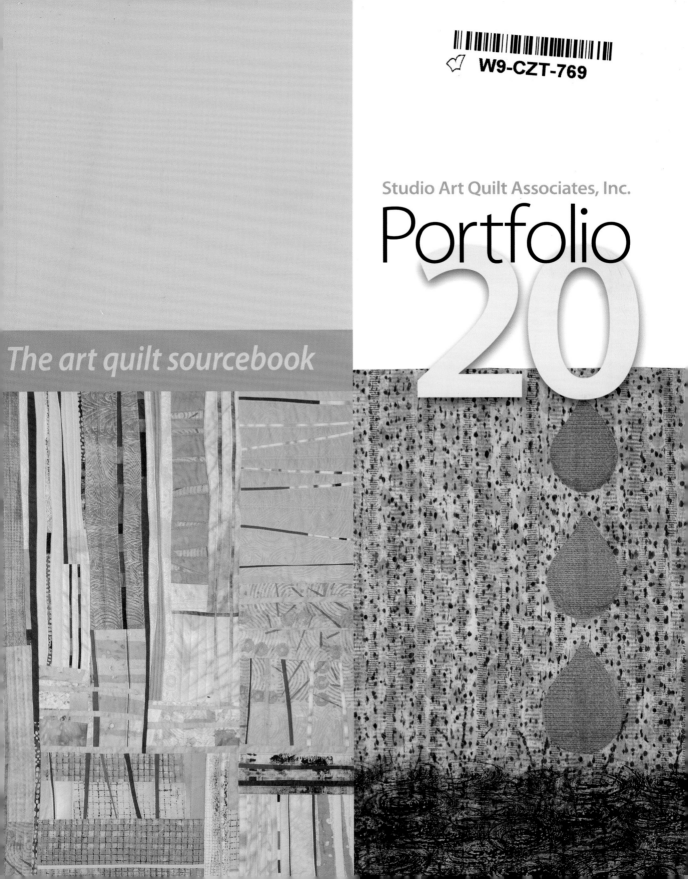

Studio Art Quilt Associates, Inc.

Portfolio

20

The art quilt sourcebook

Portfolio 20: The art quilt sourcebook

published by Studio Art Quilt Associates, Inc.

front cover (clockwise from top left): Z Denise Gallup, Ginnie Eckley, Dianne Vottero Dockery
back cover (clockwise from top left): Gail Baar, Regula Affolter, Charlotte Bird, Rosemary Claus-Gray
title page (left to right): Rosemary Hoffenberg, Sandy Gregg

design by Deidre Adams

ISBN: 978-0-9834468-8-0

SAQA™
Studio **Art** Quilt Associates

PO Box 572
Storrs, CT 06268-0572
860.487.4199

www.saqa.com

Printed in China

Introduction

Studio Art Quilt Associates (SAQA) is pleased to bring you the latest volume in our Portfolio series, **Portfolio 20**, showcasing glorious artwork by 261 artists. Each artist is a professional artist member of SAQA, the world's largest organization devoted to art quilts.

Whether you're a collector, curator, or critic, we encourage you to use **Portfolio 20** as a reference tool for your work in the arts. We have included indexes of the artwork sorted by artists' locations and by genre. Genre categories include abstract, conceptual, figurative, landscape, nature, representational, and sculptural.

Prior volumes of SAQA's Portfolio series are available through the SAQA Bookstore on our website, www.saqa.com. In addition, images from **Portfolios 17**, **18** and **19** are available in online digital versions searchable by artist, location, and genre. Access to the digital versions is provided on SAQA's home page. A digital version of this volume will be available in Spring 2014.

Founded in 1989, SAQA is a nonprofit organization whose mission is to promote the art quilt. Now comprised of almost 3,300 members in 32 countries, SAQA promotes the art quilt through exhibitions, publications, and professional development opportunities. We host an annual conference, publish a quarterly Journal, and sponsor multiple exhibitions each year. In 2013, exhibitions of SAQA member work traveled to Australia, Canada, England, France, Gabon, Italy, South Africa, and seventeen states across the U.S. They were displayed in 8 museums and 19 major quilt festivals and were seen by several hundred thousand visitors. Information about SAQA and these exhibitions is available on the SAQA website. Full-color catalogs of many of the exhibitions are also available.

We hope you enjoy this opportunity to immerse yourself in page after page of wonderfully innovative artwork which merges the tactile, technological, and traditional aspects of quilted art.

Denise Linet

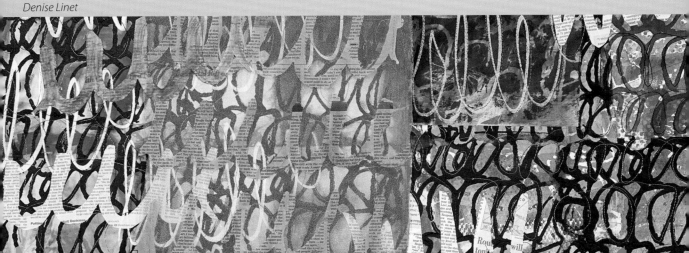

Studio Art Quilt Associates, Inc.

Portfolio
20

The artists

Linda Abrams

Lake Success, New York, USA

516-829-3859 | info@lindasartisticadventures.com | www.lindasartisticadventures.com

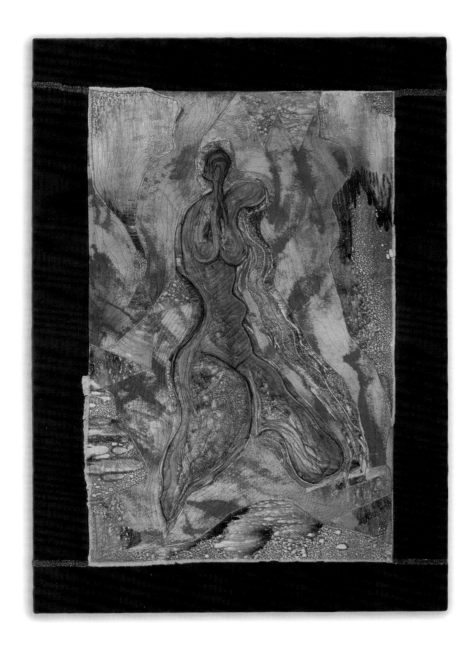

figurative

Demons Be Gone

42 x 30 inches (107 x 76 cm) | 2013

Virginia Abrams

Hockessin, Delaware, USA

302-239-5110 | ginnyabrams@gmail.com | www.virginiaabrams.com

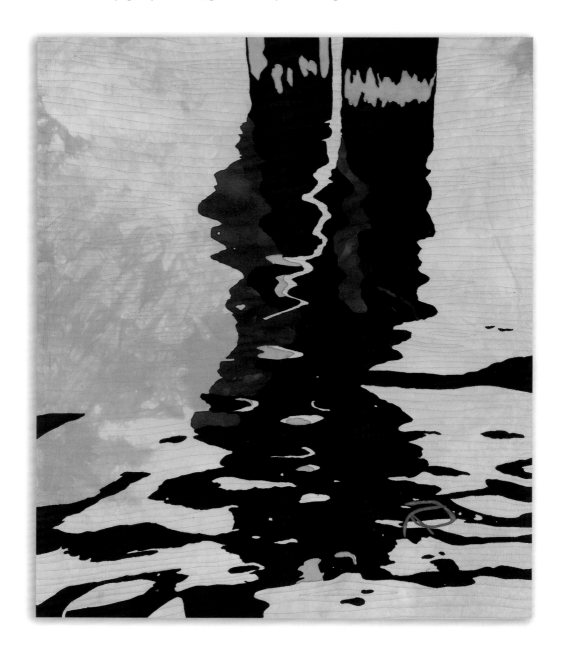

Reflections 12

32 x 26 inches (80 x 66 cm) | 2012

abstract

B. J. Adams

Washington, DC, USA

202-364-8404 | bjfiber@aol.com | www.bjadamsart.com/bjadamsmallwork.blogspot.com

 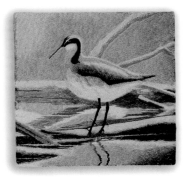

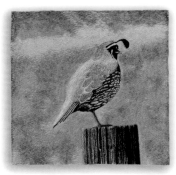 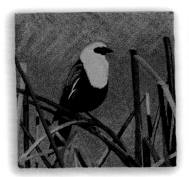 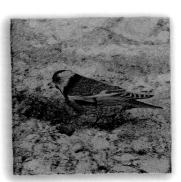

Photo by PRS Associates

representational

Six Birds

18 x 28 inches (46 x 71 cm) | 2012

Deidre Adams

Littleton, Colorado, USA
303-683-0316 | deidre@deidreadams.com | deidreadams.com

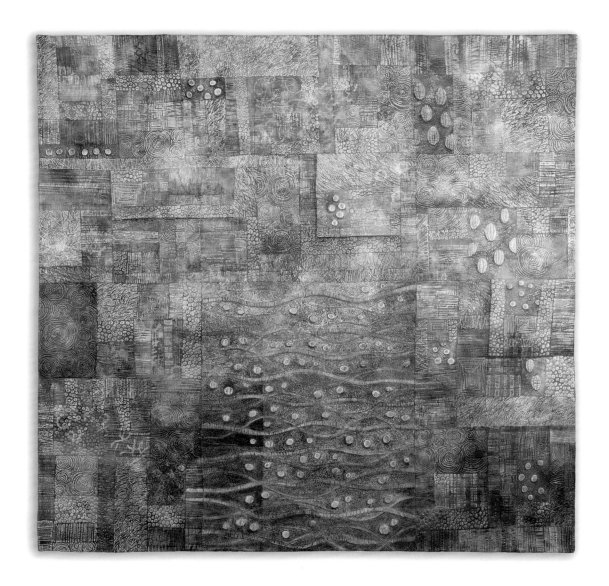

Tracings III
60 x 60 inches (152 x 152 cm) | 2011

abstract

Regula Affolter

Oekingen, Solothurn, Switzerland
+41 79 232 85 50 | regaffolter@bluewin.ch | www.regaffolter.ch

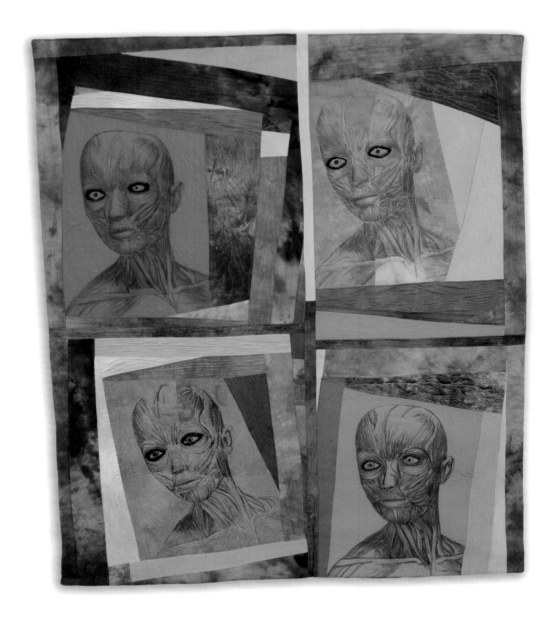

figurative

Fräulein Frontal
54 x 44 inches (137 x 112 cm) | 2012

Natalya Aikens

Pleasantville, New York, USA

917-414-7969 | natalya@artbynatalya.com | www.artbynatalya.com

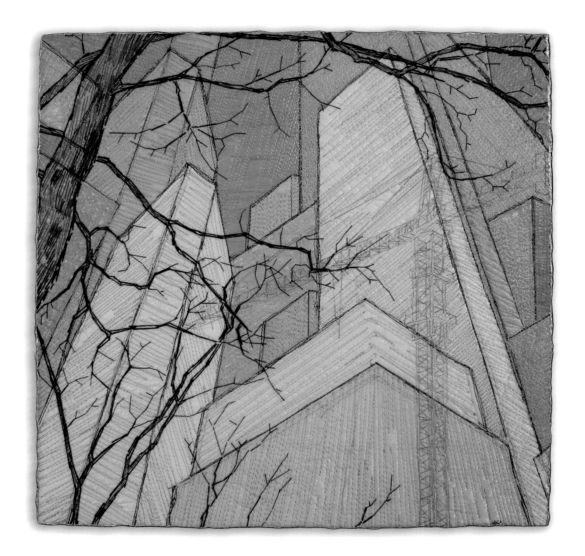

Spring

12 x 12 inches (31 x 31 x cm) | 2013

representational

Mary Lou Alexander

Hubbard, Ohio, USA

330-568-1605 | maryloualexander@aol.com | maryloualexander.com

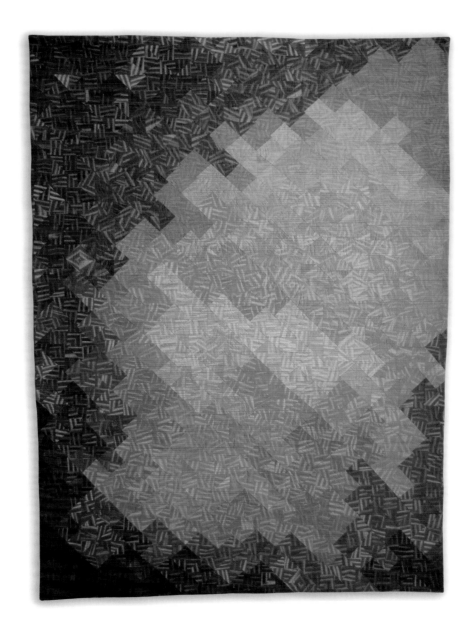

Global Warming

60 x 43 inches (152 x 109 cm) | 2012

Frieda L. Anderson

Elgin, Illinois, USA
847-987-7556 | frieda@friestyle.com | www.friestyle.com

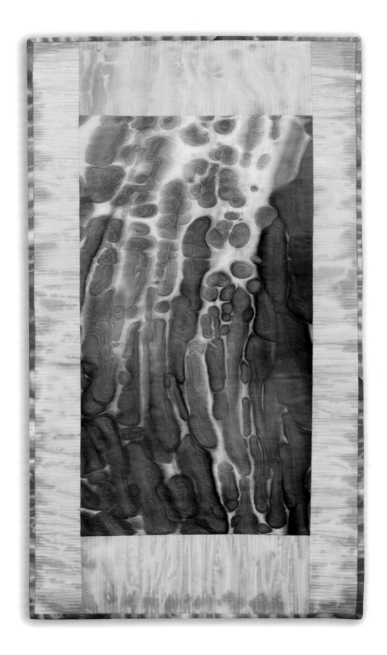

Bubble Up
43 x 23 inches (109 x 58 cm) | 2012

abstract

Linda Anderson

La Mesa, California, USA

619-876-1609 | andersonlinda2@gmail.com | www.laartquilts.com

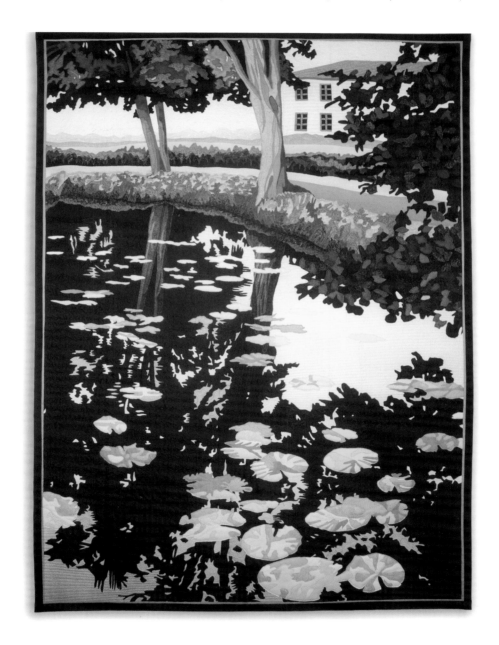

landscape

Britta Ankenbauer

Leipzig, Sachsen, Germany
0049-3412465216 | britank@hotmail.com | www.britta-ankenbauer.de

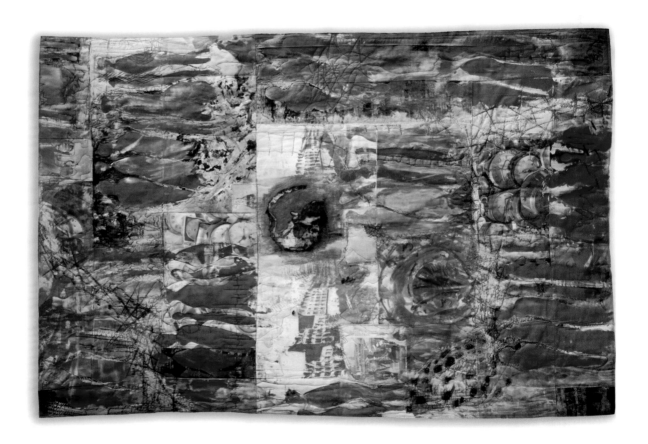

Alles Bestens

31 x 50 inches (79 x 127 cm) | 2011

conceptual

Ludmila Aristova

Brooklyn, New York, USA

646-345-8777 | ludmila.aristova@gmail.com | www.ludmilaaristova.com

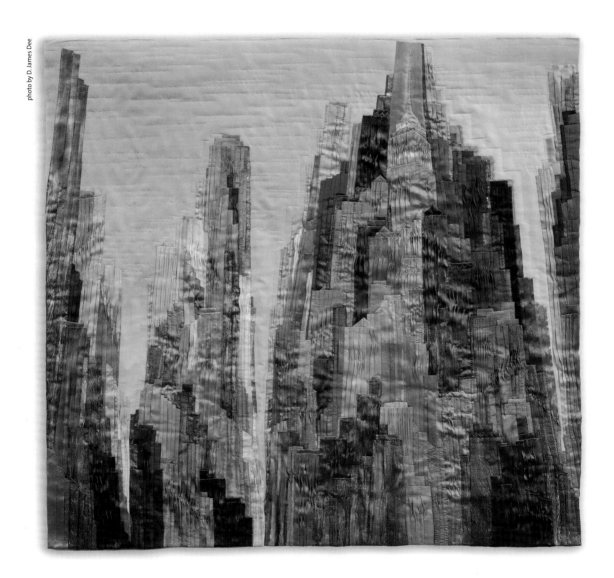

photo by D. James Dee

landscape

Summertime

36 x 36 inches (91 x 91 cm) | 2011

Jill Ault

Ann Arbor, Michigan, USA
734-665-4601 | jillault@umich.edu | jillault.com

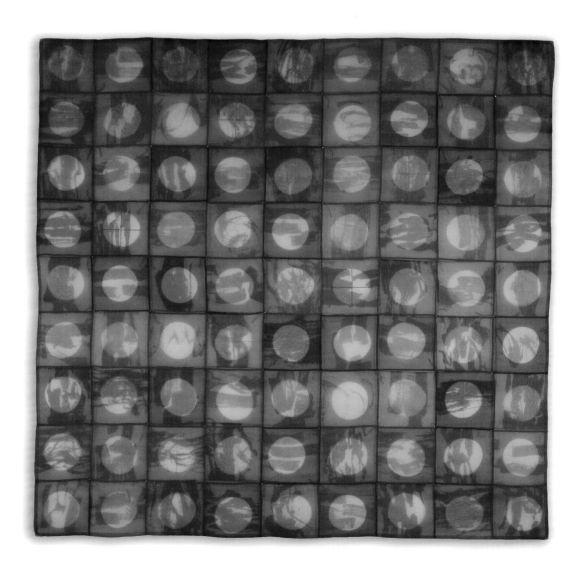

Markings: Flush

45 x 45 inches (114 x 114 cm) | 2012

abstract

Gail J. Baar

Buffalo Grove, Illinois, USA
847-537-3890 | gail.baar@gmail.com | www.gjbquilts.blogspot.com

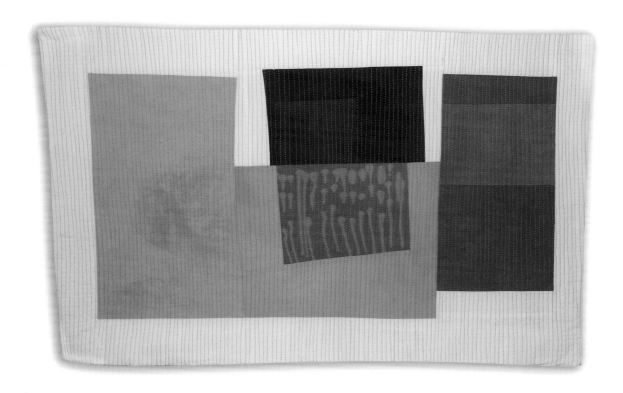

abstract

ColorForm 32
15 x 23 inches (38 x 58 cm) | 2013

Deborah Babin

Indianola, Washington, USA

443-624-2400 | debbiebabin@studioquilts.com | www.deborahbabin.com

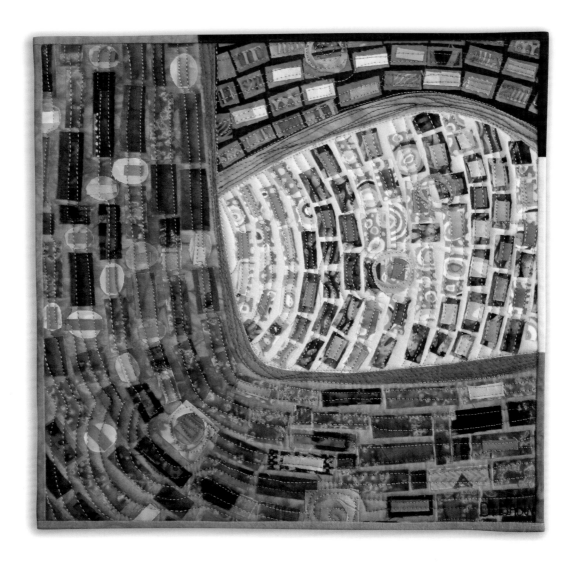

Circle The Block

12 x 12 inches (31 x 31 cm) | 2013

abstract

Roberta Baker

Grass Valley, California, USA

510-333-1528 | artquiltsbyrobertabaker@gmail.com | artquiltsbyrobertabaker.com

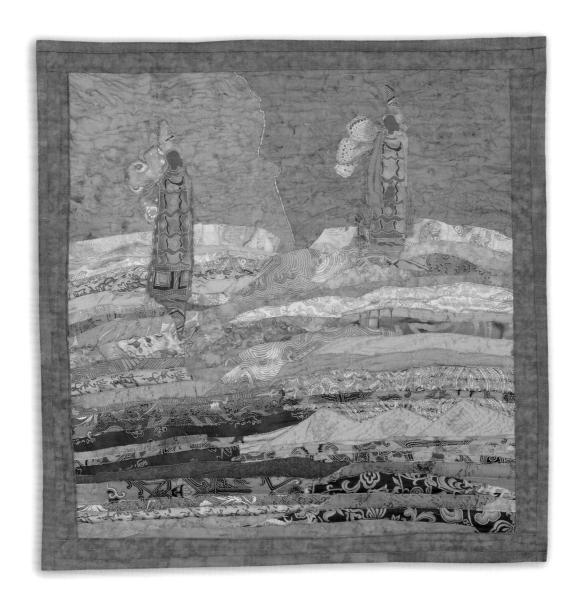

figurative

Earth Angels

24 x 26 inches (61 x 66 cm) | 2011

Nancy Bardach

Berkeley, California, USA

510-524-5589 | nancybardach@gmail.com | nancybardach.com

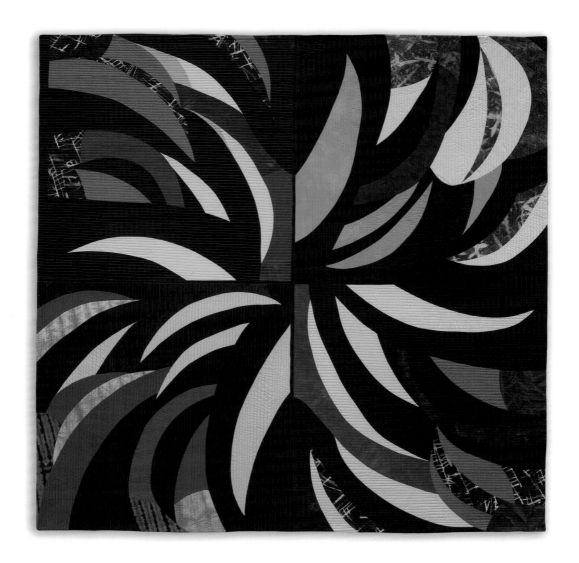

Ignition

83 x 83 inches (211 x 211 cm) | 2012

conceptual

Teresa Barkley

Maplewood, New Jersey, USA
973-830-7097 | quiltduck@aol.com

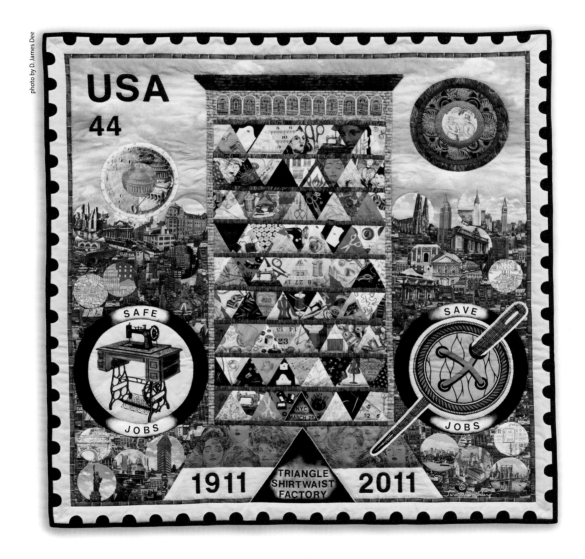

photo by D. James Dee

The Triangle
36 x 36 inches (91 x 91 cm) | 2011

Sharon M. W. Bass

Lawrence, Kansas, USA
785-842-2285 | bass@ku.edu | www.smwbass.com

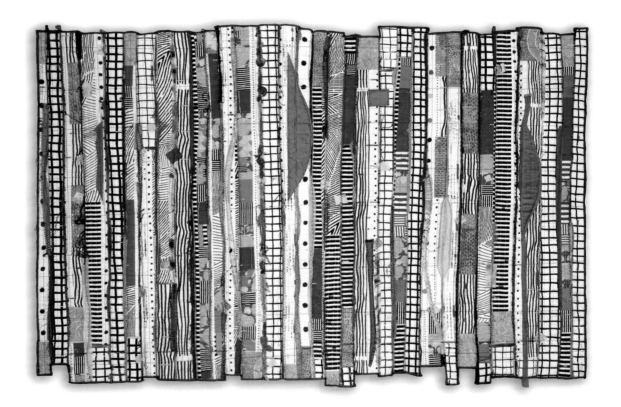

Fenceline

31 x 45 inches (79 x 114 cm) | 2011

abstract

Linda Beach

Estes Park, Colorado, USA

970-480-5016 | linda@lindabeachartquilts.com | www.lindabeachartquilts.com

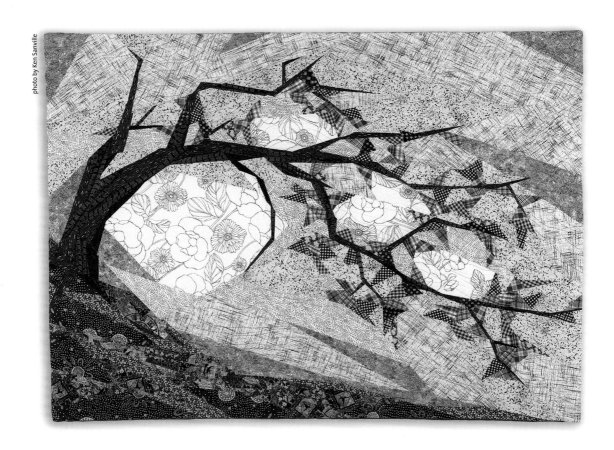

photo by Ken Sanville

nature

Krummholz

36 x 48 inches (90 x 121 cm) | 2011

Catherine Beard

Springfield, Oregon, USA

541-914-7571 | cathbeard@aol.com | catherinebeardfiberartist.com

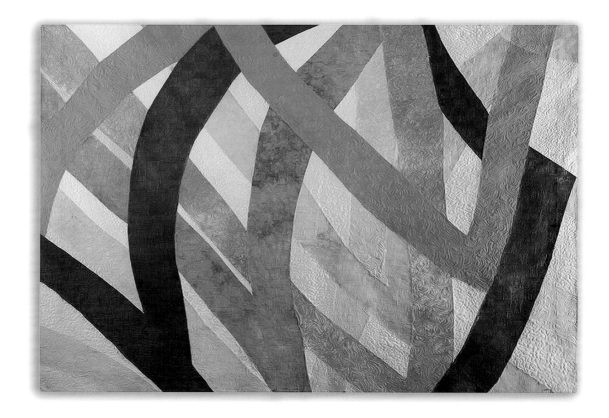

Adagio

34 x 52 inches (86 x 132 cm) | 2012

abstract

Alice Beasley

Oakland, California, USA

510-543-4763 | abeasley@sbcglobal.net | www.alicebeasley.com

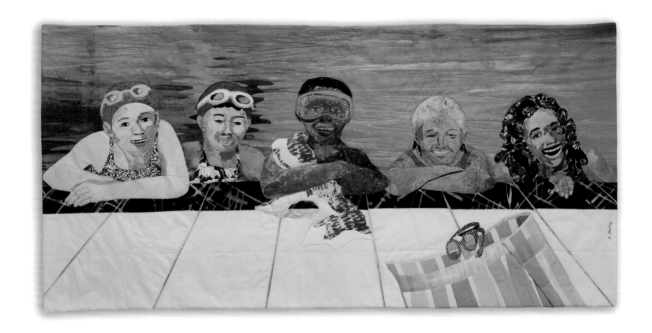

figurative

The Summer We Learned to Swim

30 x 59 inches (76 x 150 cm) | 2013

Nancy Greyson Beckerman

Pound Ridge, New York, USA

914-764-8106 | nancybgb@verizon.net

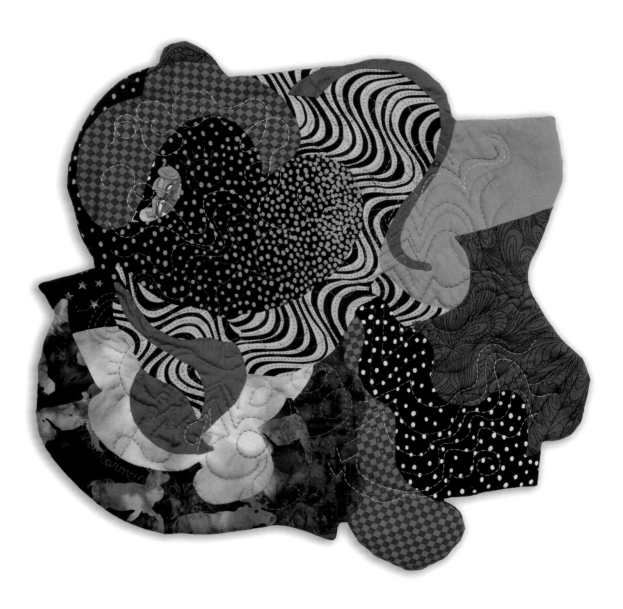

The Blue Heart of the Tiger

18 x 18 inches (46 x 46 cm) | 2012

abstract

Christi Beckmann

Livermore, Colorado, USA
970-391-1292 | christibeckmann@yahoo.com | www.freereinarts.com

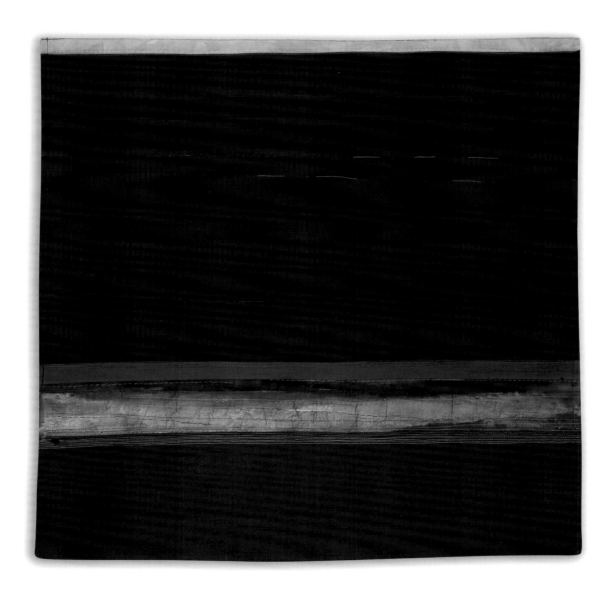

abstract

Zen landscape#1
38 x 38 inches (97 x 97 cm) | 2012

Mary Beth Bellah

Charlottesville, Virginia, USA
434-409-9213 | mb@marybethbellah.com | www.marybethbellah.com

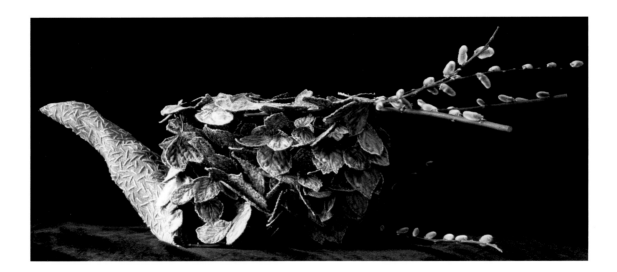

Loose Leaf Tea
11 x 32 x 20 inches (28 x 81 x 50.8 cm) | 2013

sculptural

Sue Benner

Dallas, Texas, USA

214-796-8089 | suebenner@aol.com | www.suebenner.com

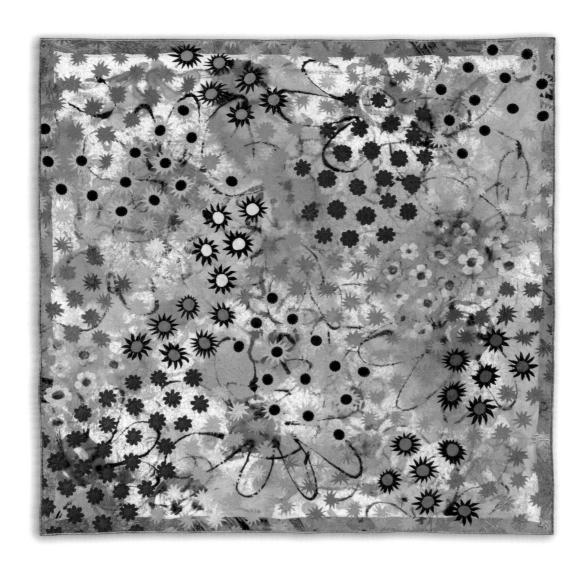

nature

Flower Field 4: Rudbeckia, et al.

46 x 46 inches (117 x 117 cm) | 2012

Regina V. Benson

Golden, Colorado, USA

303-278-0413 | regina-b@comcast.net | www.reginabenson.com

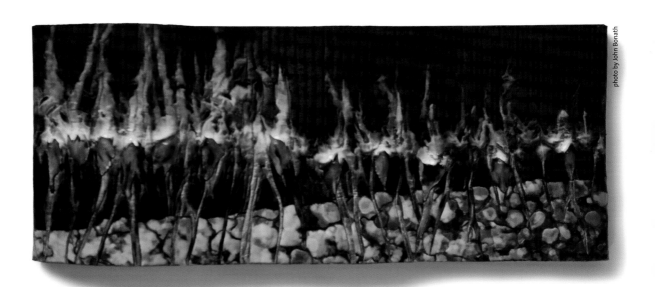

photo by John Bonath

Wildfire II

12 x 28 x 4 inches (31 x 71 x 10.2 cm) | 2011

conceptual

Nancy Billings

Miami, Florida, USA

305-775-3470 | nancybdesigns@gmail.com | nancybdesigns.com

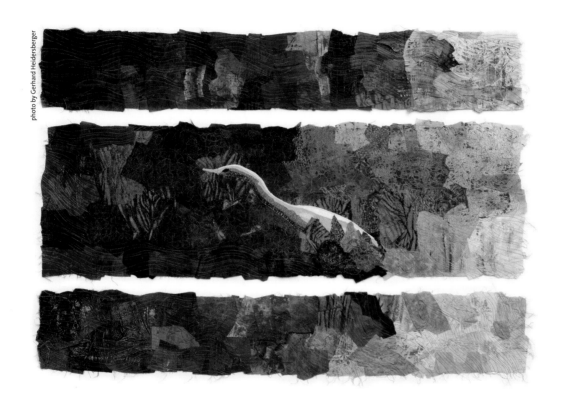

photo by Gerhard Heidersberger

nature

Solitude

28 x 36 inches (71 x 91 cm) | 2012

Charlotte Bird

San Diego, California, USA

619-294-7236 | cbird2400@aol.com | www.birdworks-fiberarts.com

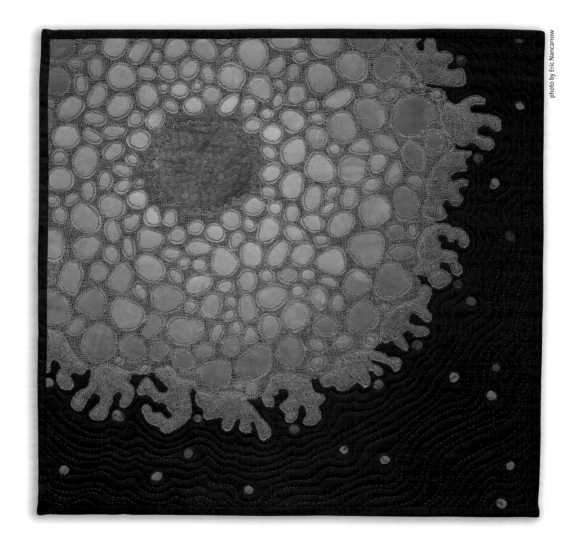

photo by Eric Nancarrow

Lichen 1

15 x 15 inches (38 x 38 cm) | 2012

abstract

Pat Bishop

Appleton, Wisconsin, USA

920-882-3748 | patbishop@new.rr.com | www.patbishop.info

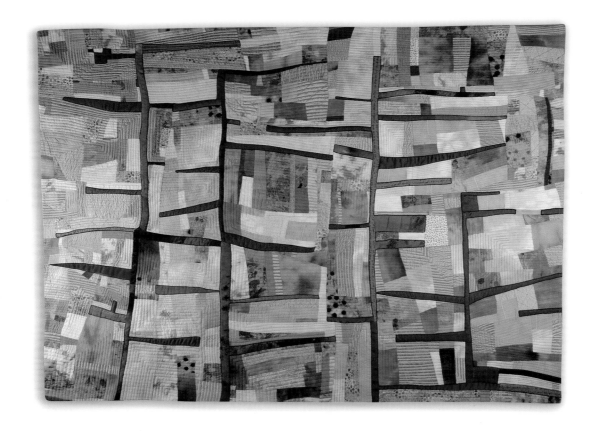

abstract

Spring Woods

34 x 46 inches (86 x 117 cm) | 2012

Patt Blair

Mt. Baldy, California, USA

909-982-7772 | patt@pattsart.com | www.pattsart.com/www.pattsart.blogspot.com

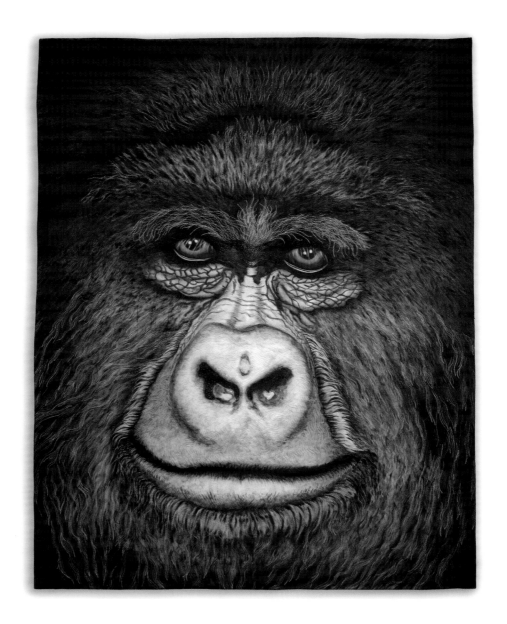

My Gentle Giant...Ben

41 x 31 inches (104 x 79 cm) | 2011

nature

Susan Bleiweiss

Upton, Massachusetts, USA

508-529-3271 | sue@suebleiweiss.com | www.suebleiweiss.com

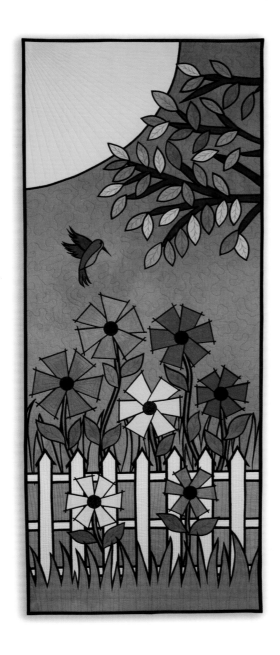

nature

The Hummingbird

60 x 24 inches (152 x 61 cm) | 2013

Ann Brauer

Shelburne Falls, Massachusetts, USA

413-834-3576 | ann@annbrauer.com | www.annbrauer.com

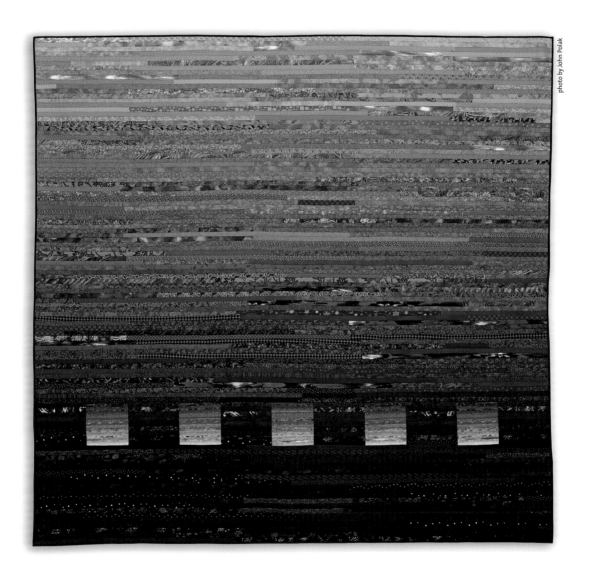

photo by John Polak

winter light

99 x 99 inches (252 x 252 cm) | 2013

abstract

Melani Brewer

Cooper City, Florida, USA

954-431-8700 | melanibrewerstudio@att.net | www.melanibrewer.com

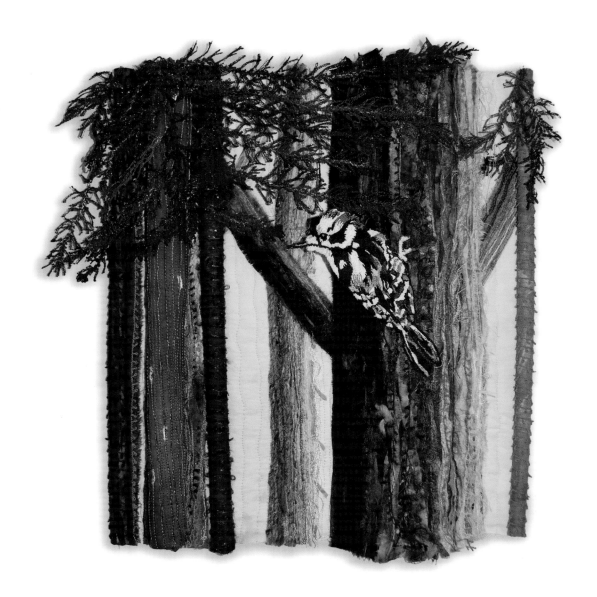

nature

Hairy Woodpecker

17 x 16 x 2 inches (42 x 39 x 5.1 cm) | 2013

Eliza Brewster

Honesdale, Pennsylvania, USA
570-448-2904 | elizal@msn.com | www.fineartquilts.com

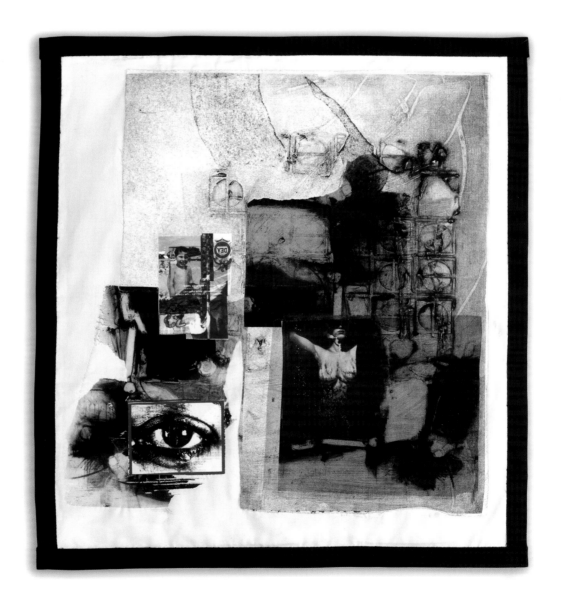

The Eye On The Prize

24 x 22 inches (61 x 55 cm) | 2012

conceptual

Kathie Briggs

Charlevoix, Michigan, USA

231-547-4971 | kathie@kathiebriggs.com | www.kathiebriggs.com

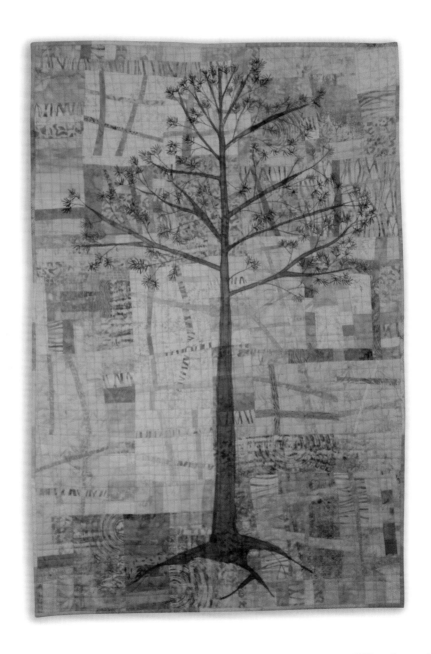

nature

For 4 Who Stood Tall

40 x 25 inches (102 x 64 cm) | 2012

Jack Brockette

Dallas, Texas, USA

214-365-0692 | jack@brockette.com | www.brockette.com

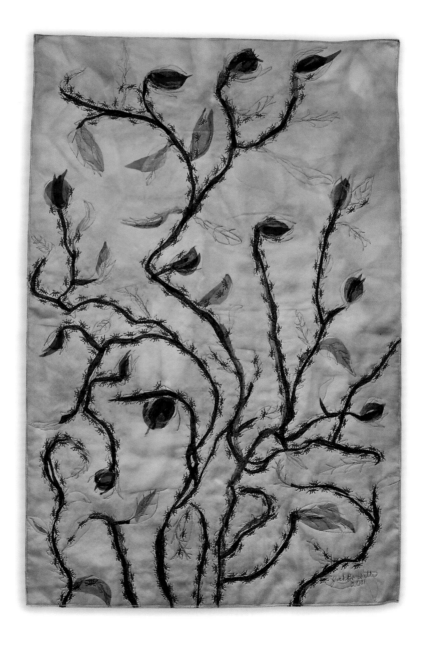

"Lunch"

36 x 22 inches (91 x 56 cm) | 2012

nature

Peggy Brown

Nashville, Indiana, USA

812-988-7271 | jpwestbreeze@aol.com | www.peggybrownart.com

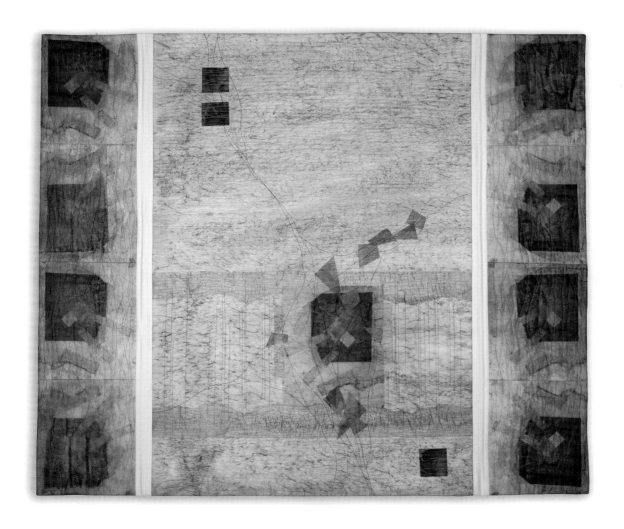

abstract

Fly Away

36 x 39 inches (91 x 99 cm) | 2011

Susan Brubaker Knapp

Mooresville, North Carolina, USA

704-663-0335 | susan@bluemoonriver.com | www.bluemoonriver.com

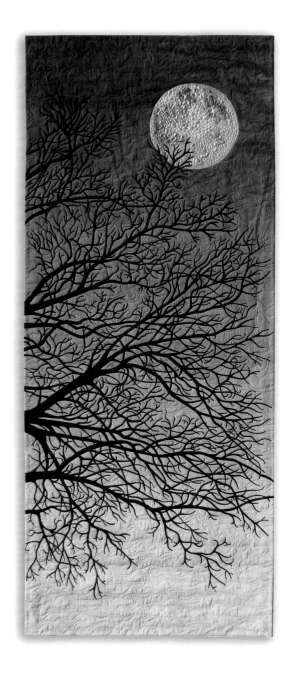

I See the Moon

60 x 24 inches (152 x 61 cm) | 2012

nature

Shelley Brucar

Buffalo Grove, Illinois, USA

847-921-4364 | shelley@handmade-creations.com | www.handmade-memories.com

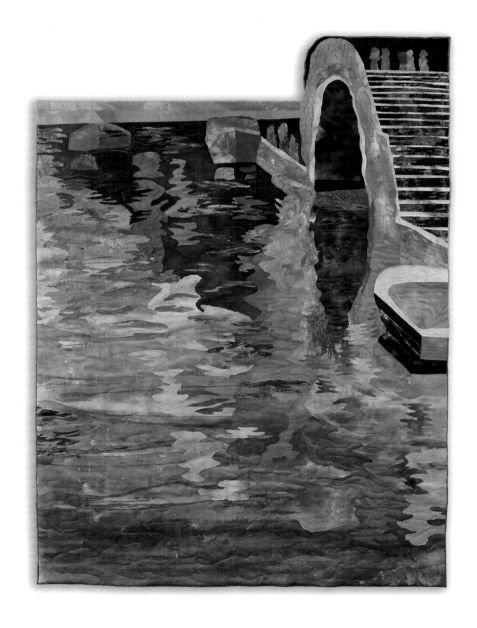

representational

Venetian Reflections II

45 x 33 inches (114 x 84 cm) | 2012

Mary T. Buchanan

Richmond, Virginia, USA

804-366-4804 | mbtbuchanan@aol.com | mary-t-buchanan.com

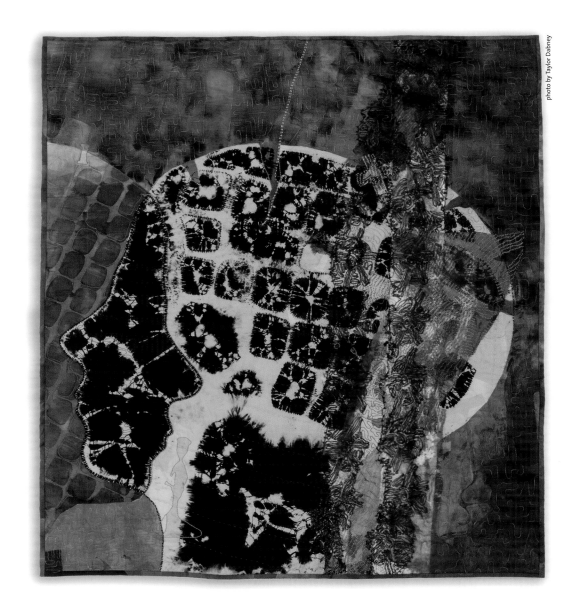

photo by Taylor Dabney

Opposites Attract

39 x 36 inches (99 x 91 cm) | 2012

figurative

Betty Busby

Albuquerque, New Mexico, USA

505-275-9511 | fbusby3@comcast.net | bbusbyarts.com

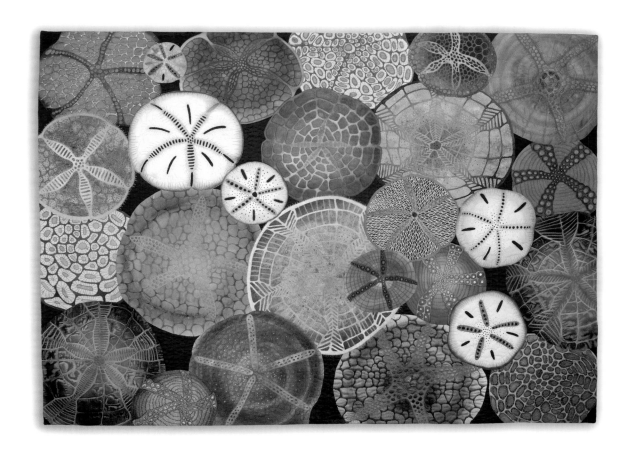

nature

Sand Dollar Spectrum

49 x 68 inches (125 x 173 cm) | 2013

Judith Busby

Clifton, Virginia, USA

703-298-3238 | judithcbusby@cox.net | www.judybusby.com

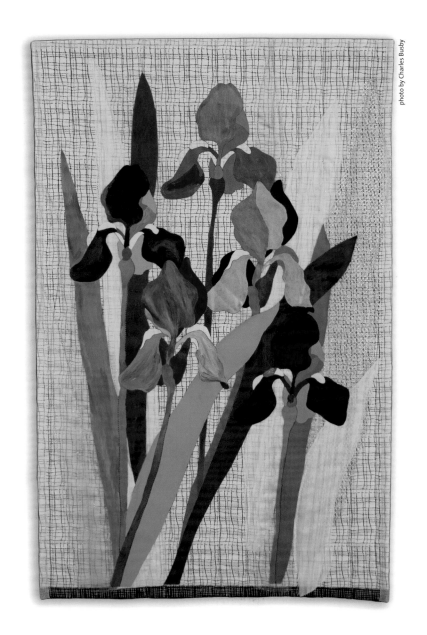

photo by Charles Busby

Purple Irises

28 x 17 inches (71 x 43 cm) | 2012

nature

Elizabeth Busch

Glenburn, Maine, USA

207-942-7820 | ebartist@infionline.net | www.elizabethbusch.com

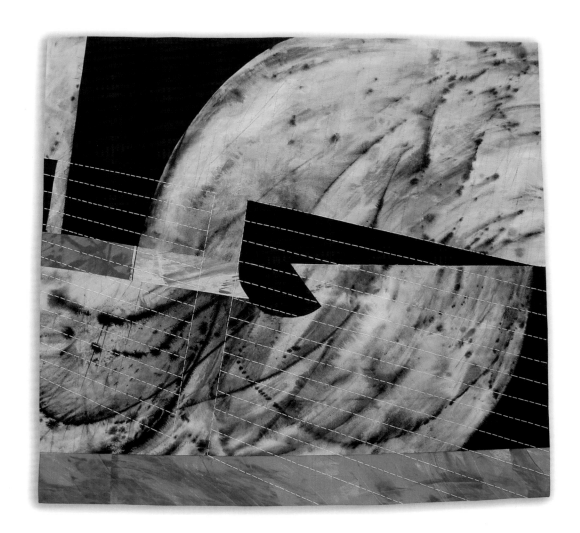

conceptual

Progress

57 x 59 inches (145 x 150 cm) | 2012

Joke Buursma

Portlaw, Co. Waterford, Ireland
00353 51 645091 | jokebuursma@gmail.com | www.jokebuursma.weebly.com

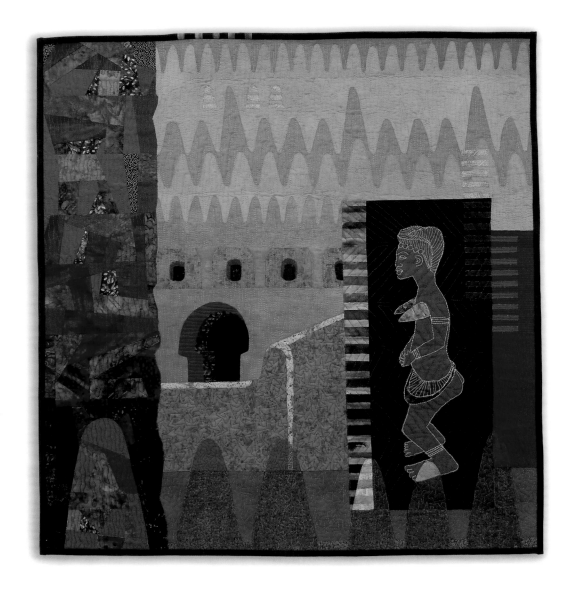

Mali, Hermaphrodite II

30 x 28 inches (77 x 72 cm) | 2013

figurative

Benedicte Caneill

Larchmont, New York, USA

914-833-8313 | benedictecaneill@gmail.com | www.benedictecaneill.com

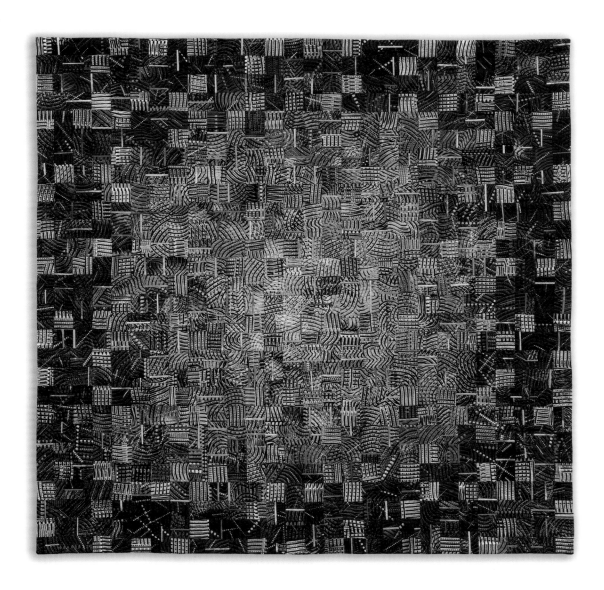

abstract

Units 27: Sunburst

69 x 69 inches (175 x 175 cm) | 2012

Ruth Carden

Fernandina Beach, Florida, USA
904-277-1562 | rdcarden@gmail.com

photo by Amanda Martin

A Year Without: Sadness Glistening With Hope

34 x 47 inches (86 x 119 cm) | 2012

abstract

Carolyn Carson

Pittsburgh, Pennsylvania, USA

412-979-5722 | carolyncarson753@hotmail.com | carolyncarsonart.com

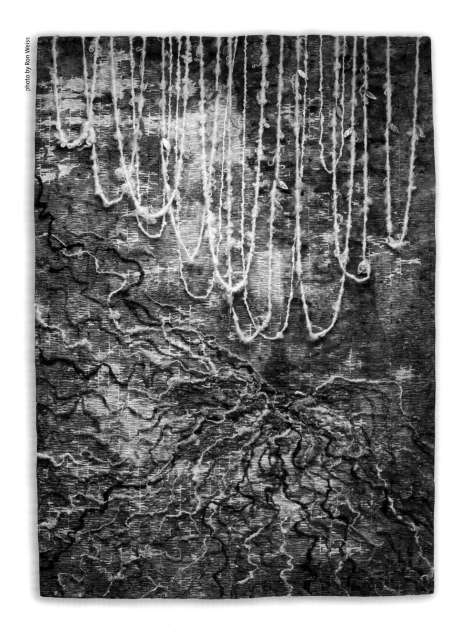

photo by Ron Weiss

abstract

Rooted

64 x 43 inches (163 x 109 cm) | 2013

Shin-hee Chin

McPherson, Kansas, USA
620-241-1406 | shinheec@tabor.edu | www.shinheechin.com

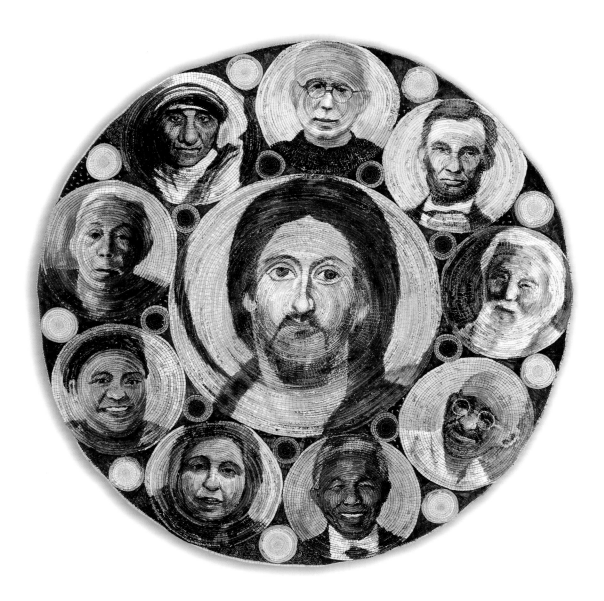

Imago Dei 2: Peacemakers

63 x 63 inches (160 x 160 cm) | 2011

figurative

Susan Christensen

Petersburg, Alaska, USA
907-518-1591 | sjchristensen.com@gmail.com

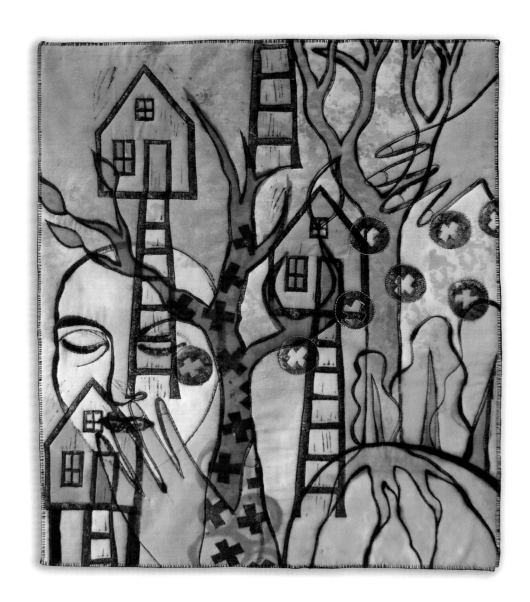

conceptual

Fortune Teller
22 x 18 inches (56 x 45 cm) | 2012

Paula Chung

Zephyr Cove, Nevada, USA

805-428-2204 | 2paulachung@gmail.com | www.paulachung.com

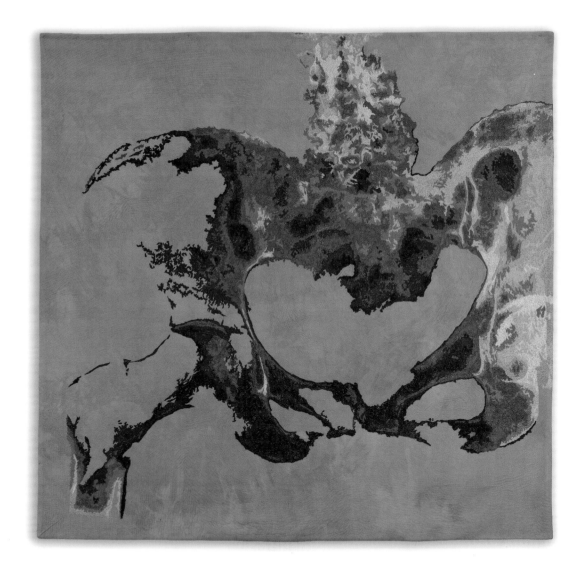

Femur V: Pelvis

36 x 36 inches (91 x 91 cm) | 2011

figurative

Rosemary Claus-Gray

Doniphan, Missouri, USA

573-354-2634 | rosemary10@windstream.net | www.rosemaryclaus-gray.com

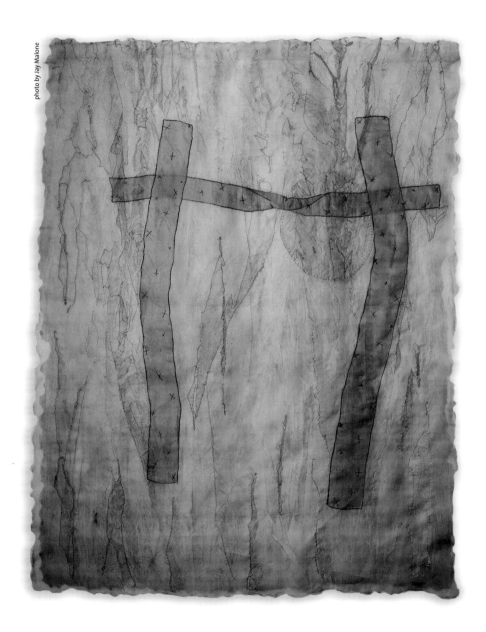

photo by Jay Malone

conceptual

Portals VIII

54 x 40 inches (137 x 102 cm) | 2012

Jette Clover

Antwerp, Belgium

003232397437 | jette@jetteclover.com | www.jetteclover.com

WORDS 6

39 x 39 inches (99 x 99 cm) | 2011

conceptual

Sharon Collins

Arnprior, Ontario, Canada

613-622-5842 | sharoncol@gmail.com | sharoncollinsart.com

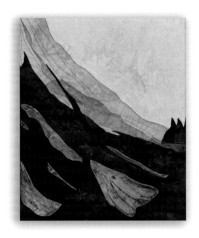
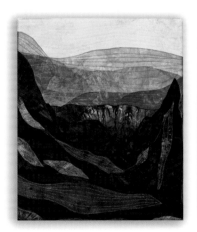
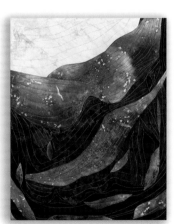

conceptual

Trance

46 x 56 inches (117 x 142 cm) | 2013

Linda Colsh

Everberg, Belgium
011-322-757-2580 | linda@lindacolsh.com | www.lindacolsh.com

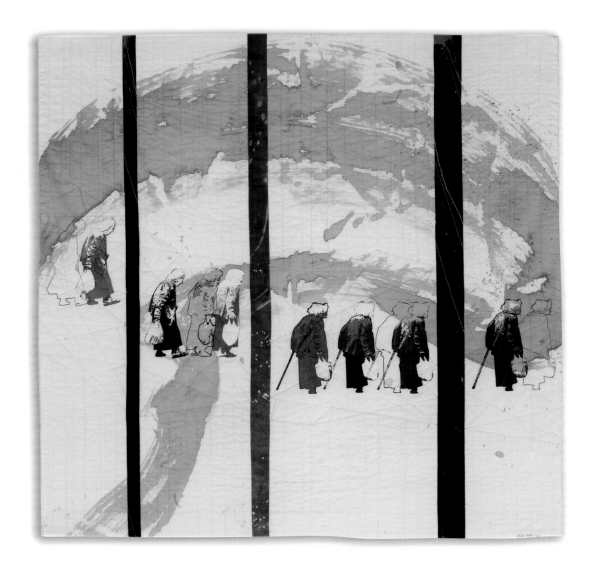

Red
40 x 40 inches (102 x 102 cm) | 2012

figurative

Jennifer Conrad

Minneapolis, Minnesota, USA

443-255-6740 | designsbyjconrad@me.com | www.designsbyjconrad.com

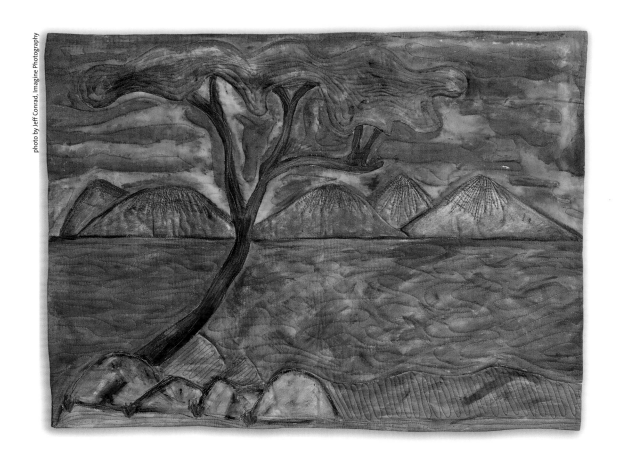

photo by Jeff Conrad, Imagine Photography

landscape

Midnight Under The Family Tree

26 x 34 inches (66 x 86 cm) | 2013

Judith Content

Palo Alto, California, USA

650-857-0289 | judithcontent@earthlink.net | www.jsauergallery.com

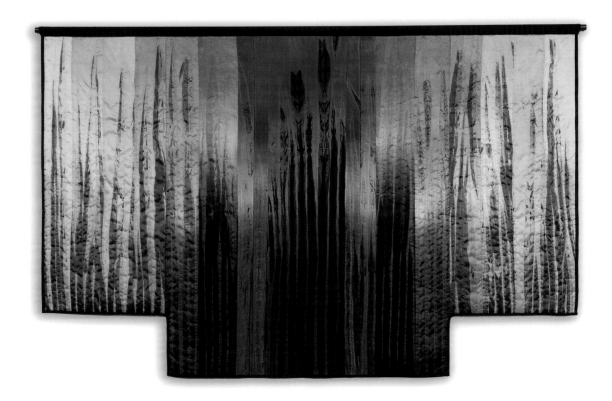

Cenote Azul

46 x 64 inches (117 x 163 cm) | 2011

abstract

Nancy G. Cook

Charlotte, North Carolina, USA

704-366-9643 | ngcook1@bellsouth.net | www.nancygcook.com

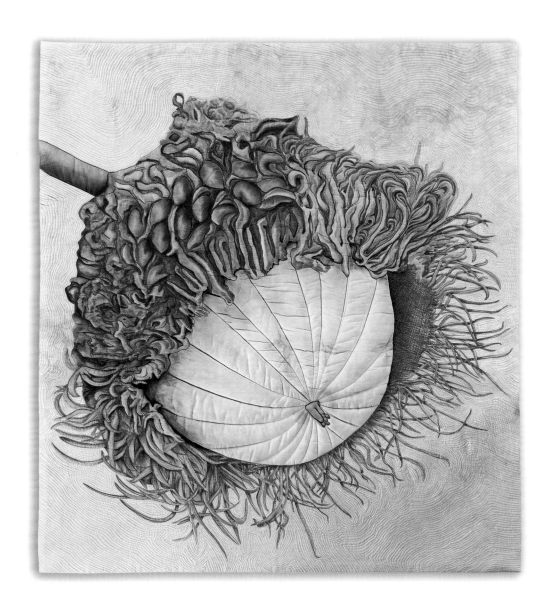

nature

Mossy-Cup Oak (Quercus Macrocarpa)

42 x 36 inches (107 x 91 cm) | 2011

Robin Cowley

Oakland, California, USA

510-325-8327 | art@robincowley.com | www.robincowley.com

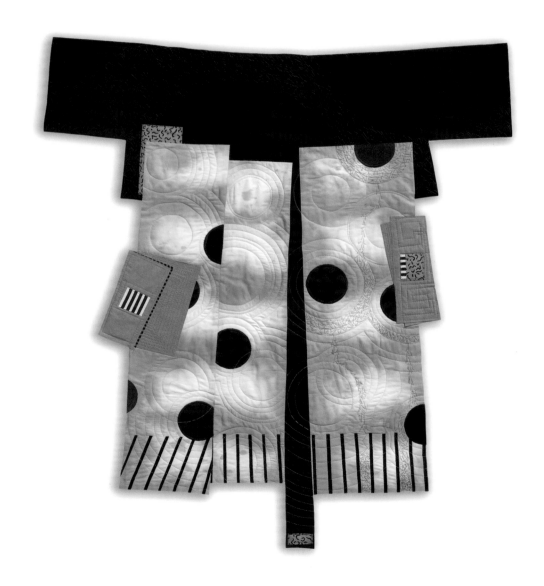

Slice

42 x 38 inches (107 x 97 cm) | 2012

abstract

Dena Dale Crain

Nakuru, Kenya

+254-710-608388 | dena@denacrain.com | www.denacrain.com

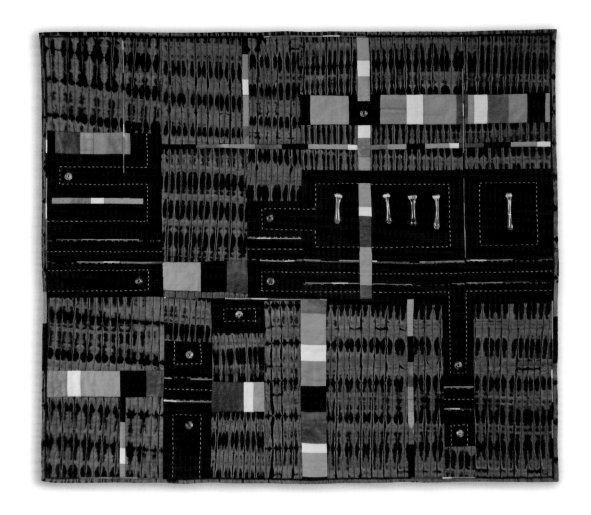

conceptual

Redefinitions V: Urban Africa

34 x 38 inches (86 x 97 cm) | 2012

Lenore Crawford

Midland, Michigan, USA

989-708-9390 | lenore@lenorecrawford.com | www.lenorecrawford.com

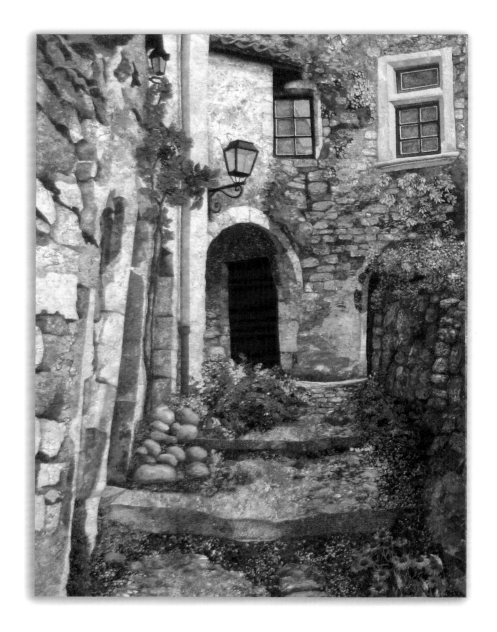

Le Poet Laval III

43 x 34 inches (109 x 86 cm) | 2012

landscape

Sandy Curran

Newport News, Virginia, USA

757-930-0666 | sandy_curran@hotmail.com | www.sandycurran.com

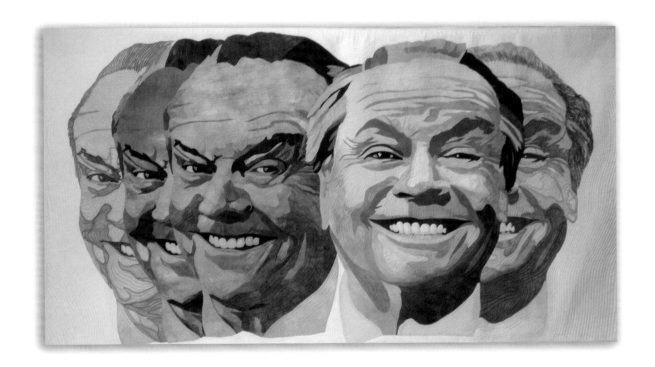

figurative

Jack

43 x 74 inches (109 x 188 cm) | 2011

Denise A. Currier

Mesa, Arizona, USA

480-964-6019 | deniseacurrier@msn.com | deniseacurrier.com

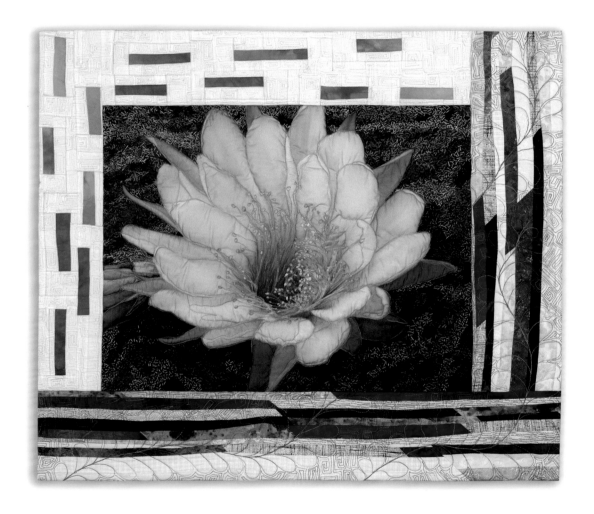

"Is It A-Z Botanical Journey" Series

27 x 31 inches (69 x 79 cm) | 2012

nature

Judy B. Dales

Greensboro, Vermont, USA
802-533-7733 | judy@judydales.com | judydales.com

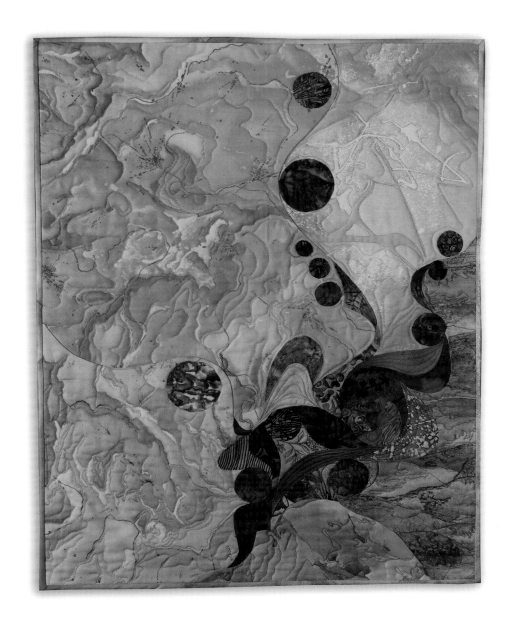

abstract

Dream A Little Dream
28 x 22 inches (71 x 56 cm) | 2013

Michele David

Boston, Massachusetts, USA

617-699-3693 | micheledavid.fiberart@gmail.com | www.creole-creations.com

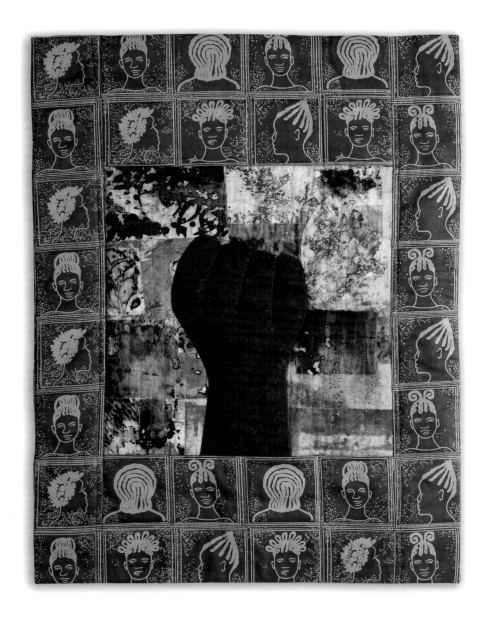

Liberté ou la Mort (Liberty or Death)

24 x 18 inches (61 x 46 cm) | 2012

representational

Yael David-Cohen

London, UK

442084587988 | yael@yaeldc.co.uk | www.yaeldc.co.uk

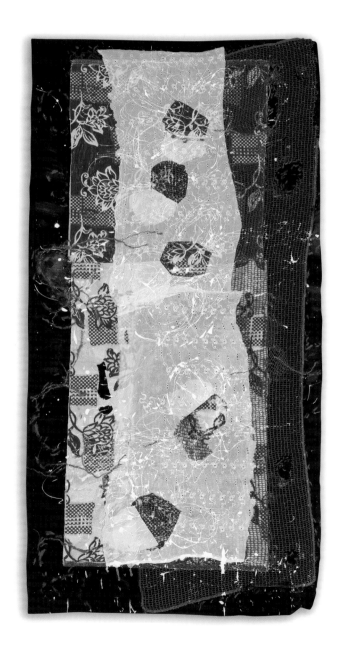

abstract

White on Orange

61 x 30 inches (155 x 76 cm) | 2012

Margie Davidson

Edmonton, Alberta, Canada
780-452-9692 | teamdavidson@interbaun.com | www.margiedavidson.ca

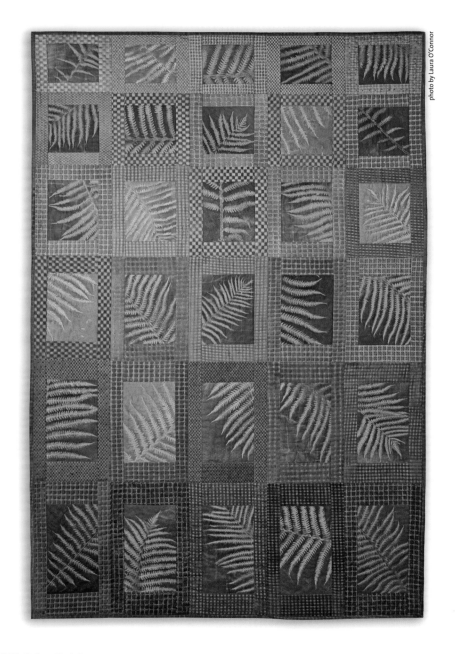

photo by Laura O'Connor

Ferns Within Grids

58 x 37 inches (147 x 94 cm) | 2013

nature

Fenella Davies

Bath, Somerset, UK

0044 1373831721 | fenelladavies@btinternet.com | www.fenelladavies.com

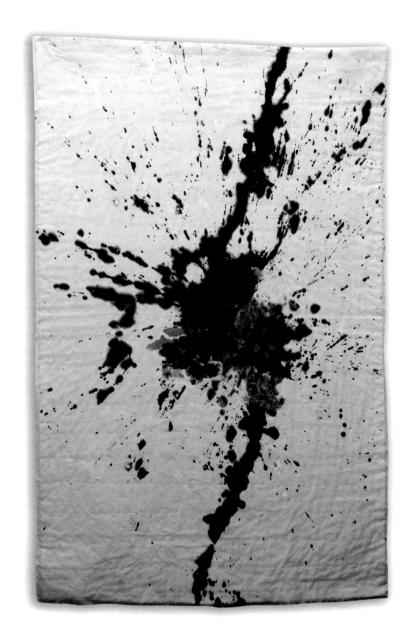

abstract

explosion

67 x 41 inches (170 x 104 cm) | 2012

Jacque Davis

Freeburg, Illinois, USA
618-363-9653 | jacque@jacquedavis.com | www.jacquedavis.com

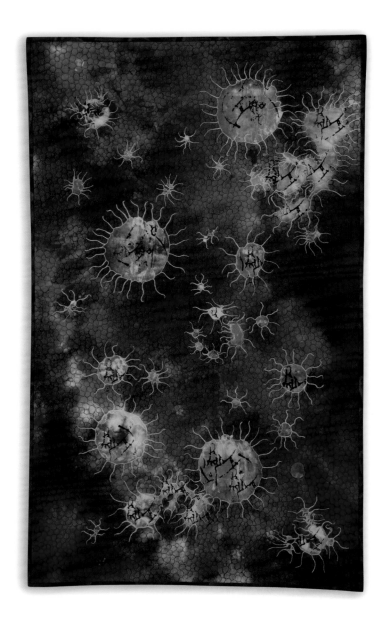

Life

37 x 22 inches (94 x 56 cm) | 2013

representational

Jennifer Day

Santa Fe, New Mexico, USA

505-660-8656 | jennifer@jdaydesign.com | www.jdaydesign.com

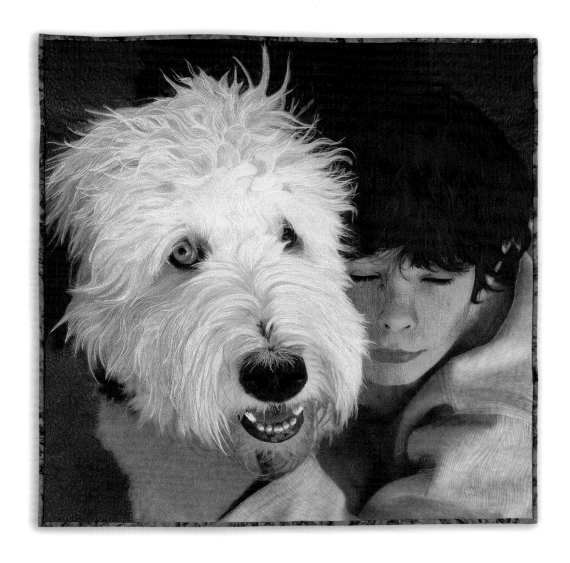

figurative

Boy and His Best Friend

34 x 34 inches (86 x 86 cm) | 2012

Ruth de Vos

Mt Nasura, Washington, Australia

+618 9399 2272 | ruth@ruthdevos.com | www.ruthdevos.com/blog

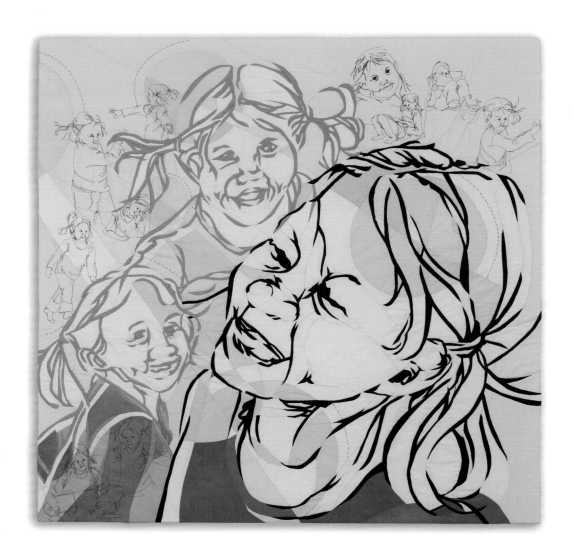

Flibbertigibbit

40 x 40 inches (102 x 102 cm) | 2012

figurative

Marcia DeCamp

Palmyra, New York, USA

315-597-9095 | mydecamp@gmail.com | www.marciadecamp.com

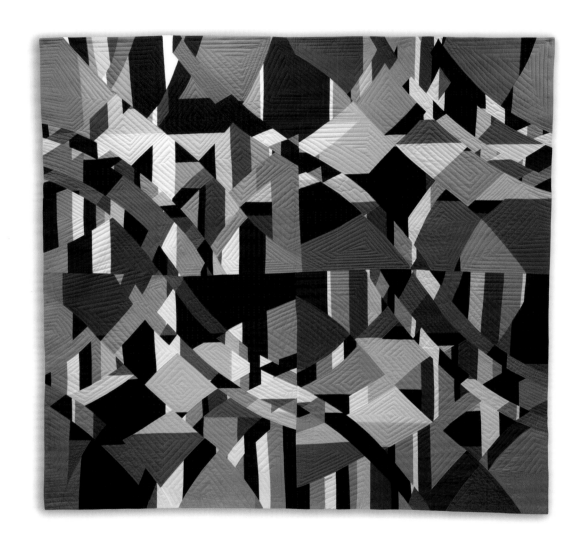

abstract

Whirlpool

70 x 73 inches (178 x 185 cm) | 2011

Sue Dennis

Brisbane, Queensland, Australia
+61 7 33454994 | bsdennis@bigpond.com | www.suedennis.com

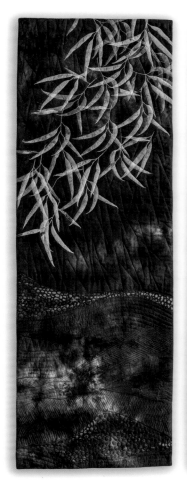
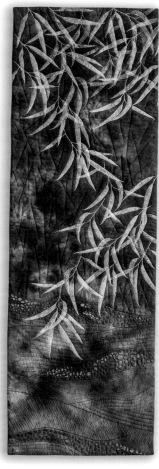
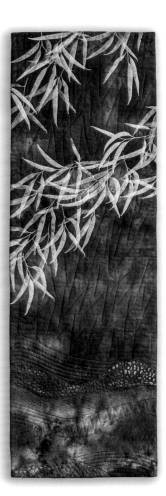

In the Moonlight

54 x 52 inches (137 x 132 cm) | 2012

nature

Dianne Vottero Dockery

Kutztown, Pennsylvania, USA

610-683-6137 | dvdathome@yahoo.com | www.diannevotterodockery.com

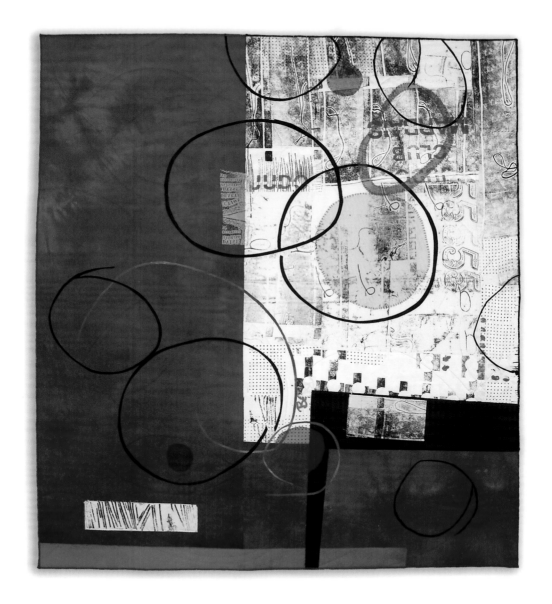

abstract

Emotions in Motion

37 x 33 inches (94 x 84 cm) | 2012

Chiaki Dosho

Kawasaki-shi, Kanagawa-ken, Japan
+81-44-987-9120 | chiakidoshoart@mac.com | chiakidoshoart.com

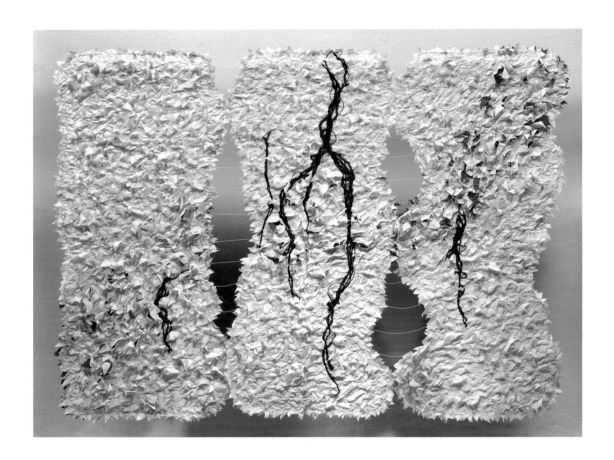

Cherry Blossom 10

63 x 82 inches (160 x 208 cm) | 2012

abstract

Eileen Doughty

Vienna, Virginia, USA

703-938-6916 | artist@doughtydesigns.com | www.doughtydesigns.com

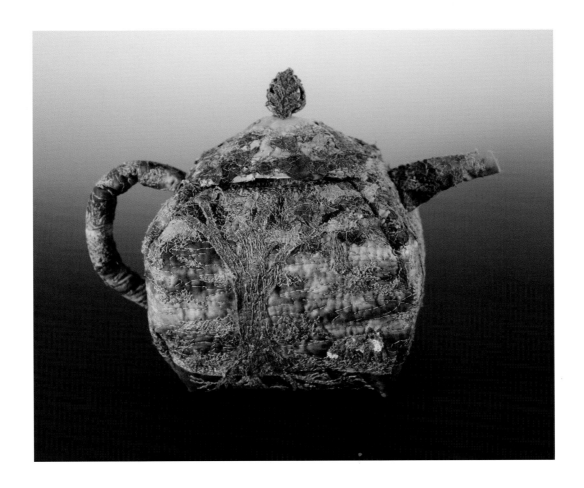

sculptural

Woodland Tea

6 x 8 x 5 inches (15 x 20 x 13 cm) | 2012

Pamela Druhen

Northfield, Vermont, USA

802-485-9650 | druhens@yahoo.com | www.pameladruhen.com

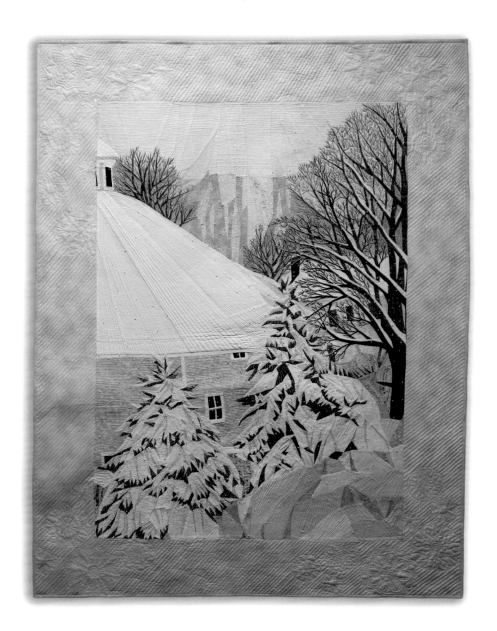

Winter Inn

53 x 40 inches (133 x 100 cm) | 2012

landscape

Heather Dubreuil

Hudson, Quebec, Canada

450-458-7408 | hdubreuil@sympatico.ca | www.heatherdubreuil.com

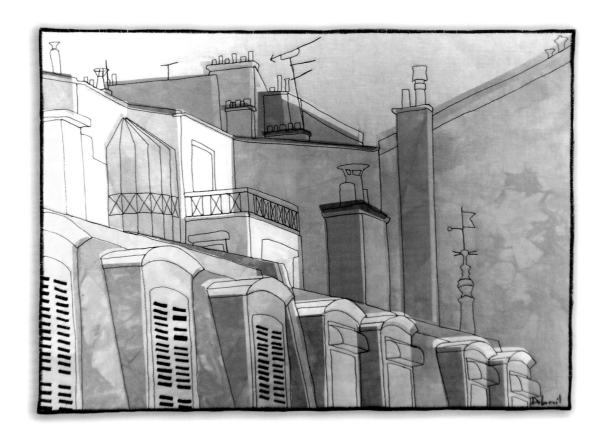

landscape

Montmartre #1

18 x 24 inches (46 x 61 cm) | 2012

Pat Durbin

Eureka, California, USA
707-443-2047 | stitching@suddenlink.net | www.patdurbin.com

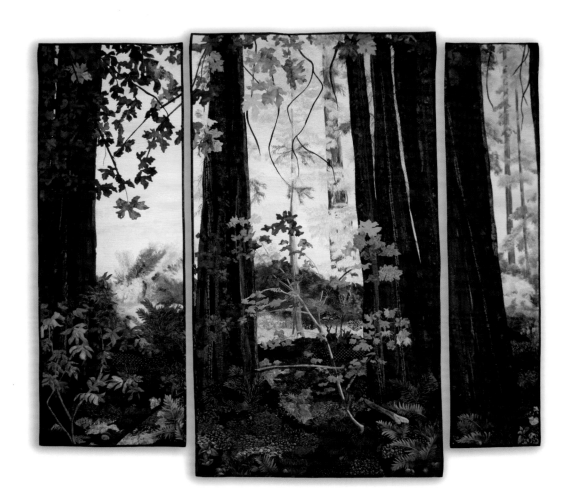

Sunlight in the Forest
58 x 65 inches (147 x 165 cm) | 2013

landscape

Juliette Eckel

Beverstedt, Germany
004947478730126 | juliette.a.eckel@t-online.de

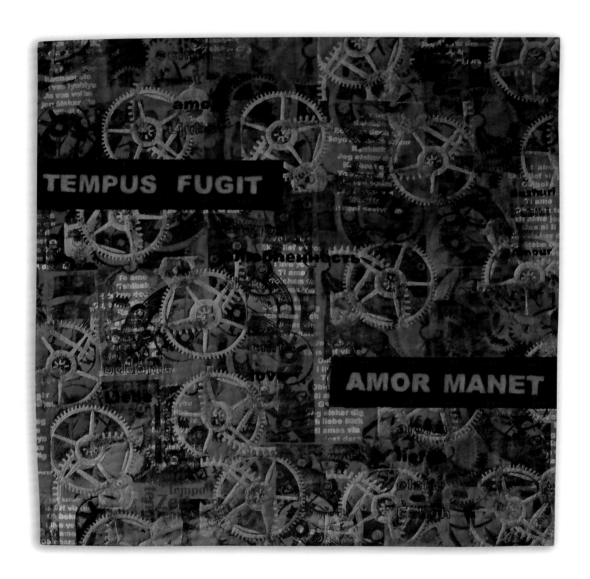

conceptual

TEMPUS FUGIT AMOR MANET

39 x 39 inches (100 x 100 cm) | 2012

Ginny Eckley

Kingwood, Texas, USA

281-415-9688 | arthread@embarqmail.com | www.fabricpainting.com

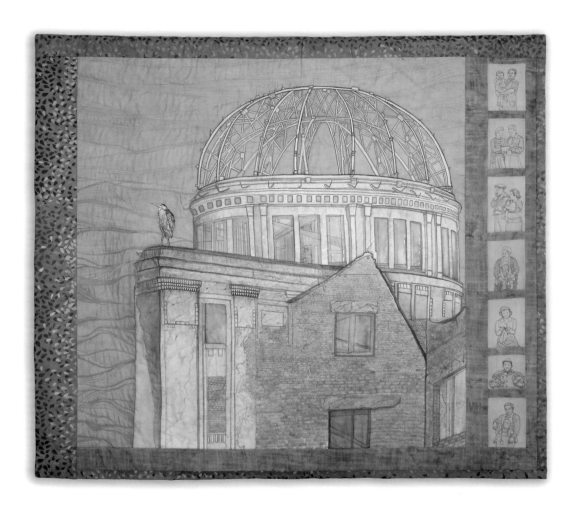

War Ripples

55 x 62 inches (140 x 158 cm) | 2011

representational

Ellen Anne Eddy

Chesterton, Indiana, USA

219-921-0885 | ellenanneeddy@gmail.com | www.ellenanneeddy@gmail.com

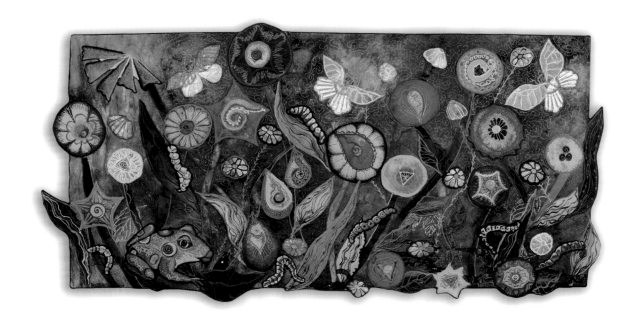

nature

Butterfly Garden

27 x 54 inches (69 x 137 cm) | 2011

Susan Else

Santa Cruz, California, USA

831-227-0373 | selse@pacbell.net | www.susanelse.com

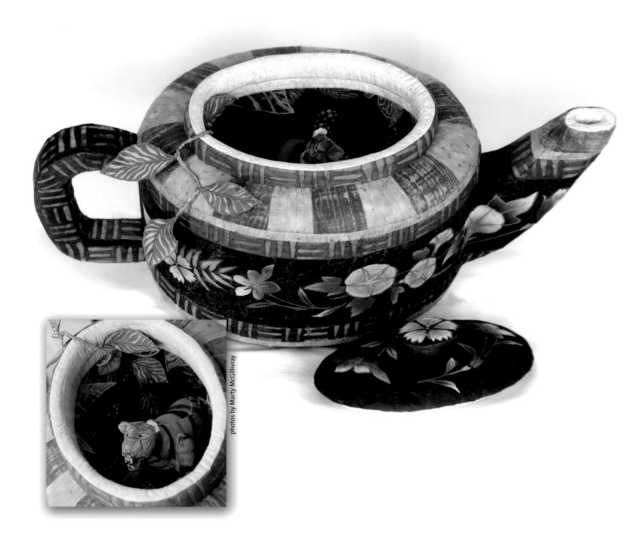

photos by Marty McGillivray

Wake-Up Call

15 x 28 x 12 inches (38 x 71 x 30.5 cm) | 2013

sculptural

Noriko Endo

Setagaya-ku, Tokyo, Japan
81-3-3308-3800 | norikoendojp@gmail.com | www.norikoendo.com

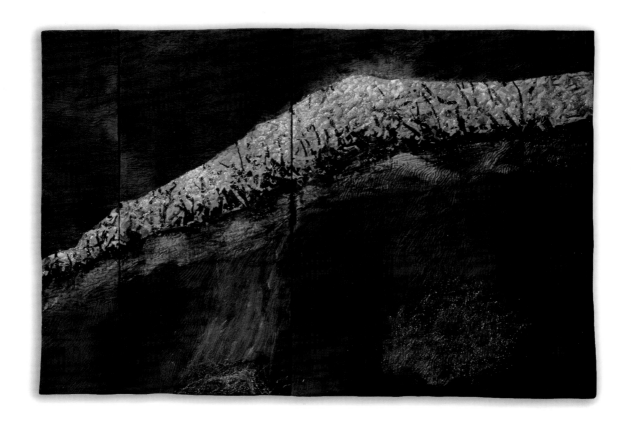

landscape

Secret Vantage
25 x 37 inches (64 x 94 cm) | 2012

Nancy Erickson

Missoula, Montana, USA

406-549-4671 | nancron@aol.com | nancyerickson.com

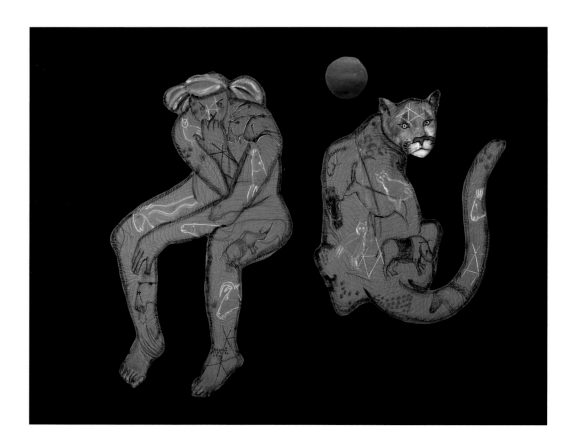

Fire Season, Western Montana

66 x 71 inches (168 x 180 cm) | 2012

representational

Deborah Fell

Urbana, Illinois, USA

217-778-1412 | art@deborahfell.com | www.deborahfell.com

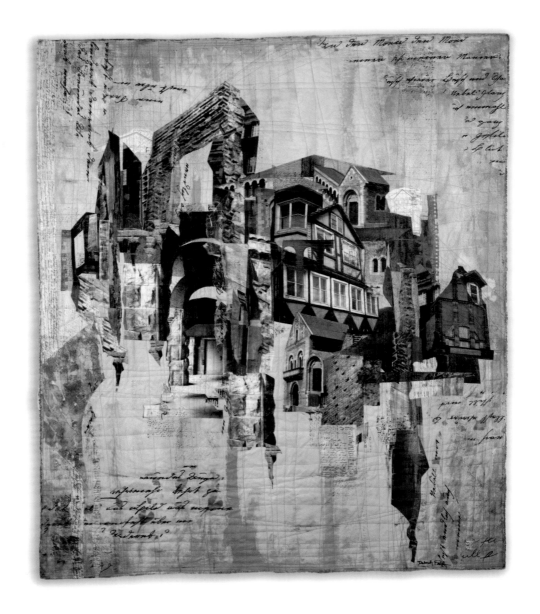

representational

Weathered 1

70 x 59 inches (178 x 150 cm) | 2012

Clairan Ferrono

Chicago, Illinois, USA

773-750-0460 | fabric8tions@hotmail.com | www.fabric8tions.net

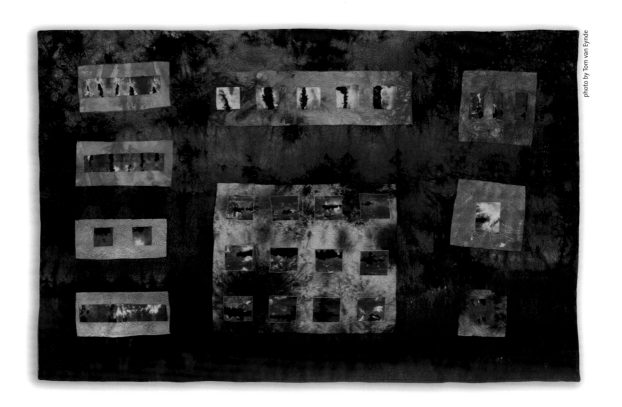

photo by Tom van Eynde

Reef

44 x 51 inches (112 x 130 cm) | 2011

abstract

Linda Filby-Fisher

Overland Park, Kansas, USA

913-722-2608 | lffkc@yahoo.com | www.lindafilby-fisher.com

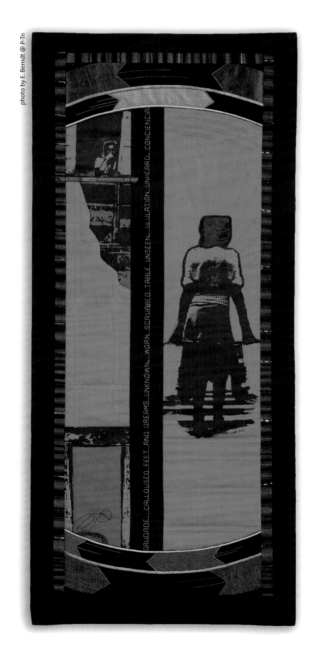

photo by E. Berndt @ P-In

From The Outside In – A Seeing Way Series

28 x 12 inches (71 x 31 cm) | 2011

Jamie Fingal

Orange, California, USA

714-612-4621 | jamie.fingal@gmail.com | jamiefingaldesigns.blogspot.com/

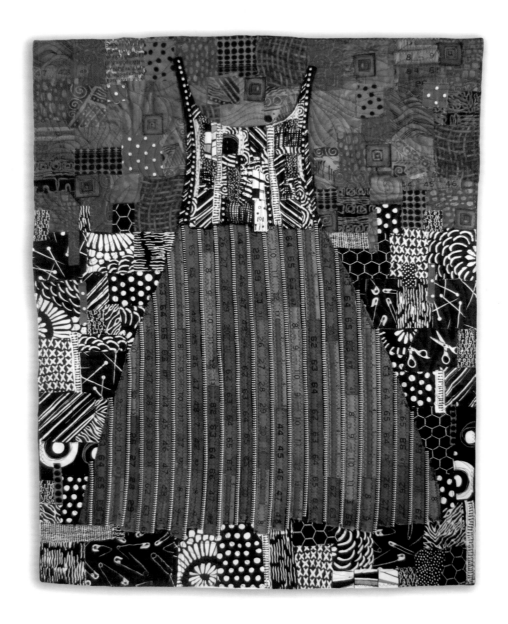

Dress Up

25 x 19 inches (62 x 48 cm) | 2012

representational

Tommy Fitzsimmons

Romeoville, Illinois, USA

630-319-7553 | tommygirl@americanstair.net | www.tommysartquilts.com

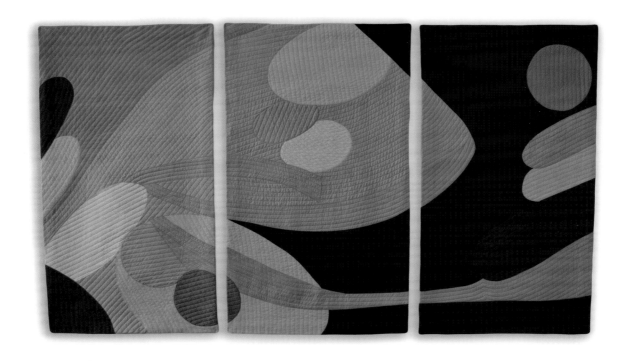

abstract

Continuation

38 x 64 inches (97 x 162 cm) | 2012

Floris Flam

Bethesda, Maryland, USA

301-530-7773 | florisflam@verizon.net | www.florisflam.com

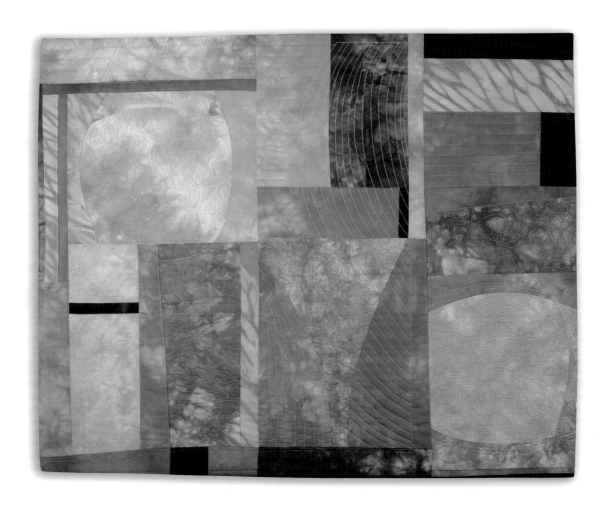

Vistas

20 x 24 inches (51 x 61 cm) | 2011

abstract

Katriina Flensburg

Storvreta, Sweden
+46733977726 | mail@katriinaflensburg.se | www.katriinaflensburg.se

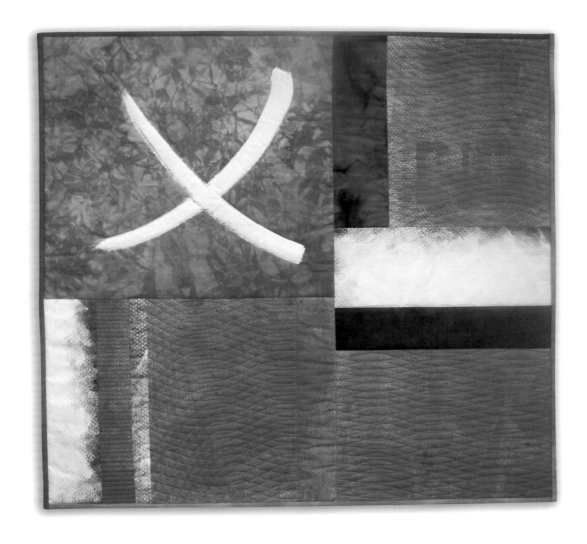

abstract

Misty (part II of a triptych)

29 x 29 inches (75 x 75 cm) | 2011

Betty Ford

N. Bethesda, Maryland, USA

301-526-4815 | bettyford301@gmail.com | bettyfordquilts.com

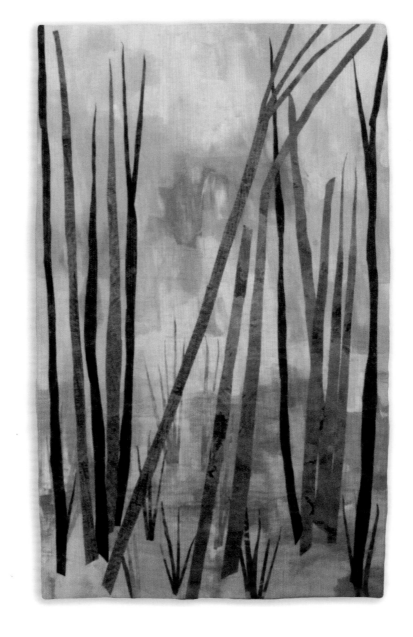

Dying Forest

44 x 26 inches (111 x 65 cm) | 2013

nature

Barb Forrister

Austin, Texas, USA
512-672-9014 | barb@barbforrister.com | www.barbforrister.com

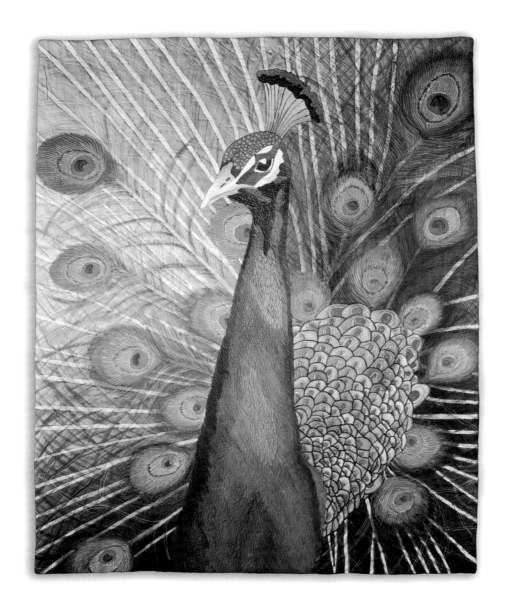

nature

The Gift of the Magi
39 x 31 inches (98 x 78 cm) | 2012

Elizabeth Fram

Waterbury Center, Vermont, USA

802-244-5116 | ehwfram@gmail.com | www.elizabethfram.com

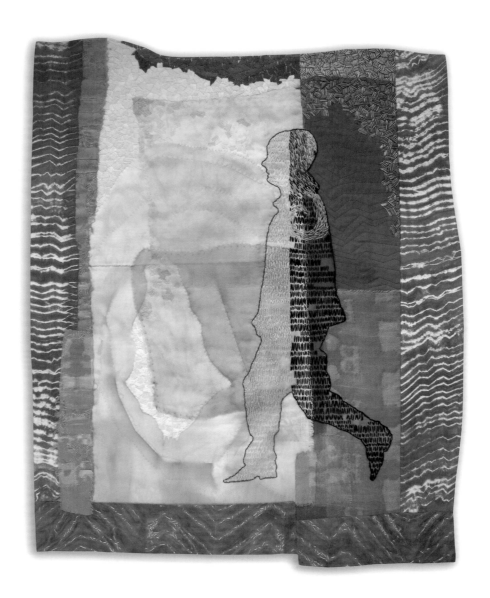

Transcendent Eclosion

25 x 20 inches (64 x 50 cm) | 2012

figurative

Sheila Frampton-Cooper

Van Nuys, California, USA

310-488-0455 | sheilaframptoncooper@gmail.com | www.zoombaby.com

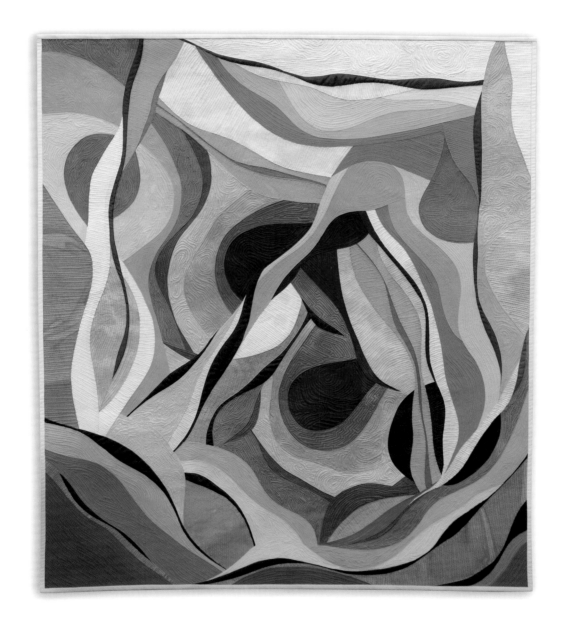

abstract

Lair of the Amethyst Deva

32 x 27 inches (81 x 69 cm) | 2012

Randy Frost

Bronxville, New York, USA

914-337-7122 | fiberarch@gmail.com

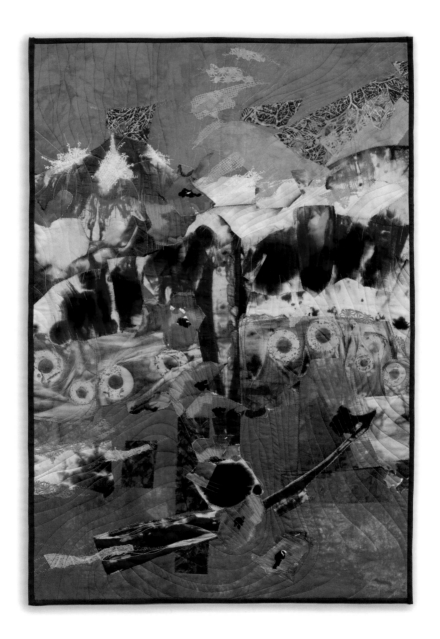

Political Colors

41 x 27 inches (103 x 69 cm) | 2013

abstract

Z Denise Gallup

Girdwood, Alaska, USA

907-575-5868 | zelmadg@alaska.net | zdenisegallup.com

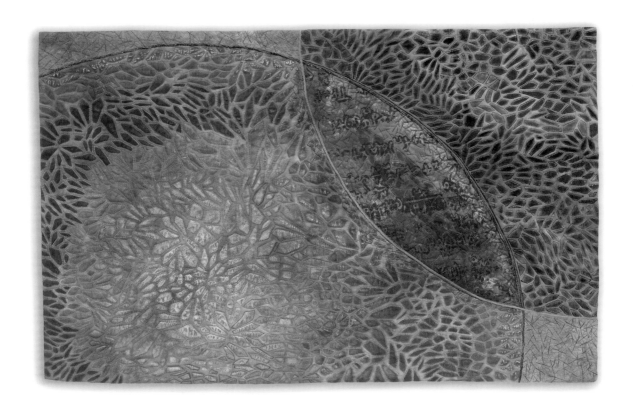

conceptual

Mandorla #4

22 x 33 inches (55 x 84 cm) | 2012

Jayne Bentley Gaskins

Fernandina Beach, Florida, USA

904-206-4470 | jaynegaskins@comcast.net | www.jaynegaskins.com

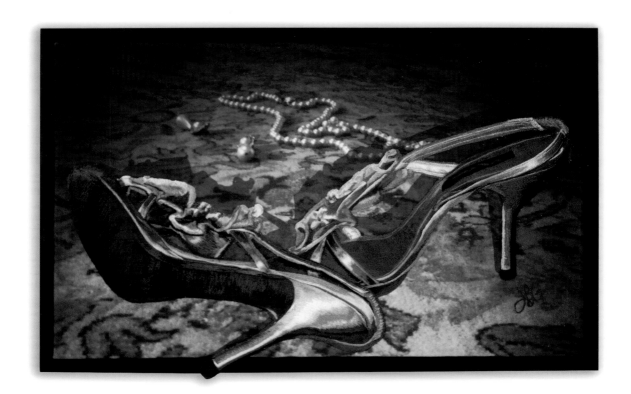

Last Night

17 x 27 inches (43 x 69 cm) | 2012

representational

Linda Gass

Los Altos, California, USA
650-948-1752 | linda@lindagass.com | lindagass.com

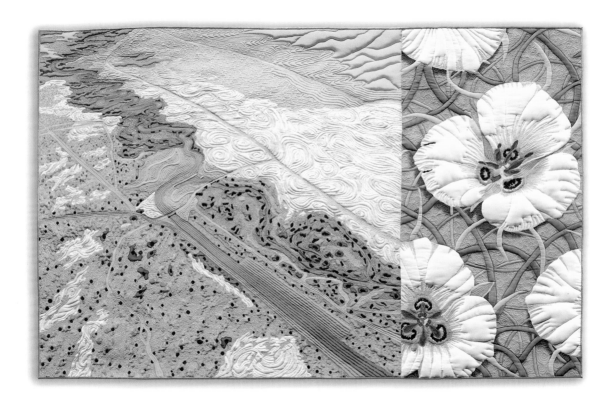

nature

Owens River Diversion
30 x 45 inches (76 x 114 cm) | 2012

Leesa Zarinelli Gawlik

Durango, Colorado, USA

314-910-2398 | lzg.artigiana@yahoo.com

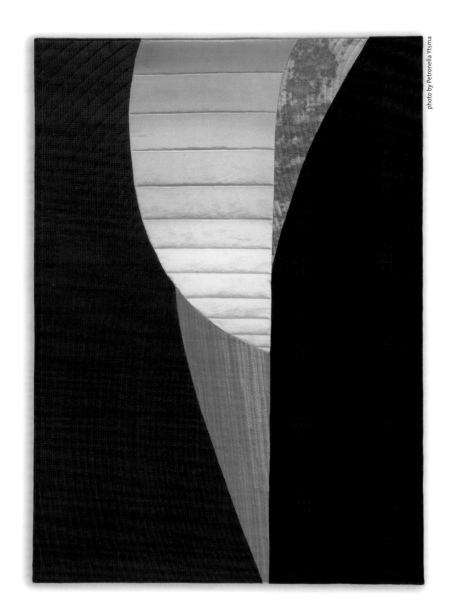

photo by Petronella Ytsma

Finding the Sky

32 x 22 inches (82 x 57 cm) | 2011

conceptual

Marilyn Gillis

Burlington, Vermont, USA

802-489-5872 | marilyngillis@gmail.com | www.marilyngillis.com

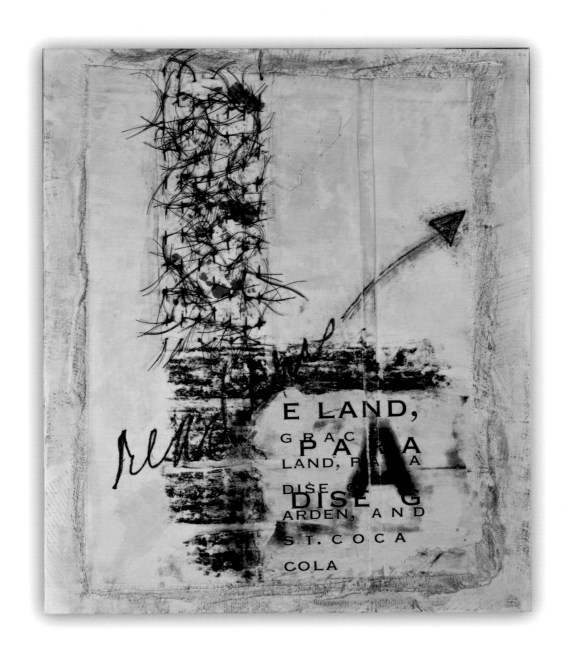

abstract

Inner Conversation 7

24 x 20 inches (61 x 51 cm) | 2012

Doria A. Goocher

San Diego, California, USA

619-582-8865 | doriadesigns@gmail.com | www.designsbydoria

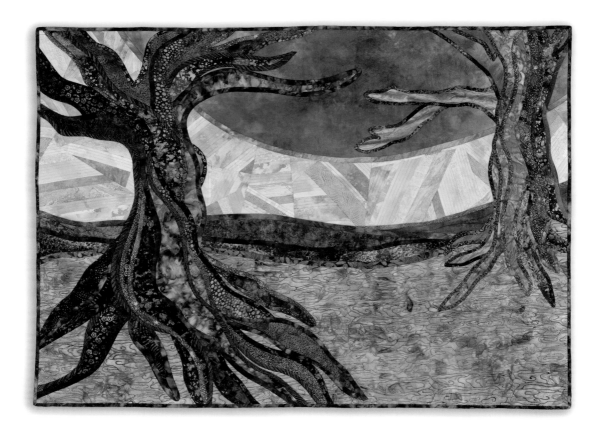

Yearning (#3 Roots Series)

35 x 47 inches (88 x 118 cm) | 2011

nature

Sandy Gregg

Cambridge, Massachusetts, USA

617-864-1890 | sgregg55@doolan.net | www.sandygregg.com

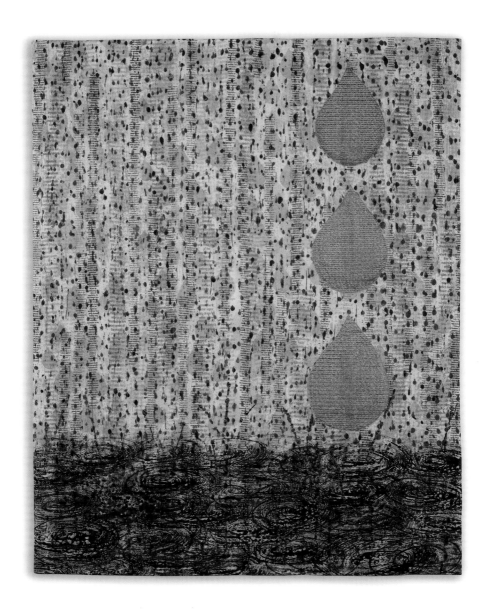

conceptual

Listen to the Rhythm of the Falling Rain

54 x 41 inches (137 x 104 cm) | 2011

Cindy Grisdela

Reston, Virginia, USA

703-402-3116 | cpgrisdela@gmail.com | www.cindygrisdela.com

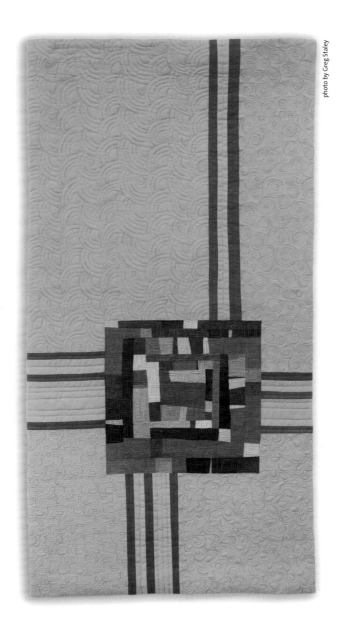

photo by Greg Staley

Green Totem

42 x 20 inches (107 x 51 cm) | 2012

abstract

Cara Gulati

San Rafael, California, USA

415-662-2121 | cara@doodlepress.com | www.doodlepress.com

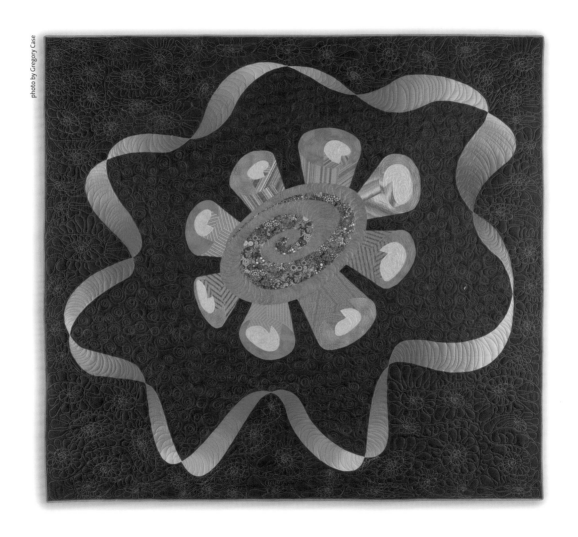

photo by Gregory Case

abstract

Serpentine Spin

88 x 84 inches (224 x 213 cm) | 2013

Gunnel Hag

Toronto, Ontario, Canada
416-532-7435 | colorvie@istar.ca | gunnelhag.blogspot.ca

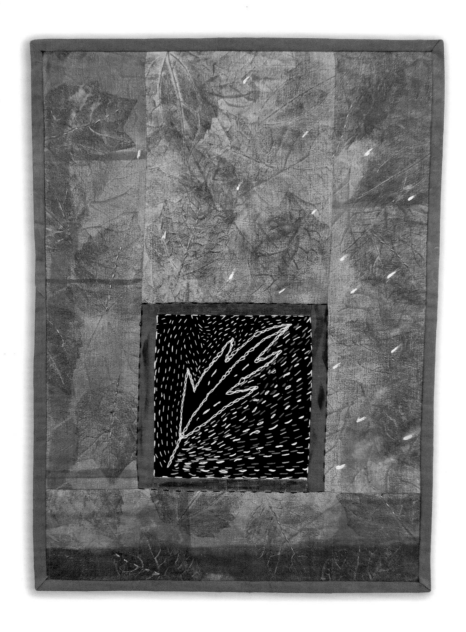

Leaves
24 x 17 inches (61 x 43 cm) | 2012

abstract

Gloria Hansen

East Windsor, New Jersey, USA

609-448-7818 | gloria@gloderworks.com | www.gloriahansen.com

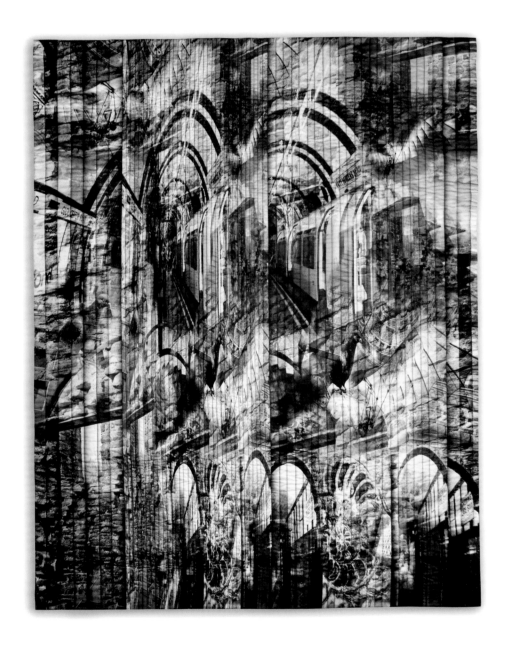

conceptual

Another Journey

56 x 43 inches (142 x 109 cm) | 2011

Phillida Hargreaves

Kingston, Ontario, Canada

613-389-8993 | hargreavescp@sympatico.ca | www.phillidahargreaves.ca

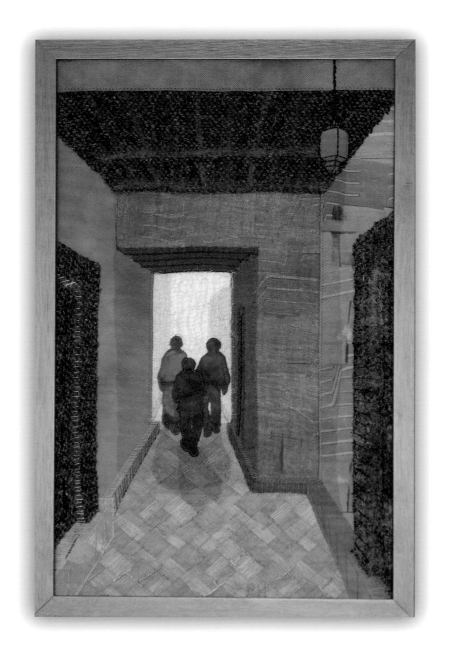

Entering the Souk

22 x 14 inches (55 x 34 cm) | 2012

figurative

Lynne G. Harrill

Greenville, South Carolina, USA

864-292-8708 | lgharrill@att.net | www.lynneharrill.weebly.com

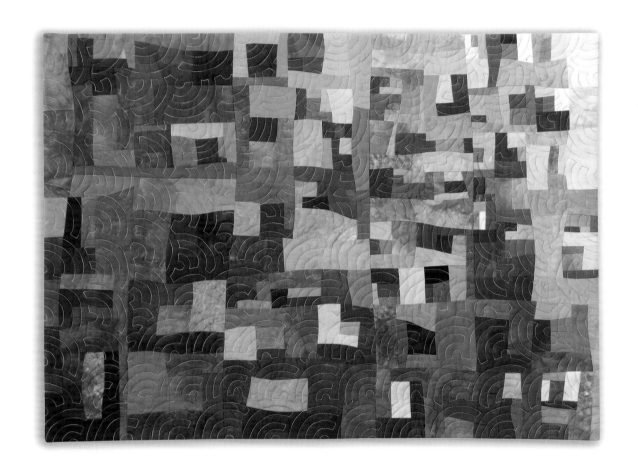

abstract

Redux XIV: Fractures

22 x 30 inches (56 x 76 cm) | 2012

Carole Harris

Detroit, Michigan, USA

313-515-2824 | charris@charris-design.com | www.charris-design.com

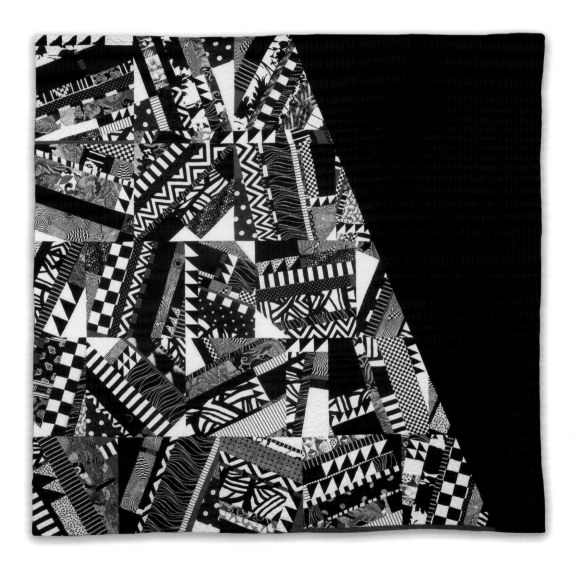

The Space Between

60 x 58 inches (152 x 146 cm) | 2012

abstract

Barbara Oliver Hartman

Flower Mound, Texas, USA
972-724-1181 | barbaraohartman@aol.com | barbaraoliverhartman.com

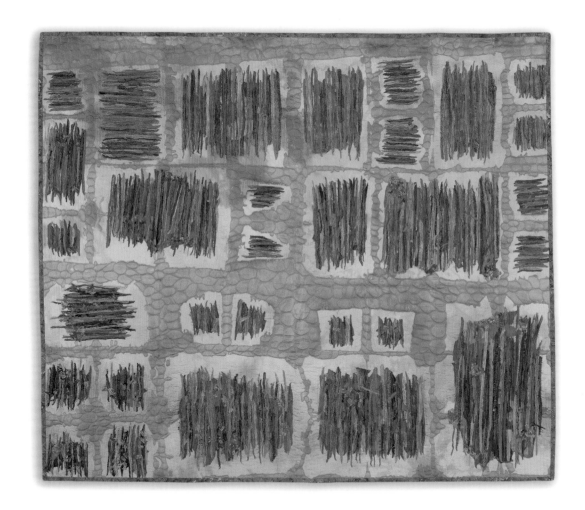

Compart-Mentalize: Avoid, Deny, Ignore
47 x 51 inches (119 x 130 cm) | 2012

Patty Hawkins

Estes Park, Colorado, USA

970-577-8042 | hawknestpw@gmail.com | www.pattyhawkins.com

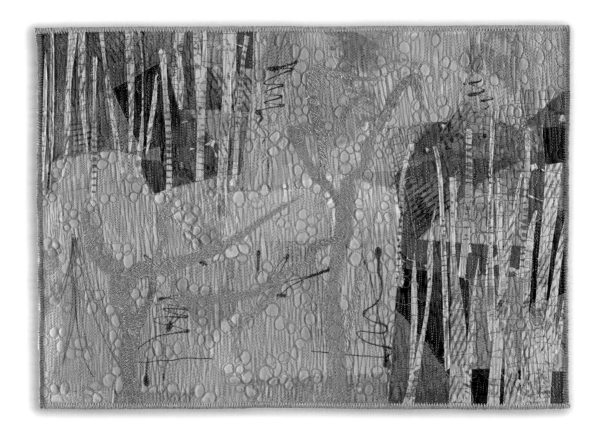

Red Canyon Spring

18 x 24 inches (46 x 61 cm) | 2012

abstract

Jim Hay

Takasaki, Gunma, Japan
+81 (0)27 360-7061 | jmhay@mail.wind.ne.jp | www7.wind.ne.jp/jimhay

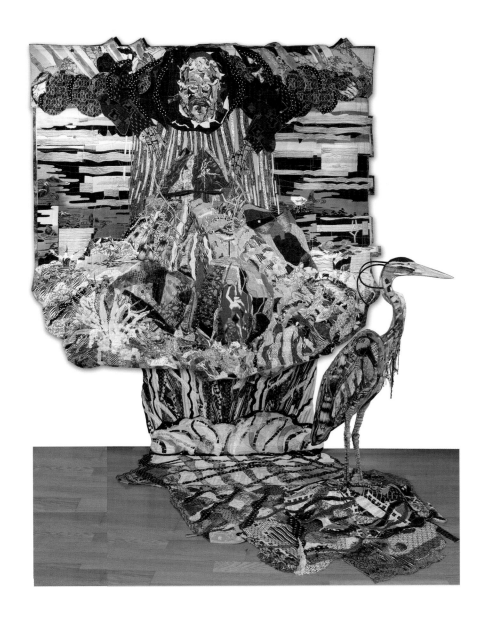

The Water Dances
132 x 132 x 60 inches (335 x 335 x 152.4 cm) | 2013

Ana Lisa Hedstrom

La Honda, California, USA

650-949-0761 | hedstorms@earthlink.net | www.analisahedstrom.com

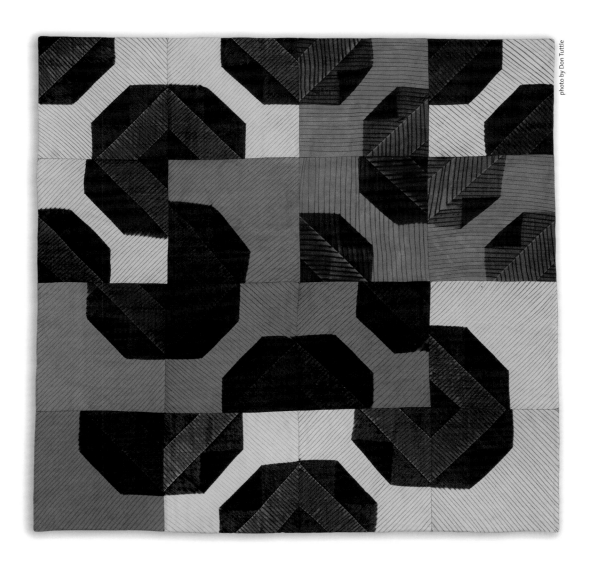

photo by Don Tuttle

Bow Tie Tease

41 x 41 inches (104 x 104 cm) | 2013

abstract

Annie Helmericks-Louder

Warrensburg, Missouri, USA
660-441-1420 | helmericks@mac.com | www.helmericks.com

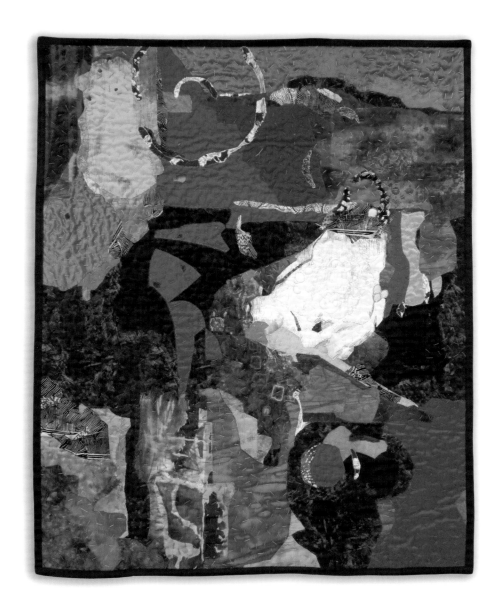

conceptual

Sleeping at the Edge of the World #3

57 x 46 inches (145 x 117 cm) | 2012

Anna Hergert

Moose Jaw, Saskatchewan, Canada

306-631-8539 | anna@annahergert.com | annahergert.wordpress.com

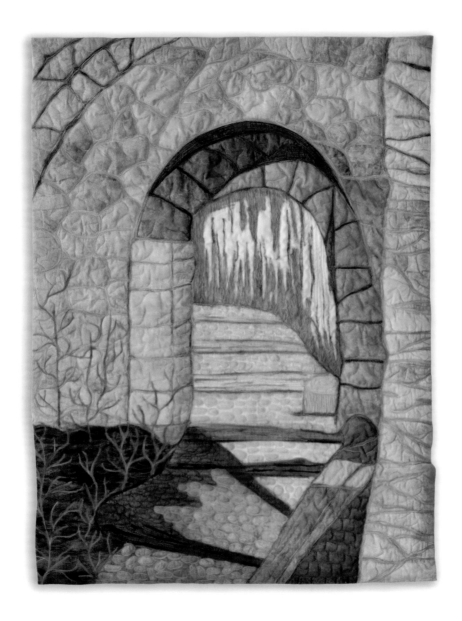

Memories of Italy: Portal to the Light

65 x 46 inches (165 x 117 cm) | 2013

representational

Jean Herman

Denver, Colorado, USA

303-596-4685 | jean.herman@gmail.com | jeanherman.com

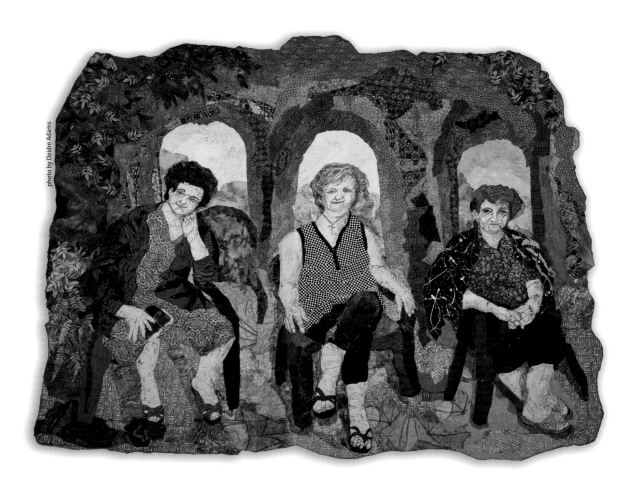

photo by Deidre Adams

figurative

The Trinity

48 x 60 inches (122 x 152 cm) | 2012

Sandra Hoefner

Grand Junction, Colorado, USA

970-812-5680 | shoefner2003@yahoo.com | sandrahoefner.com

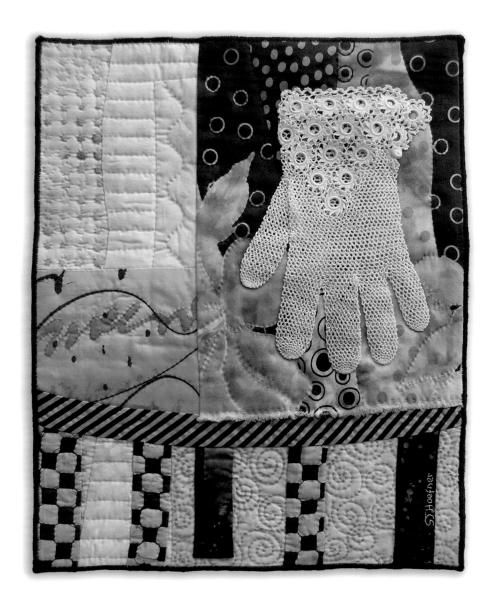

Invite

15 x 12 inches (37 x 29 cm) | 2013

abstract

Kristin Hoelscher-Schacker

Sunfish Lake, Minnesota, USA
651-248-5149 | krishoel001@mac.com | khs-art.com

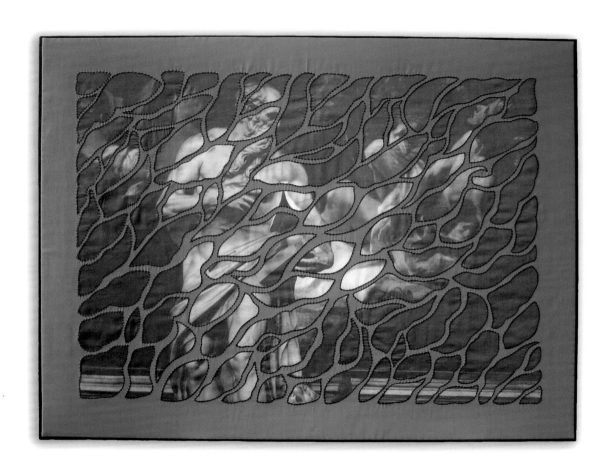

conceptual

Venetian Revelation
35 x 45 inches (89 x 114 cm) | 2012

Rosemary Hoffenberg

Wrentham, Massachusetts, USA

508-384-3866 | rozeeh@comcast.net | rosemaryhoffenberg.com

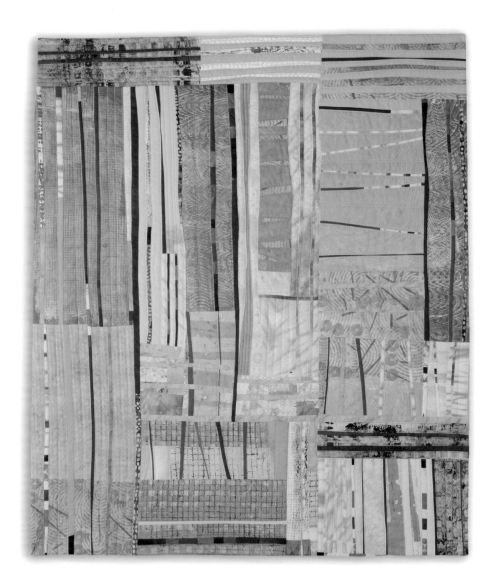

Winter Woods

40 x 33 inches (102 x 84 cm) | 2013

abstract

Sue Holdaway-Heys

Ann Arbor, Michigan, USA
734-971-4980 | shhart@aol.com | www.sueholdaway-heys.com

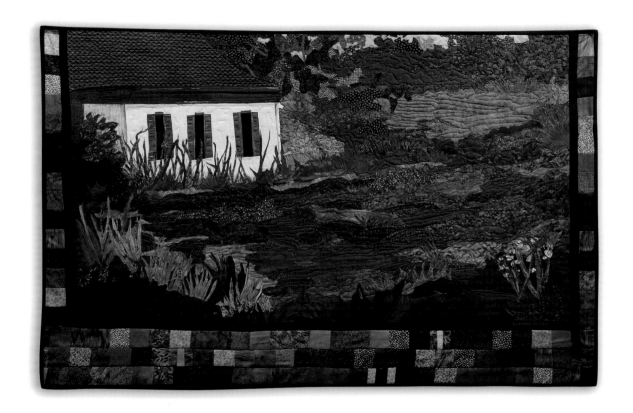

landscape

Gatehouse II
26 x 40 inches (66 x 102 cm) | 2011

Judy Hooworth

Morisset, New South Wales, Australia

61 2 4977 2684 | judyhooworth@ozemail.com.au

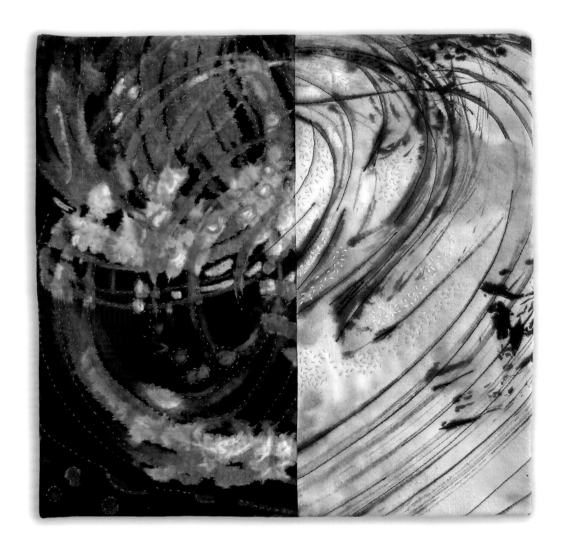

Rainy Day Dora Creek #6

12 x 12 inches (30 x 30 cm) | 2012

abstract

Michelle Jackson

Albuquerque, New Mexico, USA

505-321-7847 | michellejackson@quiltfashions.com | www.quiltfashions.com

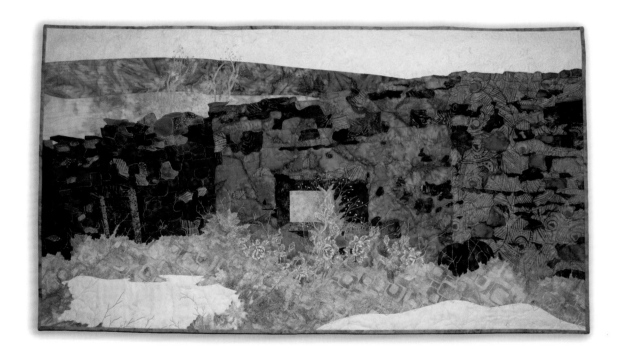

landscape

Adobe Row

25 x 42 inches (64 x 107 cm) | 2012

Laura Jaszkowski

Eugene, Oregon, USA

541-687-1190 | joyincloth@gmail.com | www.joyincloth.blogspot.com

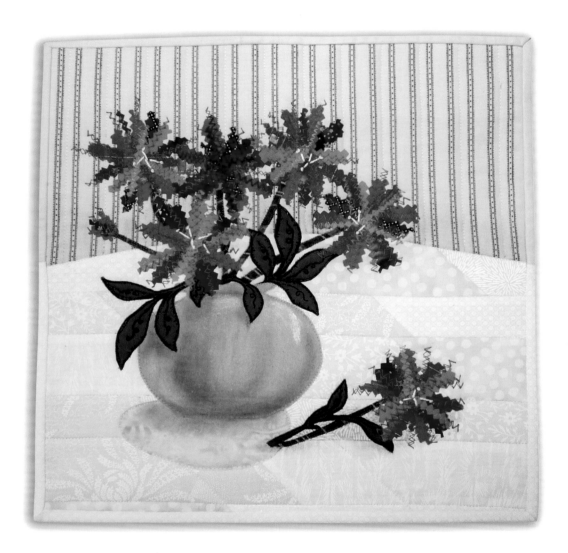

Red Carnations

12 x 12 inches (31 x 31 cm) | 2011

representational

Leslie Tucker Jenison

San Antonio, Texas, USA

210-364-6067 | leslie.jenison@gmail.com | leslietuckerjenison.com

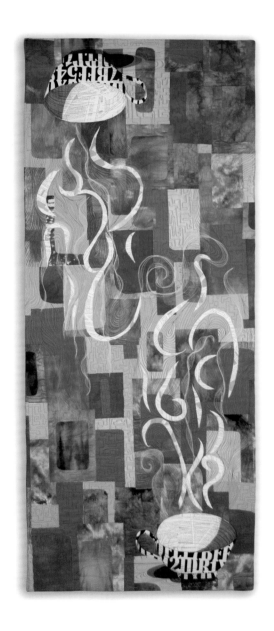

conceptual

The Coffee Break

60 x 24 inches (152 x 61 cm) | 2012

Lisa Jenni

Redmond, Washington, USA

425-898-9154 | lisa@lisajenni.com | www.think-quilts.com

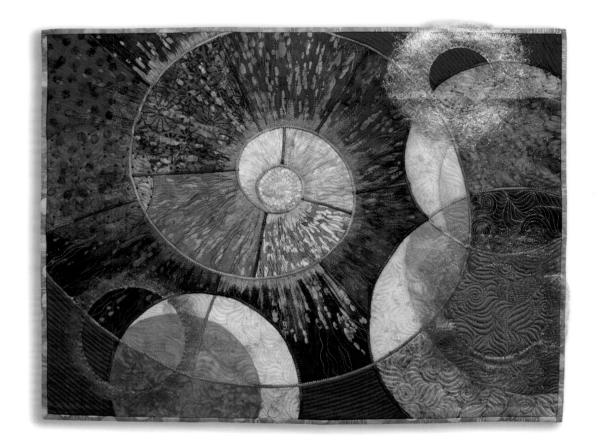

Azzurro

18 x 24 inches (46 x 60 cm) | 2012

abstract

Jill Jensen

Lynchburg, Virginia, USA

434-582-1237 | jilljensenart@hotmail.com | www.jilljensenart.com

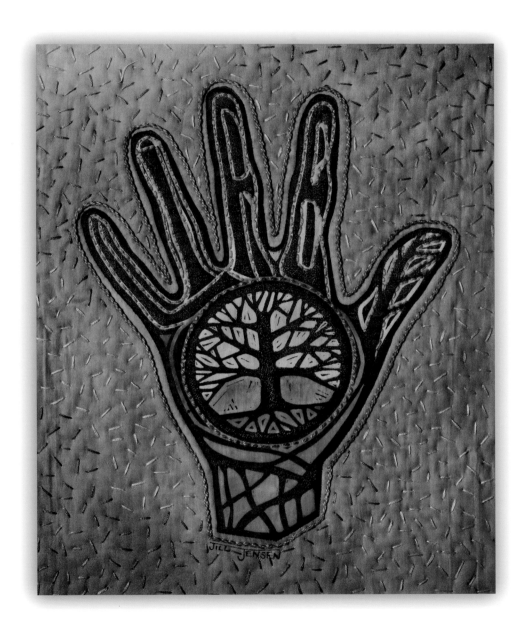

conceptual

Hand XXI: Tree of Life

11 x 9 inches (28 x 23 cm) | 2013

Ann Johnston

Lake Oswego, Oregon, USA

503-635-6791 | annjohnstonquilts@gmail.com | www.annjohnston.net

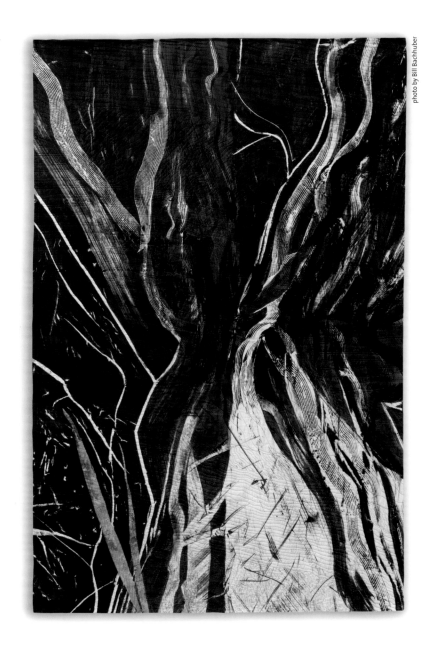

photo by Bill Bachhuber

The Contact: Nevadan Orogeny

84 x 53 inches (213 x 135 cm) | 2011

abstract

Kasia

Delafield, Wisconsin, USA

262-893-5510 | kasia@kasiasstudio.com | www.kasiasstudio.com

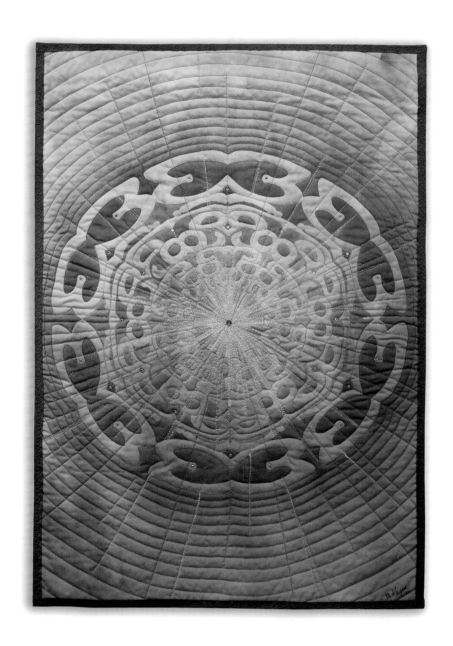

conceptual

Milagros

30 x 20 inches (76 x 51 cm) | 2011

Kathleen Kastles

Wailuku, Hawaii, USA
808-242-0299 | drkastles@hotmail.com | www.kathleenkastles.com

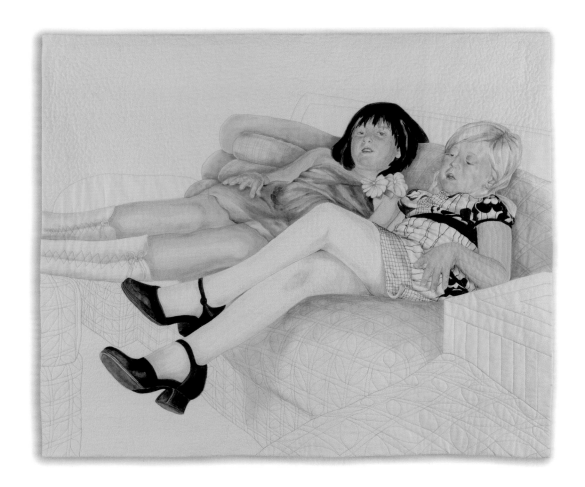

All Tuckered Out

37 x 44 inches (94 x 111 cm) | 2011

figurative

Peg Keeney

Harbor Springs, Michigan, USA

231-526-9597 | pegkeeney@gmail.com | www.pegkeeney.com

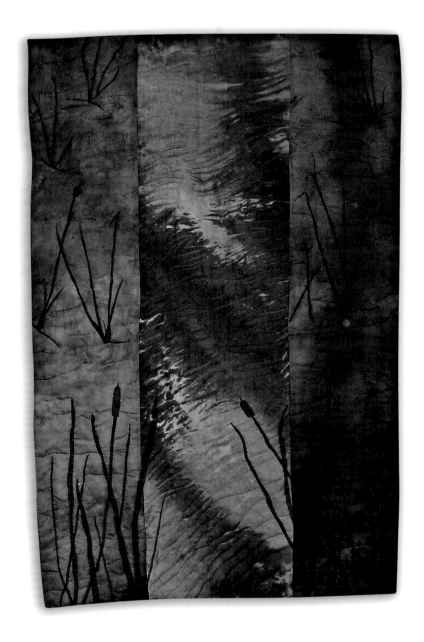

conceptual

Estuary

53 x 34 inches (135 x 86 cm) | 2012

Annette Kennedy

Longmont, Colorado, USA
303-772-3745 | annettekennedy@hotmail.com | www.annettekennedy.com

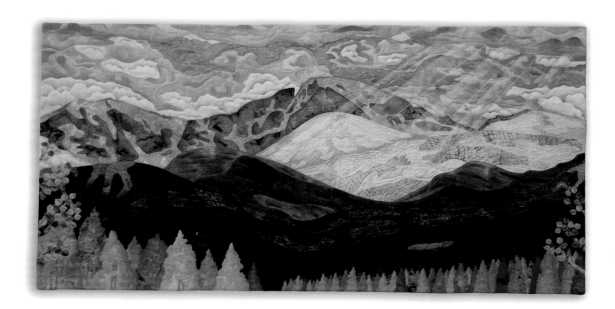

Longs Peak Rhapsody
16 x 32 inches (41 x 81 cm) | 2012

landscape

Misik Kim

Eunpyeong-gu Bulgwang1dong Bookhansan Raemian A, South Korea
82-10-3893-1963 | kmisik@naver.com

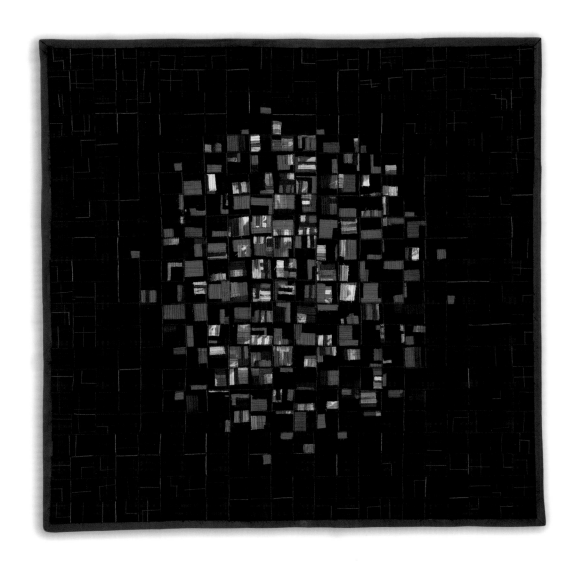

abstract

The traces
43 x 43 inches (109 x 109 cm) | 2012

Michele O'Neil Kincaid

Strafford, New Hampshire, USA

603-664-2466 | michele@fiberartdesigns.com | www.fiberartdesigns.com

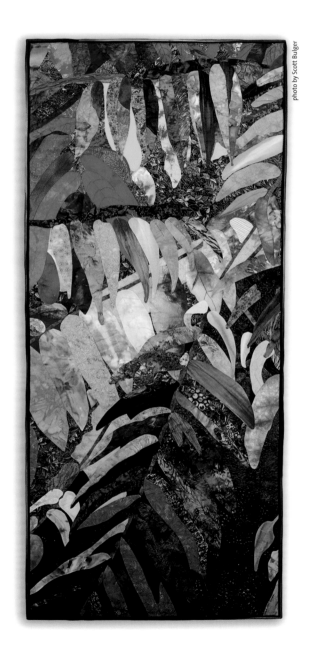

photo by Scott Bulger

Sumac Sparks

59 x 34 inches (150 x 86 cm) | 2012

nature

Pamela Price Klebaum

Ventura, California, USA

805-644-5785 | klebaumpp@gmail.com | pamprice.blogspot.com

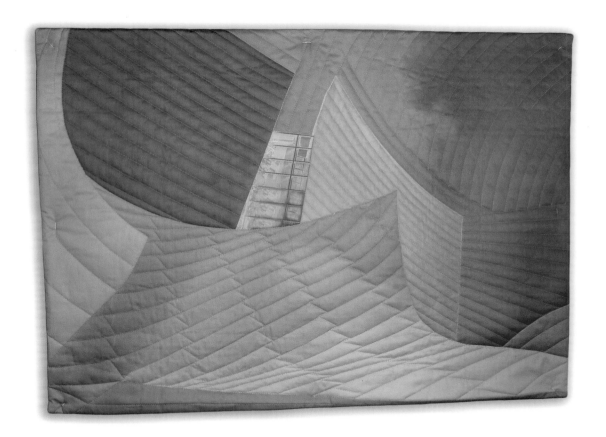

representational

Curves

18 x 24 inches (46 x 61 cm) | 2011

Catherine Kleeman

Ruxton, Maryland, USA

410-321-9438 | cathy@cathyquilts.com | www.cathyquilts.com

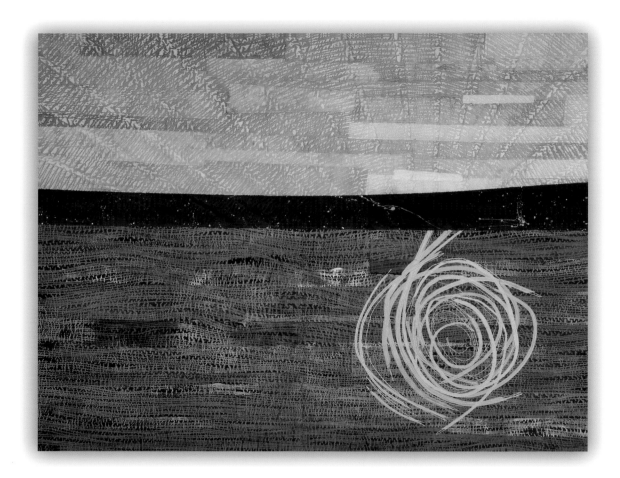

Morning Glory

33 x 42 inches (84 x 107 cm) | 2012

abstract

Sherry Davis Kleinman

Pacific Palisades, California, USA

310-459-4918 | sherrykleinman@mac.com | sherrykleinman.com

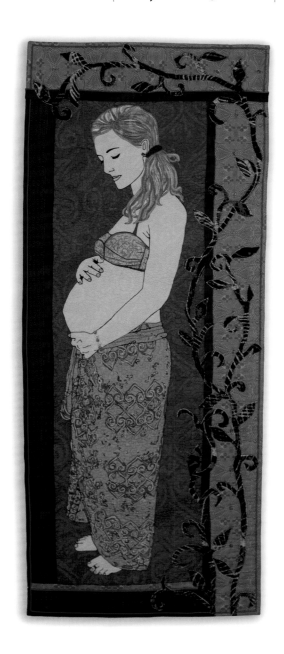

figurative

Waiting Expectantly

60 x 24 inches (152 x 61 cm) | 2013

Smadar Knobler

Calabasas, California, USA

818-222-7962 | smadarsdesigns@charter.net | www.smadarsdesigns.com

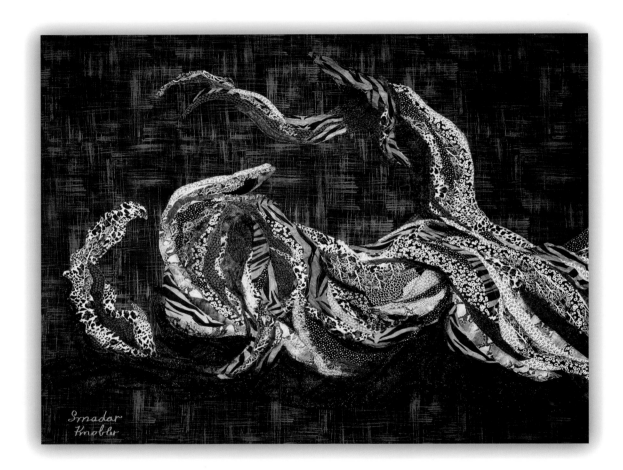

Ancient Bristlecone Pine - EMERGING

39 x 49 inches (99 x 125 cm) | 2013

nature

Harue Konishi

Wakamiya Nsksno-ku, Tokyo, Japan
81-3-3330-5257 | harue524@mac.com

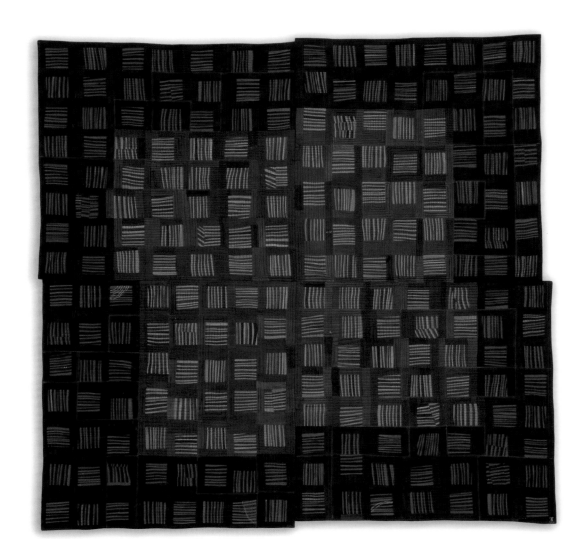

abstract

SYO#53

52 x 51 inches (132 x 130 cm) | 2011

Paula Kovarik

Memphis, Tennessee, USA

901-725-0308 | create@sogray.com | paulakovarik.com

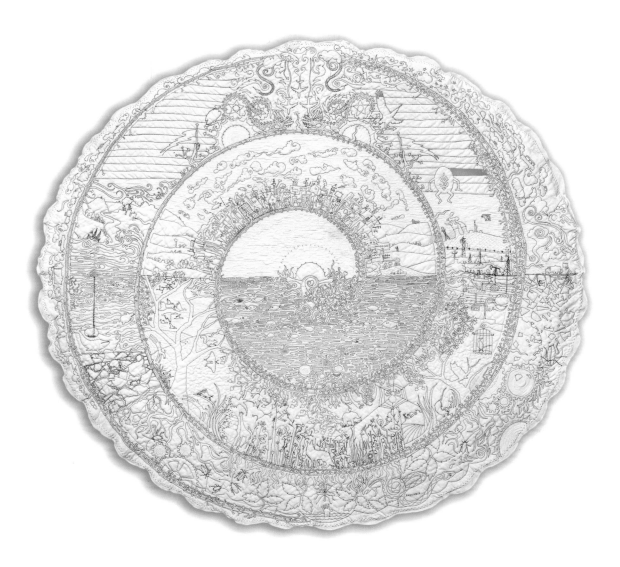

Round and Round It Goes

50 x 56 inches (127 x 142 cm) | 2012

conceptual

Ellie Kreneck

Lubbock, Texas, USA

806-792-7930 | lyntellie@yahoo.com

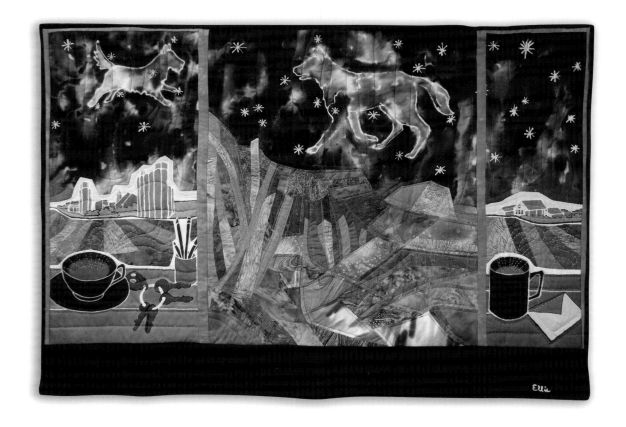

landscape

The Llano Estacado, Summer Nights, and Good Dawgs

28 x 40 inches (71 x 102 cm) | 2013

Pat Kroth

Verona, Wisconsin, USA

608-845-3970 | krothp@juno.com | krothfiberart.com

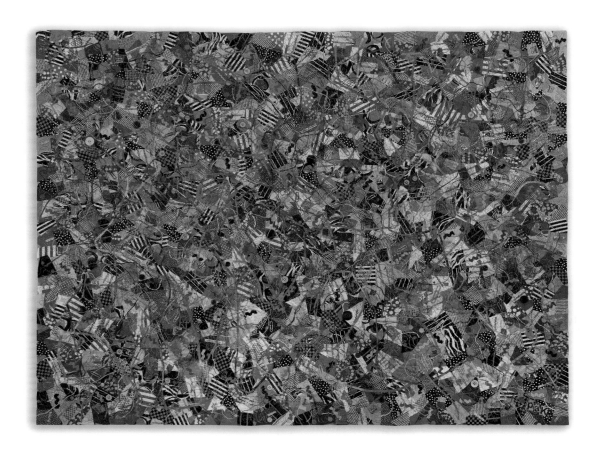

Too Sweet

40 x 53 inches (102 x 135 cm) | 2012

abstract

Pat Kumicich

Naples, Florida, USA

239-775-9517 | patkumicich@me.com | www.patkumicich.com

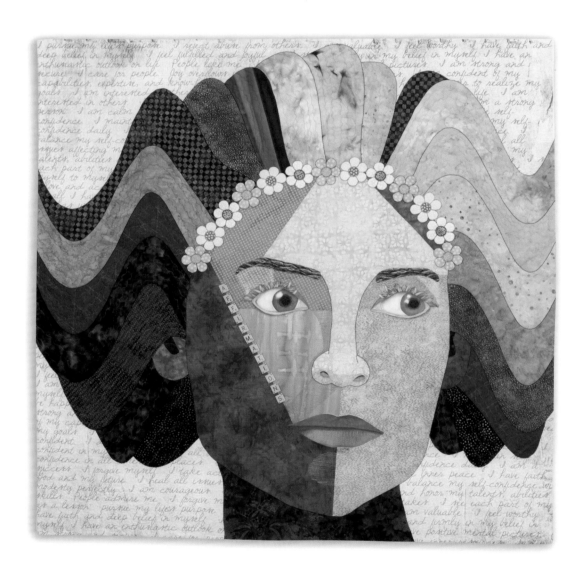

figurative

Affirmations

48 x 48 inches (122 x 122 cm) | 2012

Denise Labadie

Longmont, Colorado, USA

303-682-9696 | denise.labadie@gmail.com | www.labadiefiberart.com

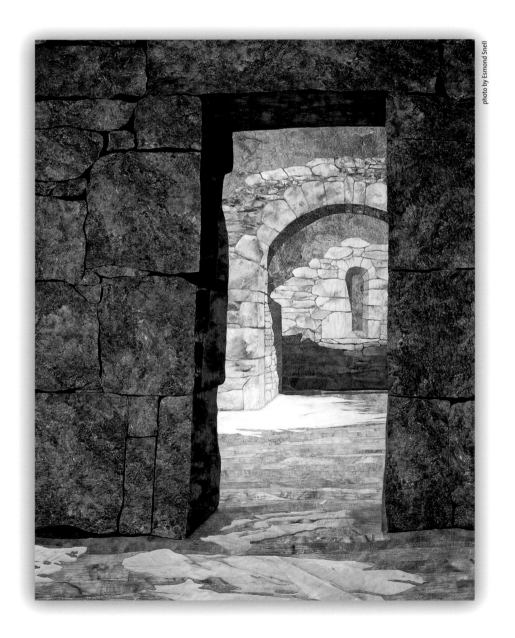

photo by Esmond Snell

Monastic Ruin at Glendalough

78 x 60 inches (198 x 152 cm) | 2011

representational

Judy Langille

Kendall Park, New Jersey, USA

732-940-0821 | judylangille7@gmail.com | www.judylangille.com

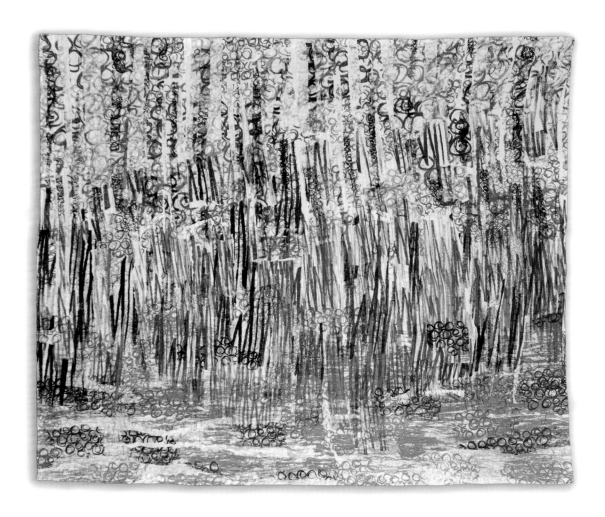

landscape

Meadowlands

52 x 59 inches (132 x 150 cm) | 2012

Kim LaPolla

Greenville, New York, USA

518-966-5219 | kim@crazybydesign.com | www.crazybydesign.com

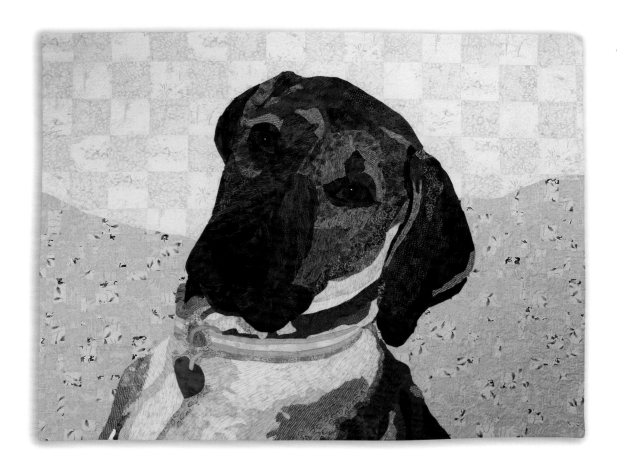

Ridgeback on the Sofa

32 x 42 inches (81 x 107 cm) | 2013

nature

Tove Pirajá Larsen

Klovborg, Denmark

+45 9890 4147 | tovinha@yahoo.com | www.tovepiraja.com/www.tovepiraja.blogspot.com

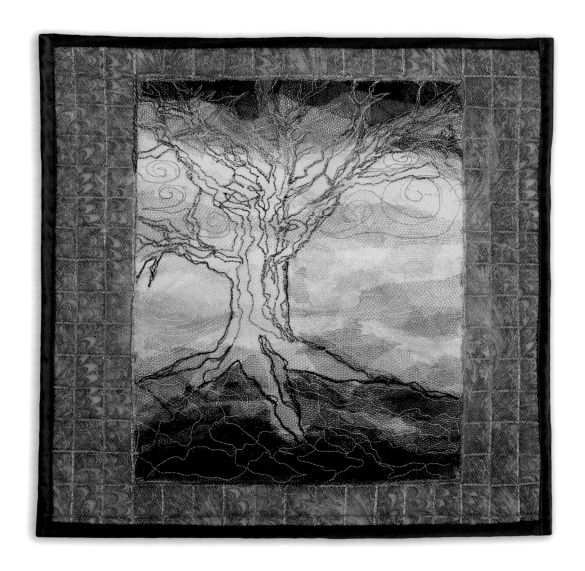

nature

When the background steals the picture

14 x 14 inches (35 x 35 cm) | 2011

Carol Larson

Petaluma, California, USA

707-695-5453 | cwlarson2@comcast.net | www.live2dye.com

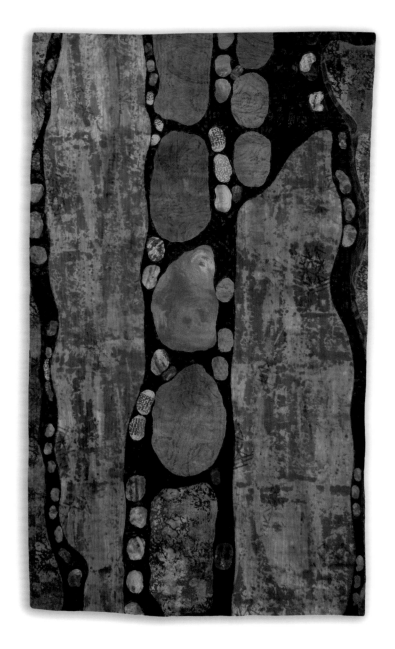

Stone Path #1

49 x 28 inches (125 x 71 cm) | 2012

abstract

Gay E. Lasher

Denver, Colorado, USA

303-369-6910 | gayelasher@comcast.net | www.gayelasher.com

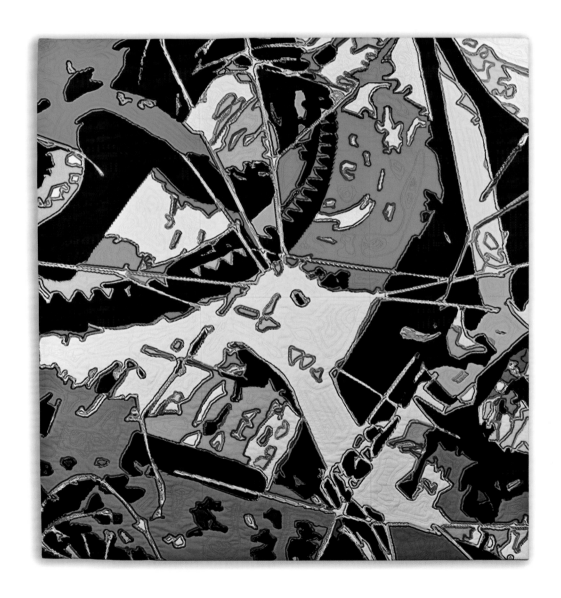

abstract

Net Work
49 x 45 inches (125 x 114 cm) | 2011

Mary-Ellen Latino

Northborough, Massachusetts, USA
508-904-0701 | melsrun2000@gmail.com | www.highinfiberart.com

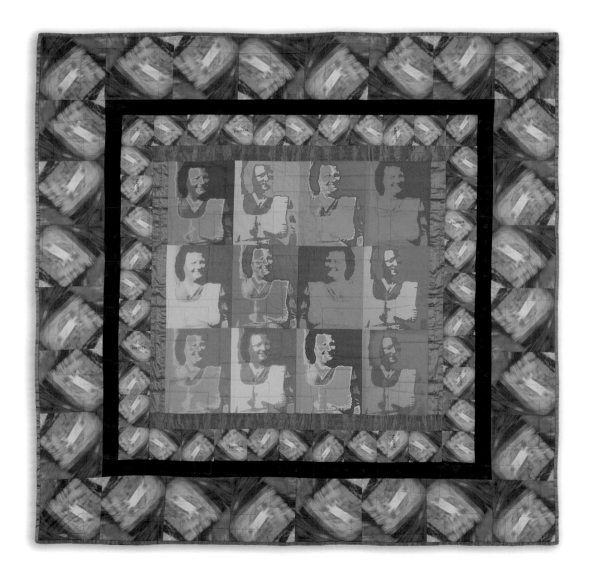

Last Memory: Mother?

46 x 46 inches (117 x 117 cm) | 2012

conceptual

Sandra E. Lauterbach

Los Angeles, California, USA

310-476-4849 | sandra@sandralauterbach.com | www.sandralauterbach.com

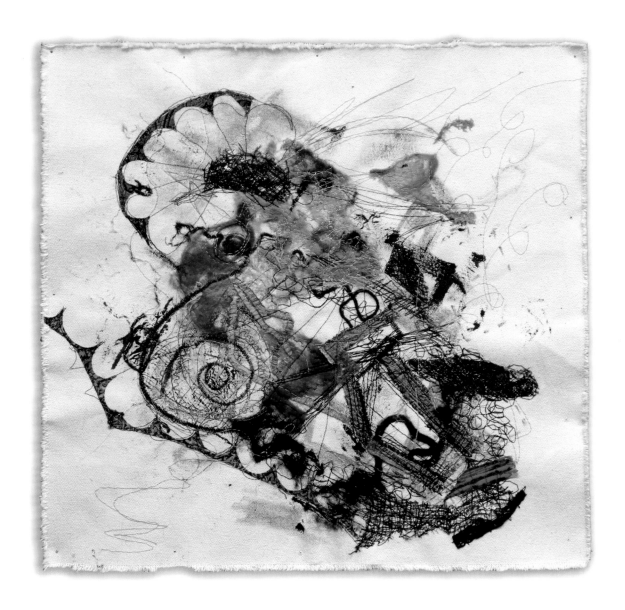

abstract

Time Machine

17 x 17 inches (43 x 43 cm) | 2013

Jill Le Croissette

Carlsbad, California, USA

760-434-7491 | artquilts25@gmail.com | www.artquilts.us

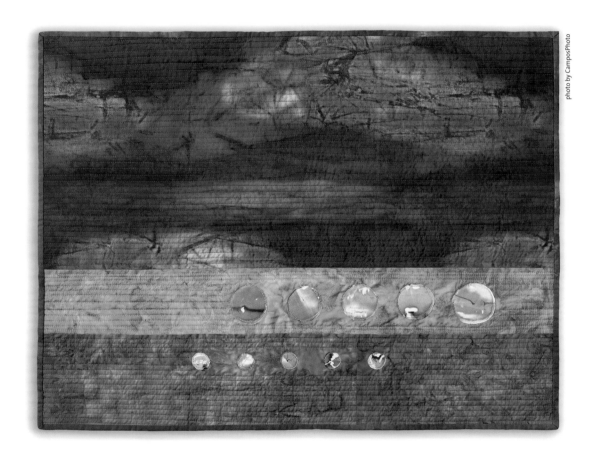

photo by CamposPhoto

Embers

24 x 30 inches (61 x 76 cm) | 2012

abstract

Michele Leavitt

Saunderstown, Rhode Island, USA

401-419- 9076 | 4micheleleavitt@gmail.com | www.micheleleavitt.com

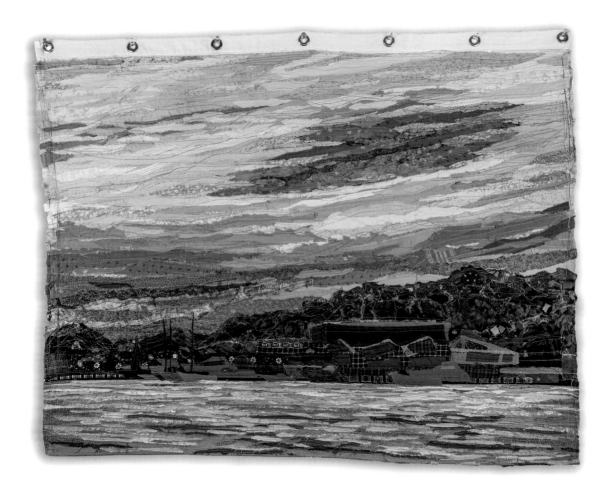

landscape

Manhasset Bay

30 x 36 inches (76 x 91 cm) | 2013

Susan Webb Lee

Barnardsville, North Carolina, USA

828-606-0091 | susanleestudio@aol.com | susanwebblee.com

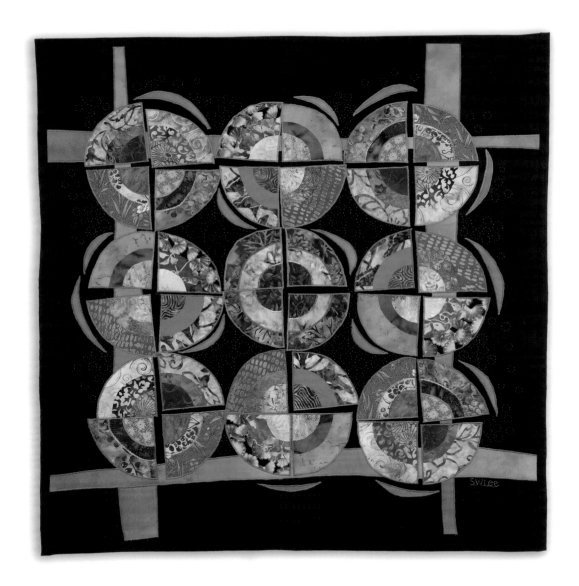

Black Saves the Day

30 x 29 inches (76 x 72 cm) | 2012

conceptual

Susan Lenz

Columbia, South Carolina, USA

803-254-0923 | mouse_house@prodigy.net | www.susanlenz.com

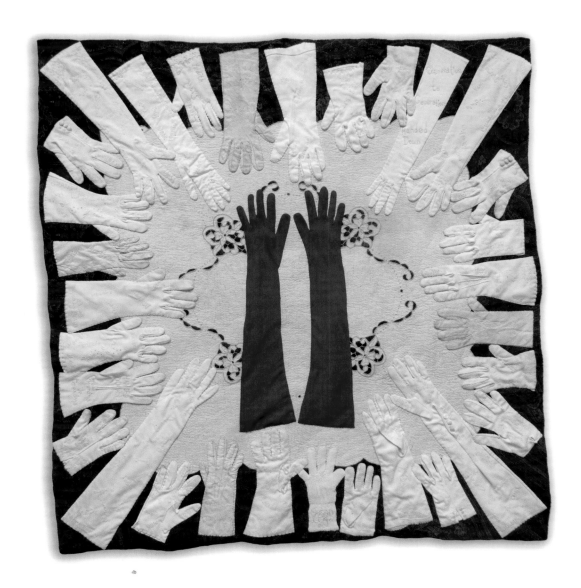

conceptual

Handed Down

47 x 33 inches (119 x 84 cm) | 2011

Alice Engel Levinson

Hillsborough, North Carolina, USA

919-932-5902 | allevs@att.net | www.alicelevinson.com

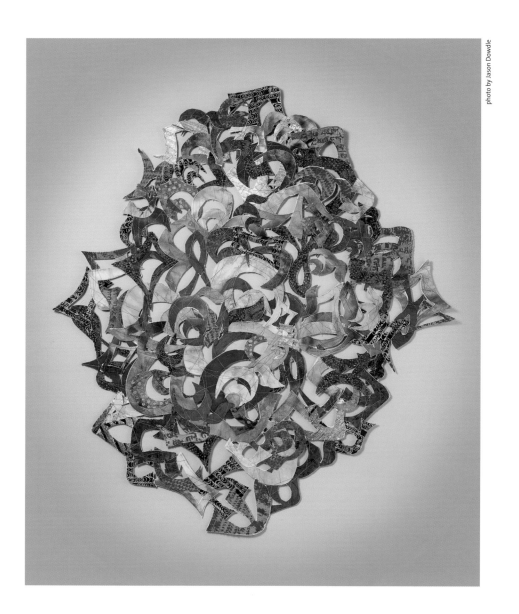

photo by Jason Dowdle

AS CLAY IN THE HANDS OF THE POTTER

40 x 34 inches (102 x 86 cm) | 2012

abstract

Kay Liggett

Monument, Colorado, USA

719-466-1557 | kkliggett@gmail.com | ridgewaystudios.org

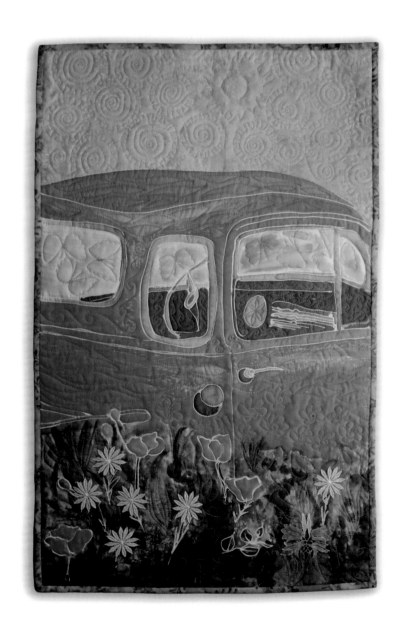

Cherry Bomb

32 x 20 inches (81 x 51 cm) | 2012

landscape

Hsin-Chen Lin

Tainan City, Taiwan

+886-6-2149696 | jenny.quilt@msa.hinet.net | www.linhsinchen.idv.tw/index.html

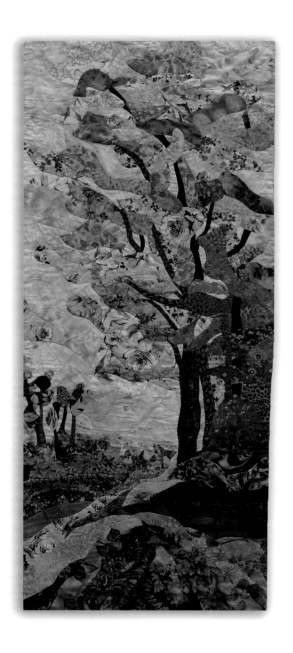

Recovery

78 x 32 inches (198 x 81 cm) | 2012

nature

Ellen Lindner

Melbourne, Florida, USA

321-724-8012 | elindner@cfl.rr.com | www.adventurequilter.com

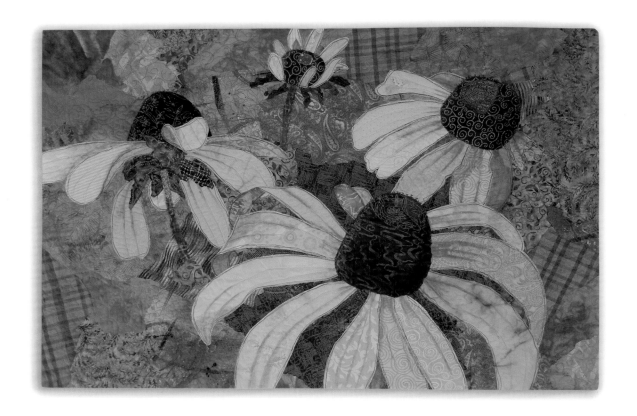

nature

Blessings Underfoot

24 x 36 inches (61 x 91 cm) | 2012

Karen Linduska

Carbondale, Illinois, USA

618-457-5228 | linduskaartquilt@galaxycable.net | www.karenlinduska.com

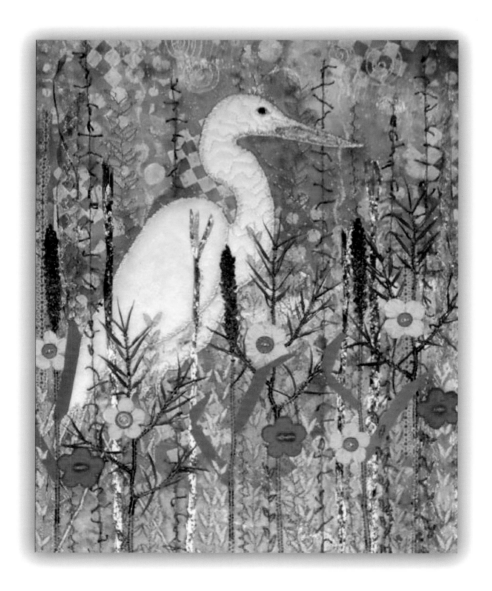

Marshland

35 x 35 inches (89 x 89 cm) | 2013

nature

Denise Linet

Brunswick, Maine, USA

207-373-0331 | dlinet@deniselinet.com | www.deniselinet.com

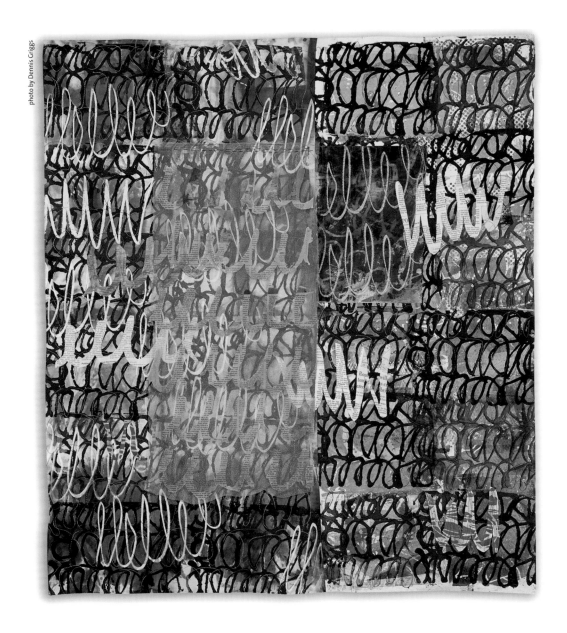

photo by Dennis Griggs

conceptual

Discourse

43 x 36 inches (109 x 91 cm) | 2012

Phyllis Harper Loney

Round Pond, Maine, USA

207-529-2310 | colorphl@tidewater.net | studiophyl.com

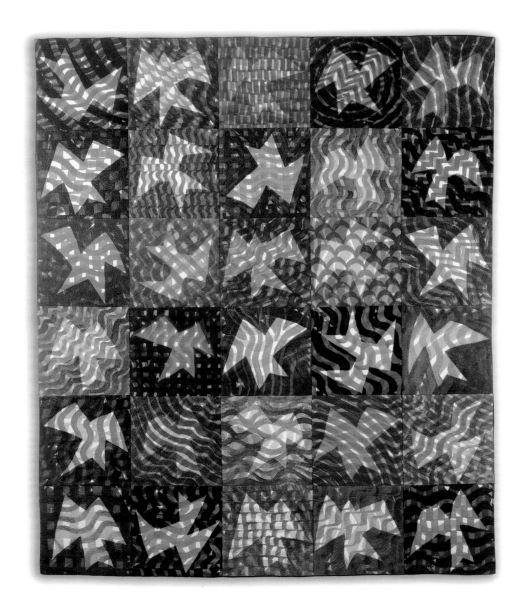

Flight Patterns

60 x 49 inches (152 x 125 cm) | 2012

abstract

Kevan Lunney

East Brunswick, New Jersey, USA

732-723-0828 | kevanart@gmail.com | www.kevanart.com

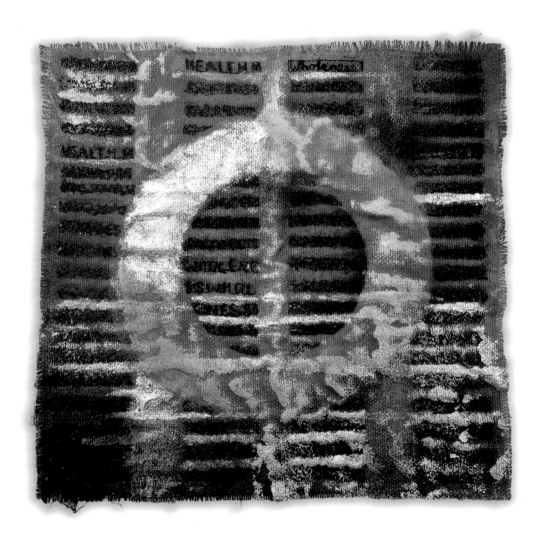

abstract

Archeology #23 Health and Wholeness

12 x 12 inches (31 x 31 cm) | 2013

Regina Marzlin

Antigonish, Nova Scotia, Canada
902-735-5442 | regina@reginamarzlin.com | www.reginamarzlin.com

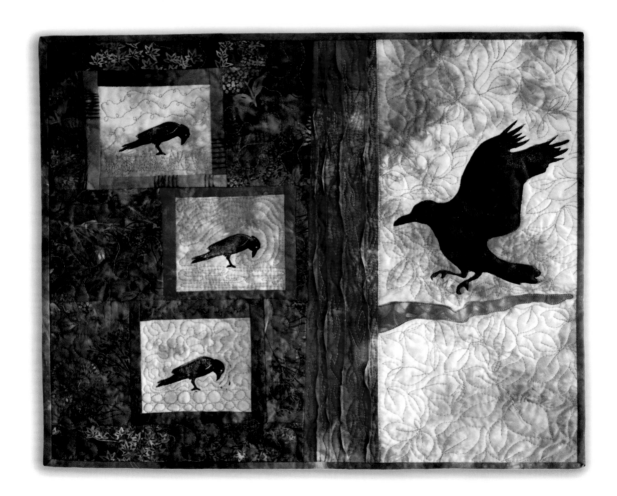

A Place to Rest

21 x 25 inches (53 x 64 cm) | 2012

nature

Katie Pasquini Masopust

Santa Fe, New Mexico, USA
505-471-2899 | katiepm@aol.com | www.katiepm.com

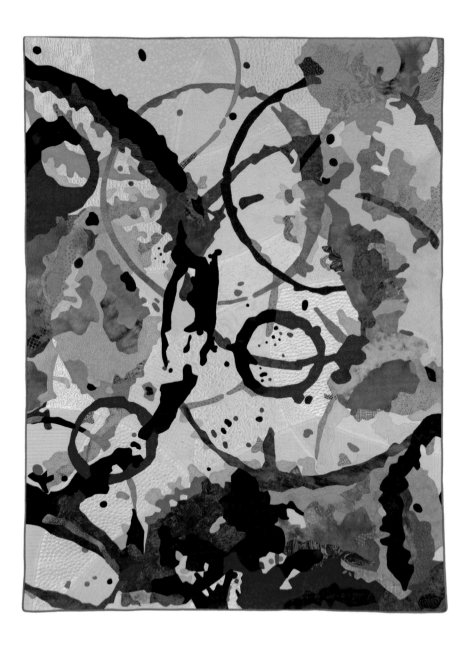

abstract

Cosmic Collisions
63 x 46 inches (160 x 117 cm) | 2013

Susan (Roberts) Mathews

Ocean Grove, Victoria, Australia

613 5255 5563 | susan@susanmathews.info | www.susanmathews.info

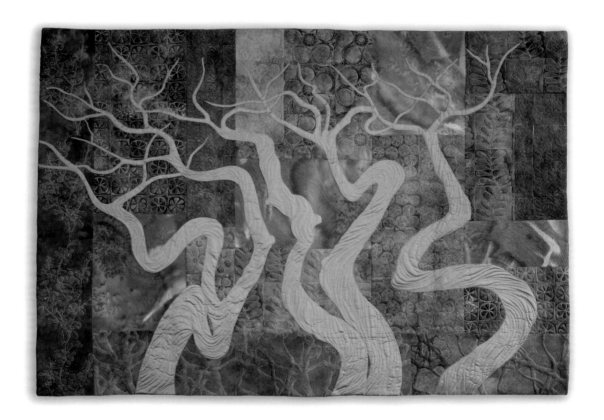

Coastal Life 3

43 x 59 inches (108 x 150 cm) | 2013

nature

Salley Mavor

Falmouth, Massachusetts, USA

508-540-1654 | weefolk@cape.com | www.weefolkstudio.com

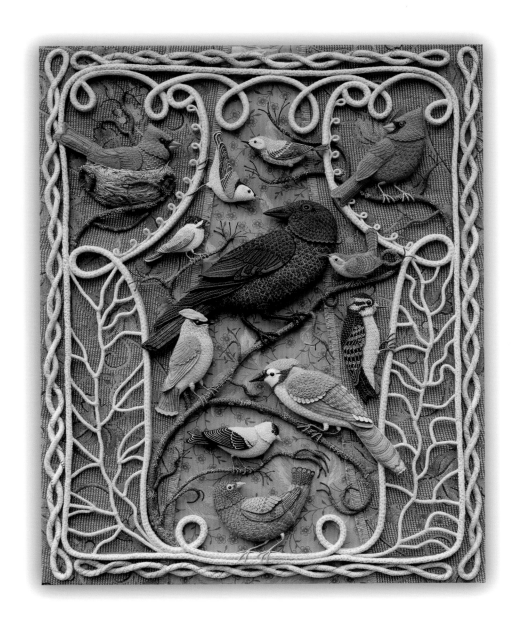

sculptural

Birds of Beebe Woods

30 x 24 x 2 inches (76 x 61 x 5.1 cm) | 2012

Therese May

San Jose, California, USA

866-292-3247 | therese@theresemay.com | www.theresemay.com

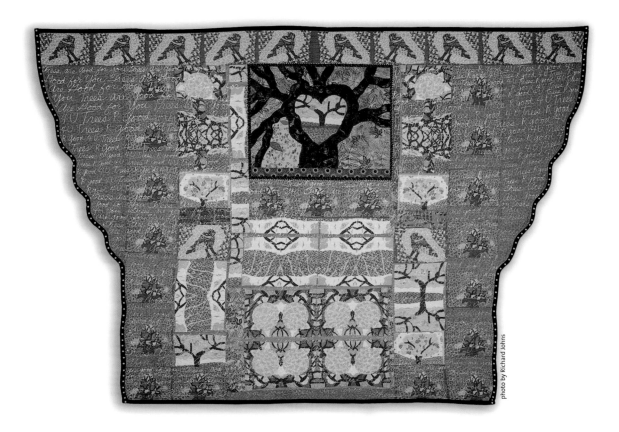

photo by Richard Johns

Trees Are Good For You

63 x 89 inches (160 x 226 cm) | 2011

nature

Mary McBride

DeLand, Florida, USA

386-736-3039 | mrsgorgon@gmail.com | www.marymcbridearts.wordpress.com

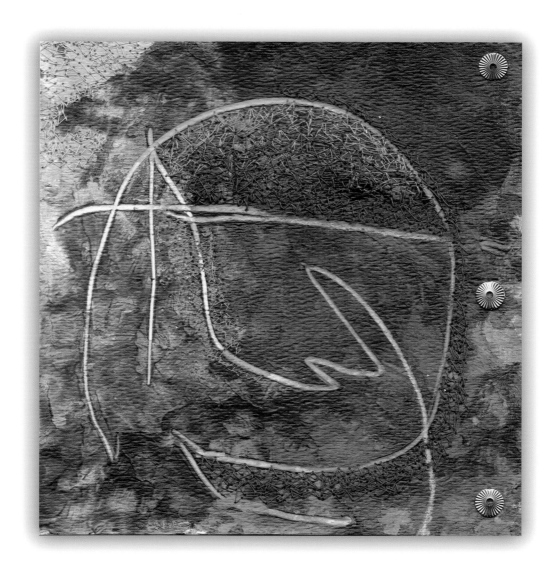

abstract

Great Idea

8 x 8 inches (20 x 20 cm) | 2013

Kathleen McCabe

Coronado, California, USA

619-435-1299 | kathmccabe@gmail.com | kathleenmccabecoronado.com

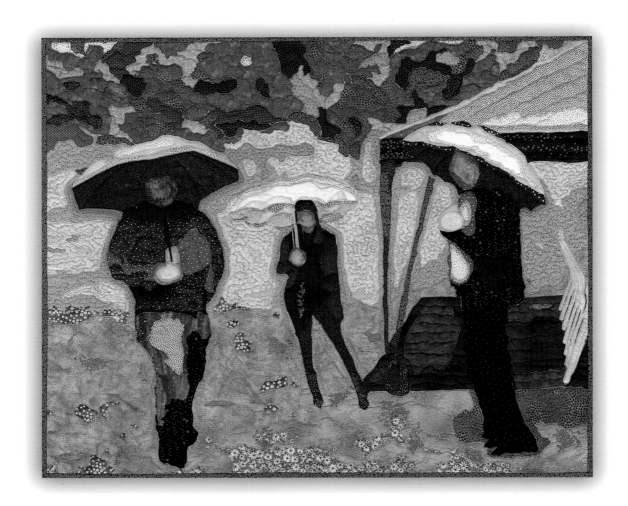

Funeral In the Rain

35 x 42 inches (89 x 107 cm) | 2012

figurative

Eleanor McCain

Shalimar, Florida, USA

850-864-3815 | emccain@eleanormccain.net | www.eleanormccain.net

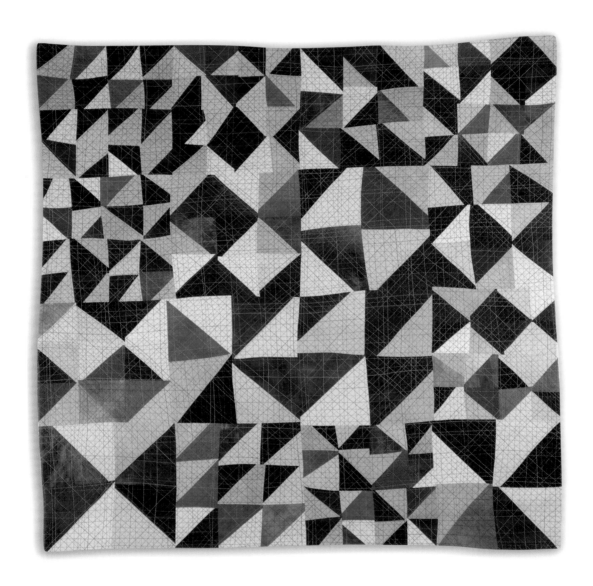

abstract

Pinwheels & Geese 1

33 x 33 inches (84 x 84 cm) | 2013

Sharon McCartney

Belchertown, Massachusetts, USA

413-323-0554 | lilypeek@aol.com | www.sharonmccartneyart.com

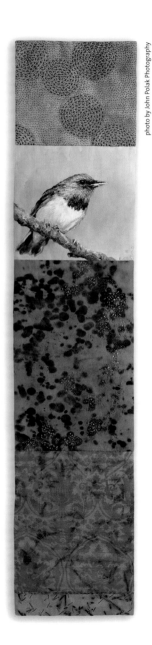

photo by John Polak Photography

Shadows of that Afternoon

50 x 10 inches (127 x 25 cm) | 2011

nature

Barbara Barrick McKie

Lyme, Connecticut, USA

860-434-5222 | mckieart@comcast.net | www.mckieart.com

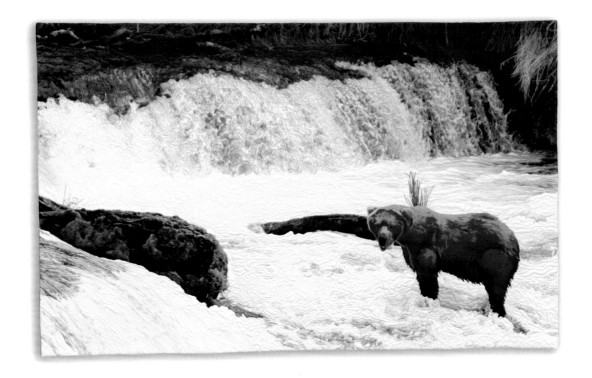

nature

My Fishing Hole

30 x 46 inches (76 x 117 cm) | 2011

Salli McQuaid

Walla Walla, Washington, USA

509-876-4016 | artistwriter6@gmail.com | www.artistwriter.com

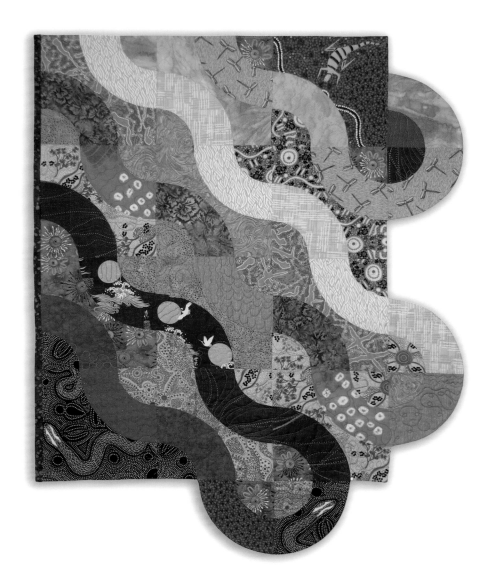

Seasons of the Mind (CI-131)

43 x 33 inches (109 x 84 cm) | 2013

conceptual

Diane Melms

Anchorage, Alaska, USA

907-345-6184 | rdzmelms@gmail.com | dianemelms.com

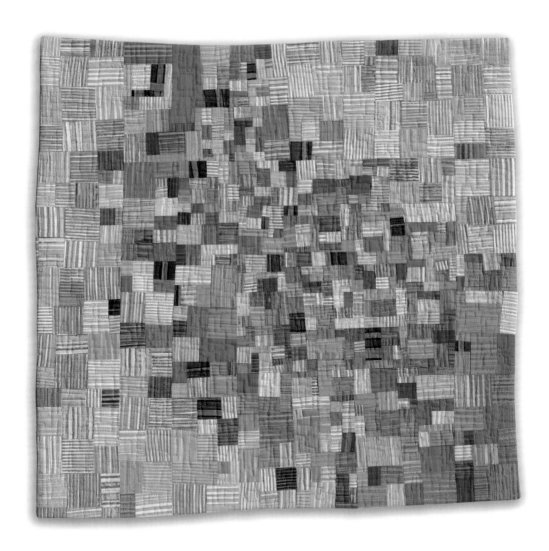

abstract

Fresh Salsa

25 x 26 inches (64 x 66 cm) | 2011

Alicia Merrett

Wells, Somerset, UK

+44 7753 677 850 | alicia@aliciamerrett.co.uk | www.aliciamerrett.co.uk

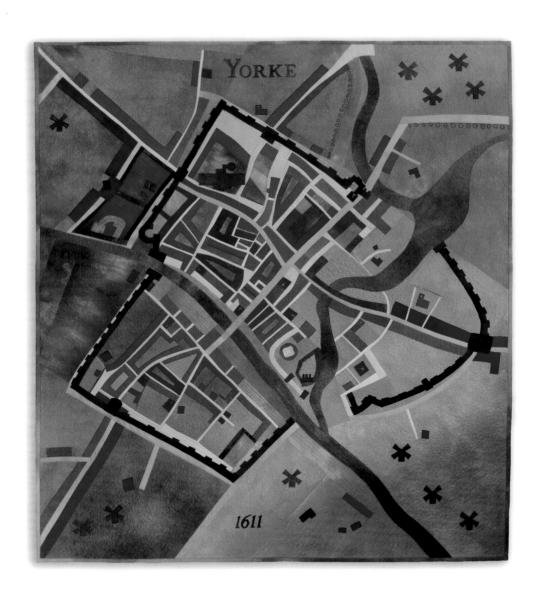

Yorke 1611

61 x 54 inches (155 x 137 cm) | 2012

conceptual

Elizabeth Michellod-Dutheil

Villette, Le Châble, Valais, Switzerland
0041 79 754 60 46 | maaesembrancher@netplus.ch | www.maaevalais.ch

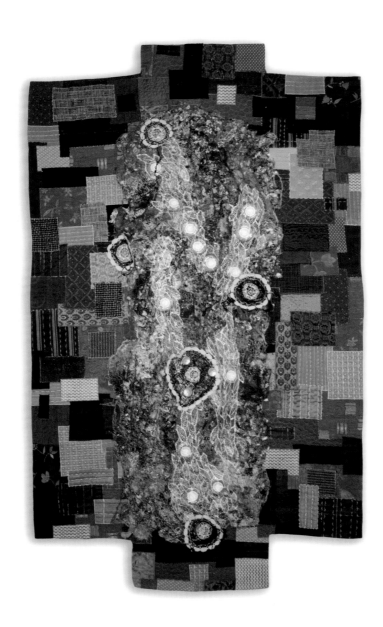

conceptual

The Blues Ménauposé
70 x 41 inches (178 x 104 cm) | 2013

Dottie Moore

Rock Hill, South Carolina, USA

803-327-5088 | dottie@dottiemoore.com | www.dottiemoore.com

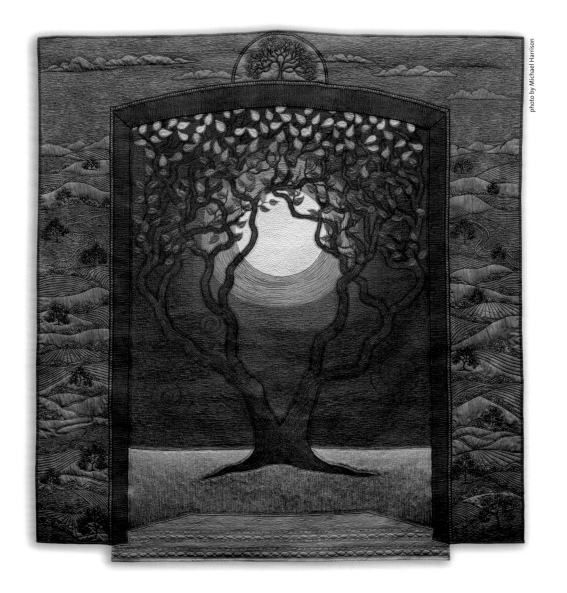

photo by Michael Harrison

I Am

72 x 66 inches (183 x 168 cm) | 2013

nature

Lynne Morin

Kanata, Ontario, Canada
613-271-0946 | lynnejmorin@gmail.com

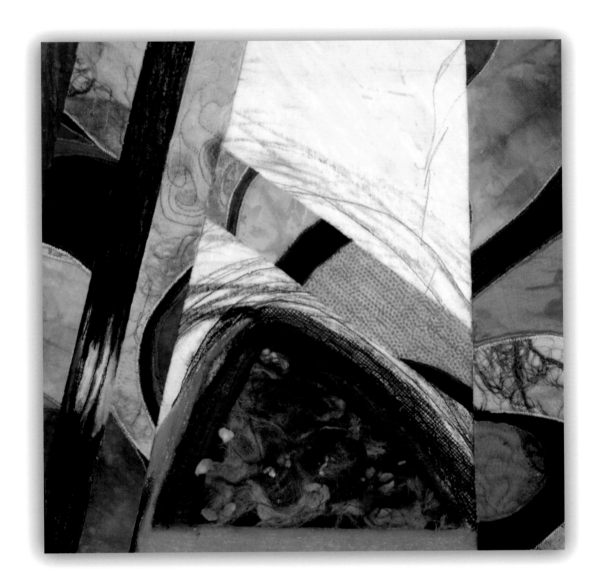

abstract

Emerging From Chaos
12 x 12 inches (31 x 31 cm) | 2012

Patti Morris

Red Deer, Alberta, Canada

403-347-3247 | p.tmorris@shaw.ca | www.morrisfabricartdesigns.com

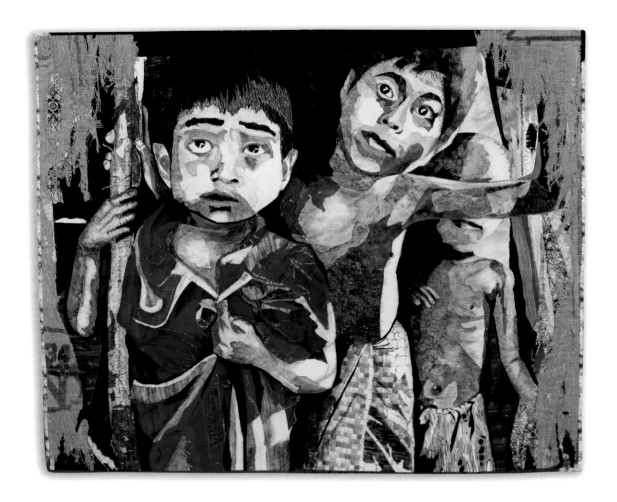

Rohingya Children

40 x 47 inches (102 x 119 cm) | 2012

figurative

Elisabeth Nacenta de la Croix

Geneva, Switzerland

+41 22 736 63 62 | ecn@bluewin.ch | www.elisabethdelacroix.com

photo by Léonard Nacenta de la Croix

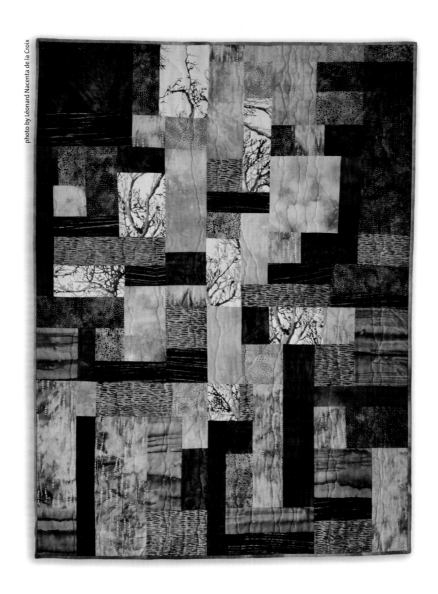

abstract

Up in the Sky

48 x 35 inches (124 x 89 cm) | 2011

Dominie Nash

Bethesda, Maryland, USA

301-213-5260 | dominien@verizon.net | www.dominienash.com

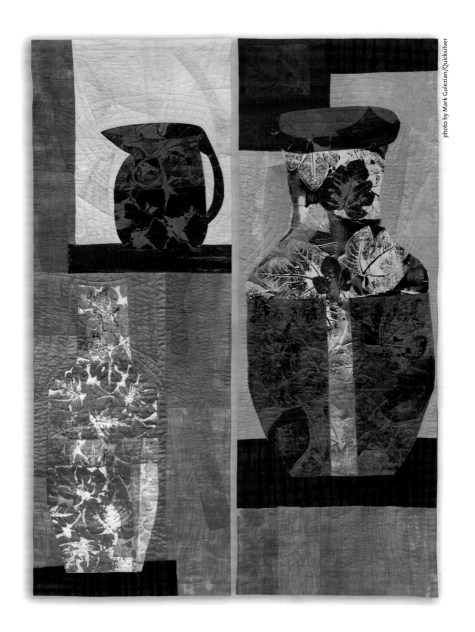

photo by Mark Gulezian/Quicksilver

Stills From a Life 42

71 x 49 inches (180 x 125 cm) | 2011

representational

Sylvia J. Naylor

Kingston, Ontario, Canada
613-384-8929 | sylvia.naylor@sympatico.ca | www.sylvianaylor.com

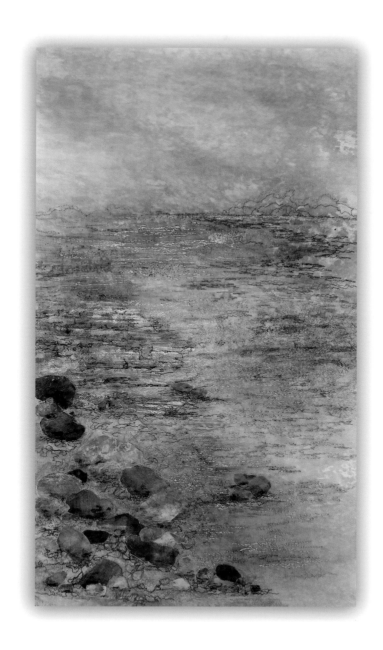

landscape

By The Lake Shore
23 x 13 inches (58 x 33 cm) | 2012

Nysha Oren Nelson

Somerville, Tennessee, USA

901-262-5509 | nyshaoren@me.com | studionysha.com

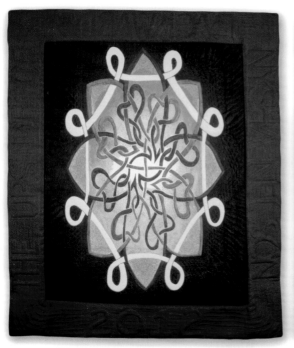 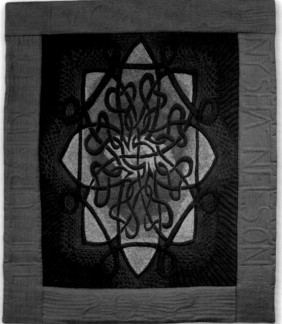

The Upside of Backwards

34 x 27 inches (86 x 69 cm) | 2012

abstract

Kathy Nida

El Cajon, California, USA

619-200-3277 | knida@cox.net | kathynida.com

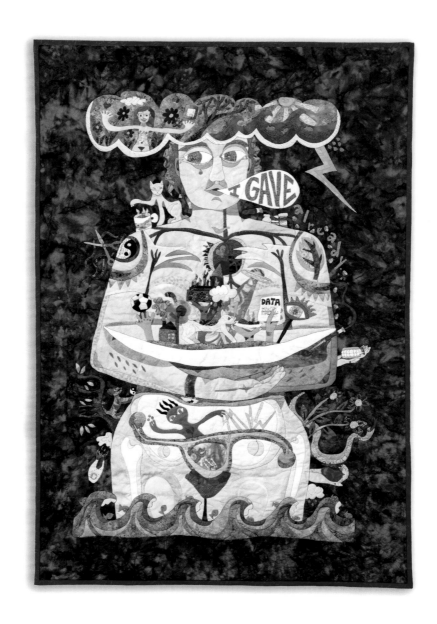

figurative

I Gave Already

60 x 40 inches (152 x 102 cm) | 2013

Elin Noble

New Bedford, Massachusetts, USA
508-287-6258 | elin@elinnoble.com | www.elinnoble.com

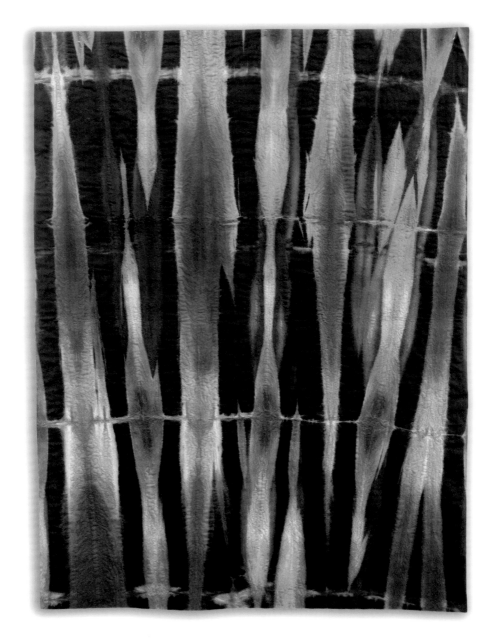

Fugitive Pieces 9
66 x 45 inches (168 x 114 cm) | 2012

abstract

Stephanie Nordlin

Poplar Grove, Illinois, USA

815-765-0498 | stephanie@stephanienordlin.com | www.stephanienordlin.com

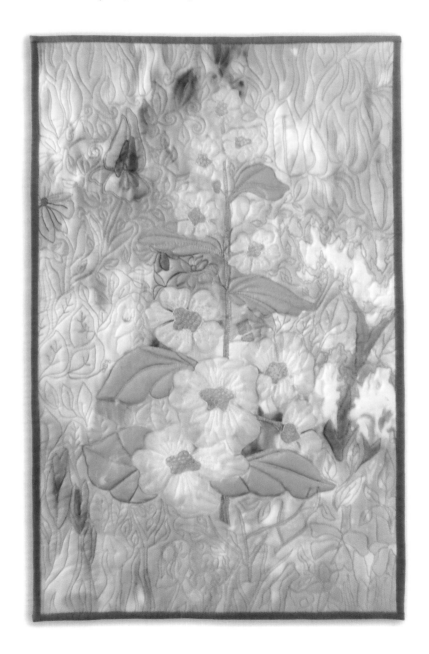

nature

Hollyhock

21 x 13 inches (53 x 33 cm) | 2012

Diane Núñez

Southfield, Michigan, USA
248-224-5934 | dnunez.art@gmail.com | www.dianenunez.com

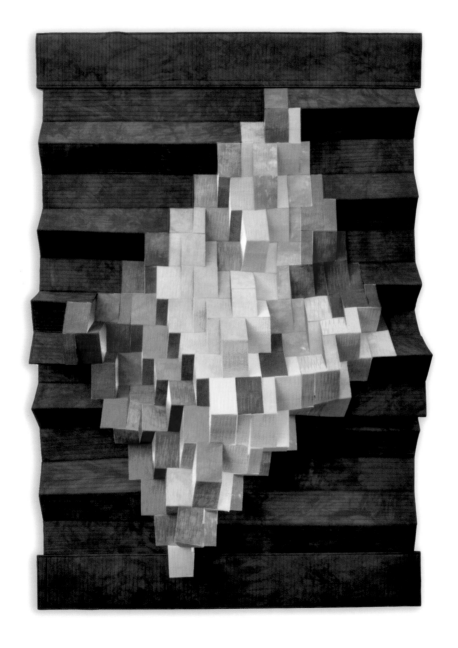

Spaces
51 x 33 x 10 inches (130 x 84 x 25 cm) | 2011

sculptural

Elsbeth Nusser-Lampe

Freiburg, Germany

004976166574 | volampe@arcor.de | www.elsbethnusser-lampe.meinatelier.de

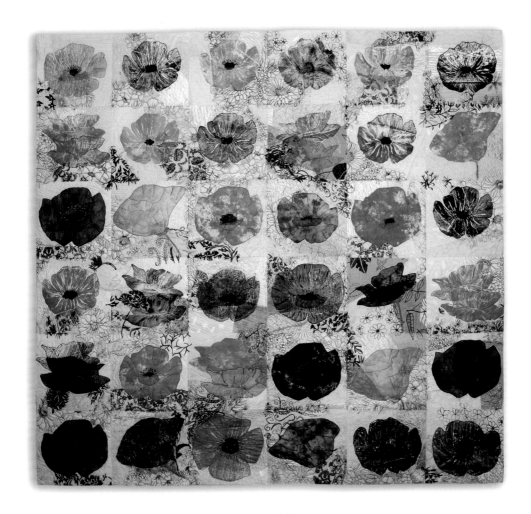

nature

Where have all the flowers gone

54 x 54 inches (137 x 137 cm) | 2012

Dan Olfe

Julian, California, USA

760-765-1500 | danolfe@hotmail.com | www.danolfe.com

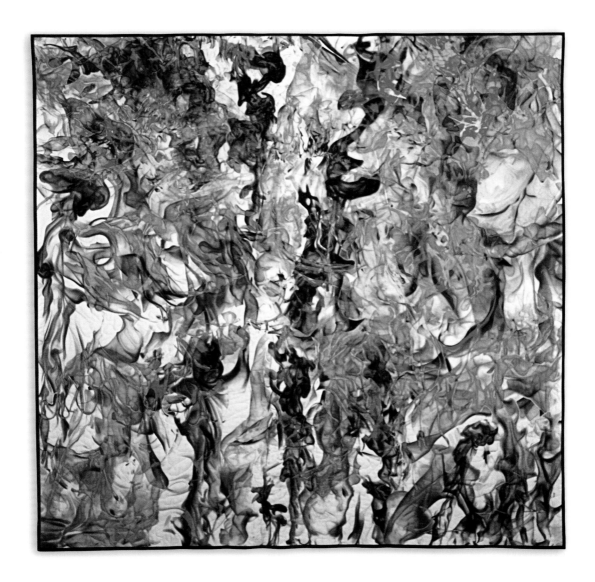

Texture Experiment #23

57 x 57 inches (145 x 145 cm) | 2012

abstract

Pat Owoc

St. Louis, Missouri, USA

314-821-7429 | owocp@mindspring.com | www.patowoc.com

photo by Casey Rae, Red Elf Inc.

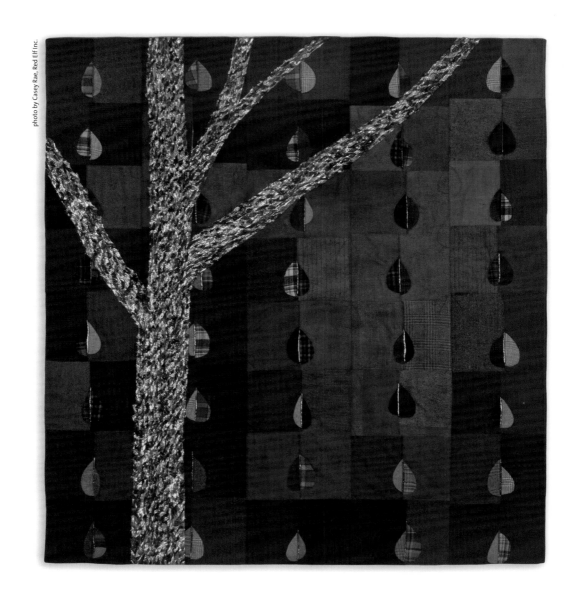

nature

Unbecoming: Smoke and Flame

77 x 71 inches (196 x 180 cm) | 2013

Mary Pal

Ottawa, Ontario, Canada

613-567-2675 | marybpal@gmail.com | www.marypaldesigns.com

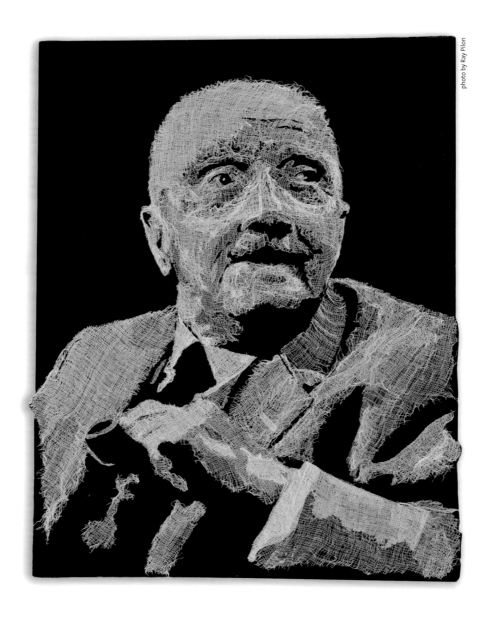

photo by Ray Pilon

JBW

24 x 18 inches (61 x 46 cm) | 2012

figurative

BJ Parady

Batavia, Illinois, USA

319-520-7096 | bj@bjparady.com | bjparady.com

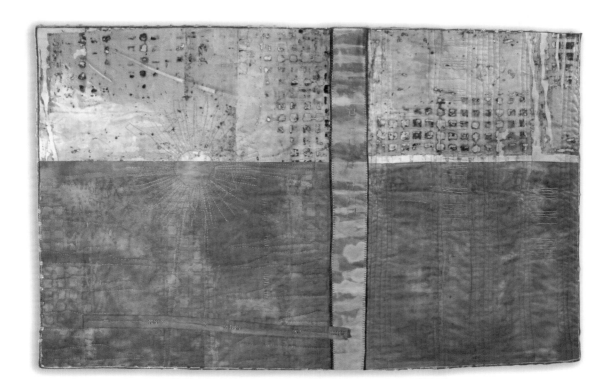

abstract

Once We Built Windmills

22 x 33 inches (56 x 84 cm) | 2012

Pat Pauly

Rochester, New York, USA

585-737-5822 | ty610@aol.com | www.patpauly.com

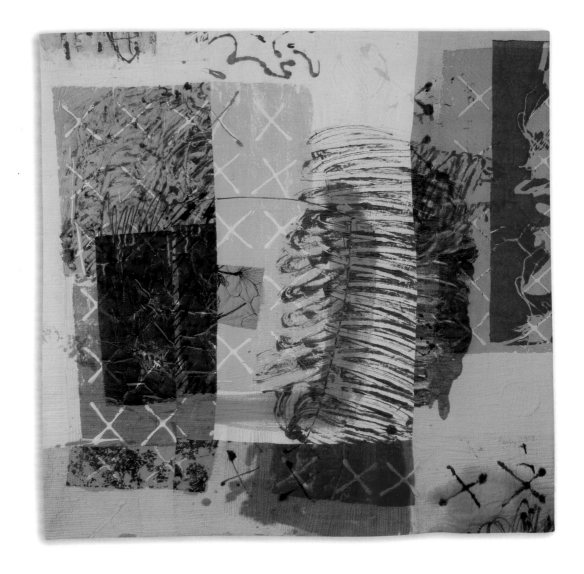

The Easy Life

51 x 51 inches (130 x 130 cm) | 2012

abstract

Mirjam Pet-Jacobs

Waalre, Netherlands
+31402217983 | mirjam@mirjampetjacobs.nl | www.mirjampetjacobs.nl

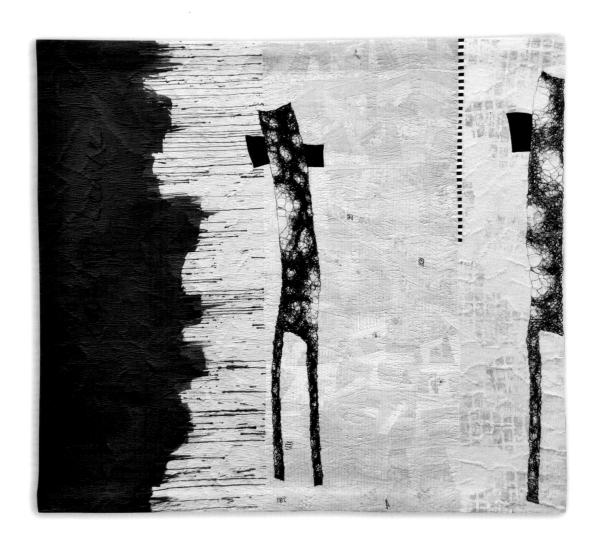

abstract

The Leave-taking
53 x 57 inches (136 x 145 cm) | 2012

Bonnie Peterson

Houghton, Michigan, USA

630-673-5530 | writebon@bonniepeterson.com | www.bonniepeterson.com

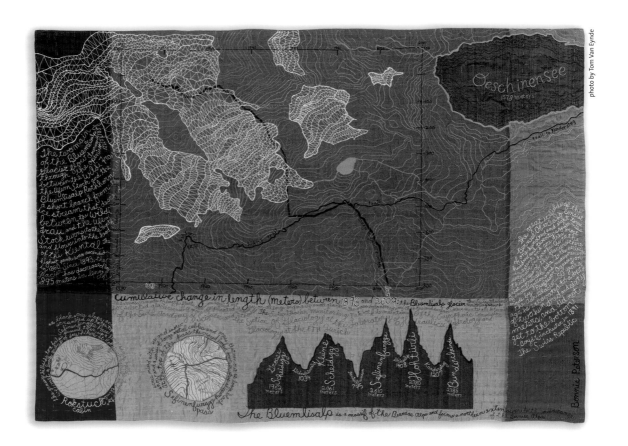

photo by Tom Van Eynde

Bluemlisalp Glacier

44 x 60 inches (112 x 152 cm) | 2012

conceptual

Julia E. Pfaff

Richmond , Virginia, USA

804-232-3966 | jepfaff@aol.com | juliapfaffquilt.blogspot.com

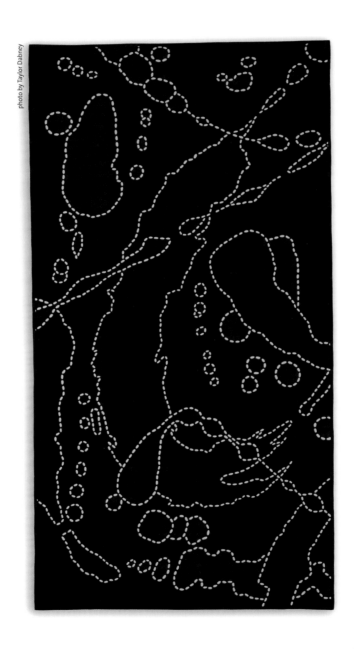

photo by Taylor Dabney

abstract

Contrast XIII

74 x 38 inches (188 x 97 cm) | 2012

Pixeladies (Deb Cashatt and Kris Sazaki)

Cameron Park, California, USA

916-320-8774 | info@pixeladies.com | www.pixeladies.com

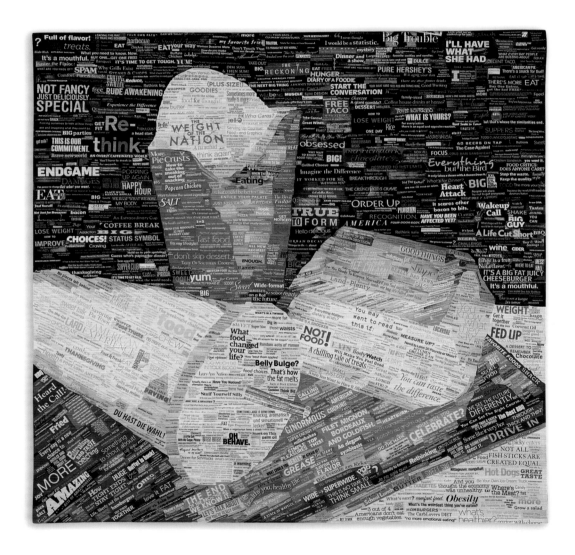

American Still Life: The Weight of the Nation

60 x 60 inches (152 x 152 cm) | 2012

conceptual

Judith Plotner

Gloversville, New York, USA

518-725-3222 | judith@judithplotner.com | www.judithplotner.com

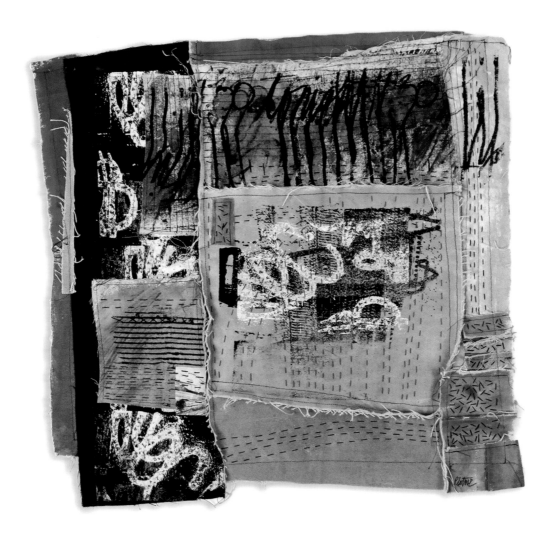

conceptual

Structure North Wall

23 x 23 inches (58 x 58 cm) | 2011

Susan V. Polansky

Lexington, Massachusetts USA

781-864-7197 | harisue@comcast.net | www.susanpolansky.com

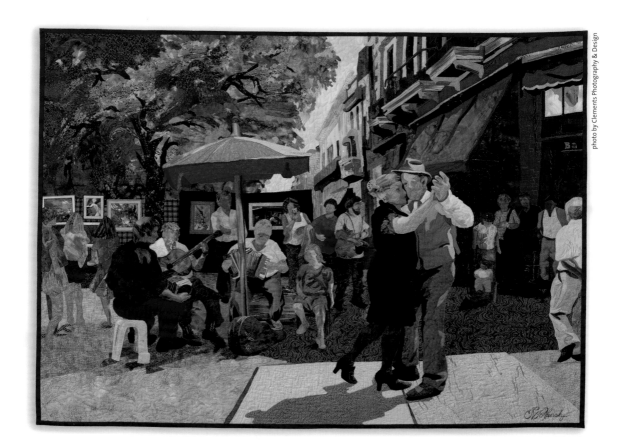

No One but You

49 x 65 inches (125 x 165 cm) | 2012

figurative

Ruth Powers

Carbondale, Kansas, USA

785-256-2361 | innokom@aol.com | www.ruthpowersartquilts.com

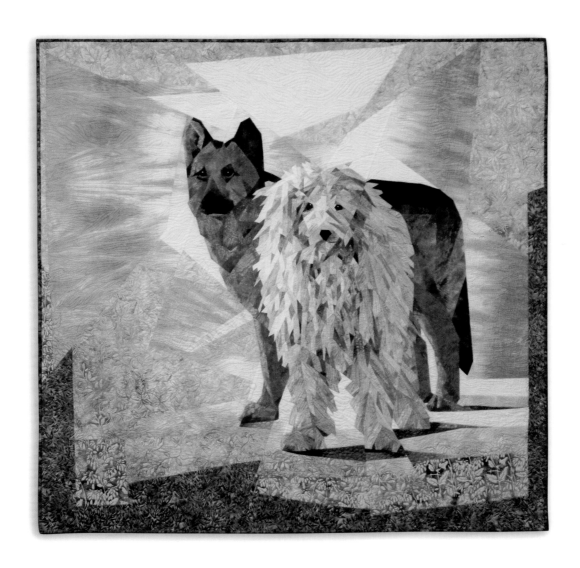

representational

Snow Buddies

48 x 48 inches (122 x 122 cm) | 2013

Casey Puetz

Waukesha, Wisconsin, USA

262-549-0763 | ppuetz@wi.rr.com | www.caseypuetz.com

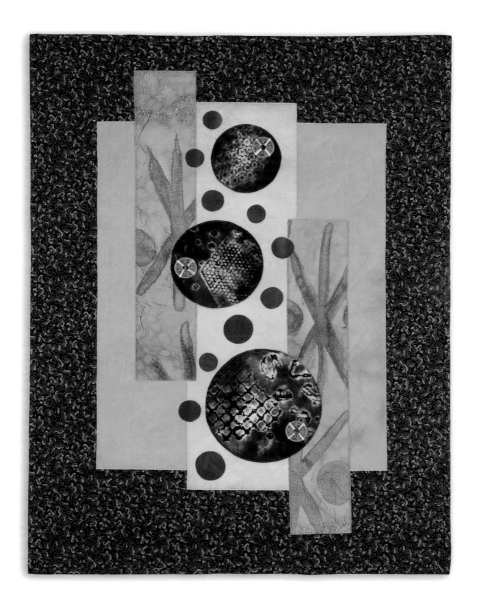

Coin Toss

24 x 18 inches (61 x 46 cm) | 2012

abstract

Elaine Quehl

Ottawa, Ontario, Canada

613-824-8050 | equehl@hotmail.com | www.elainequehl.com

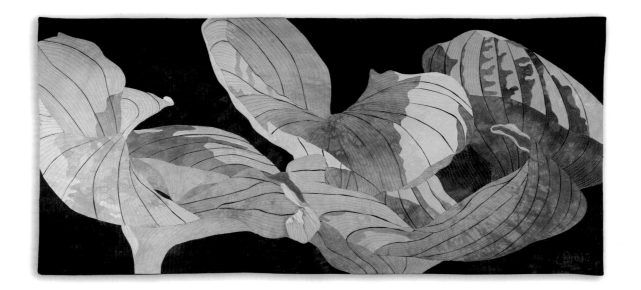

nature

Curtain Call 2

19 x 44 inches (48 x 112 cm) | 2012

Melody Randol

Loveland, Colorado, USA
970-962-9225 | randolm@earthlink.net | www.melodyquilts.com

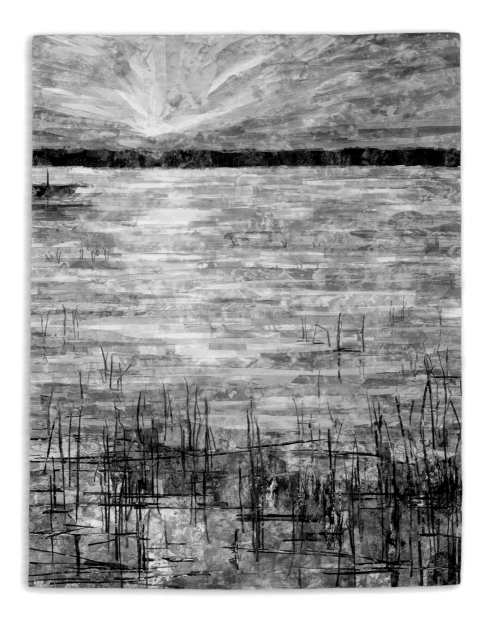

Sunrise, Sunset

47 x 36 inches (119 x 91 cm) | 2013

landscape

Wen Redmond

Strafford, New Hampshire, USA

603-312-3298 | wenredmond@yahoo.com | wenredmond.com

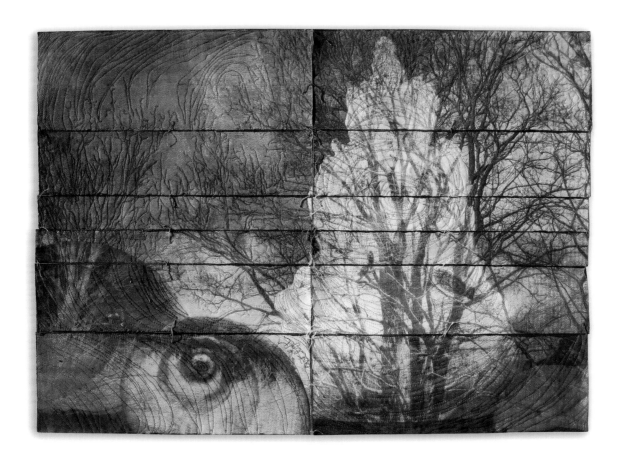

conceptual

First Light

35 x 48 inches (89 x 122 cm) | 2012

Toot Reid

Tacoma, Washington, USA

253-759-2555 | tootreid@harbornet.com

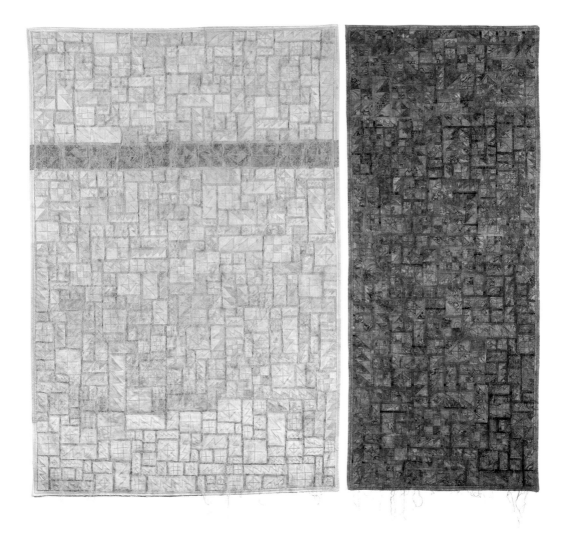

April 1, 2012 - July 2, 2012

63 x 65 inches (160 x 165 cm) | 2012

abstract

Sue Reno

Columbia, Pennsylvania, USA

717-842-0651 | sue@suereno.com | suereno.com

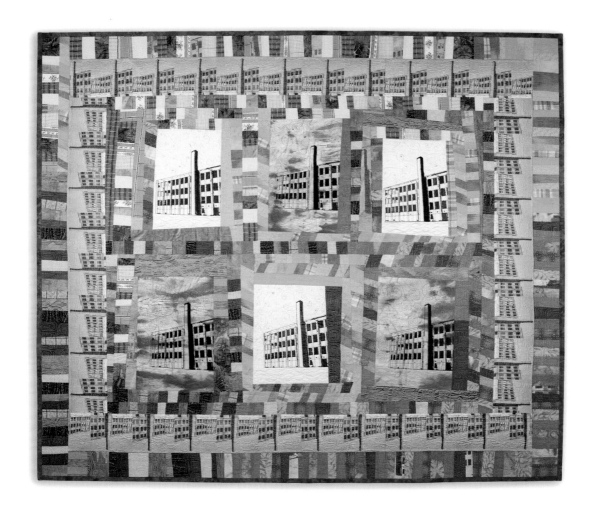

representational

Silk Mill #3

53 x 60 inches (135 x 152 cm) | 2013

Hilary Rice

Stirling, Ontario, Canada
613-848-4309 | hilary.rice@mestudios.ca | www.mestudios.ca

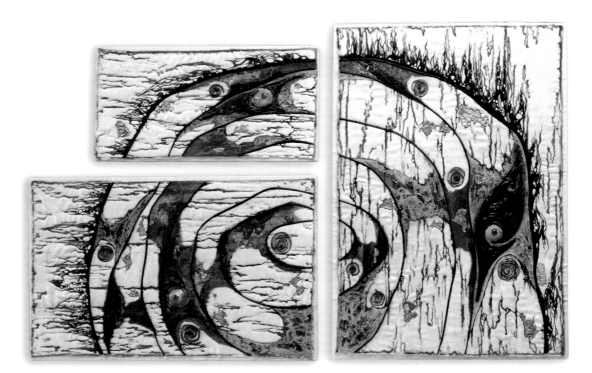

Trinity
25 x 39 inches (64 x 99 cm) | 2013

abstract

Jan Rickman

Whitewater, Colorado, USA

970-931-2231 | janfantastic01@yahoo.com | www.janrickman.com

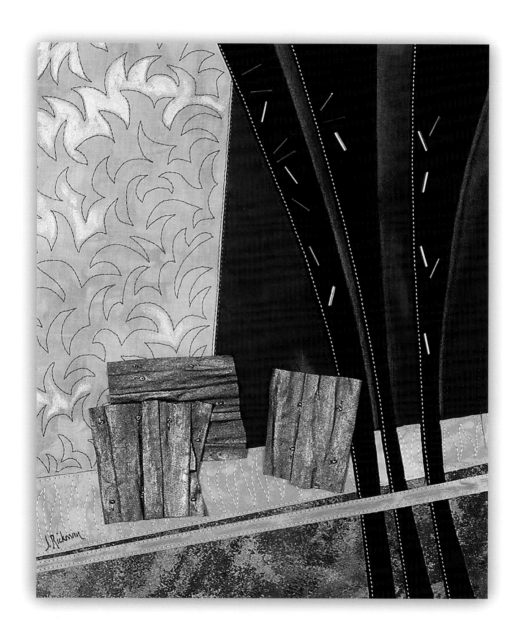

abstract

Pathways

14 x 11 inches (34 x 27 cm) | 2011

Susan Rienzo

Vero Beach, Florida, USA

772-778-0048 | srienzo@gmail.com | www.susanrienzodesigns.com

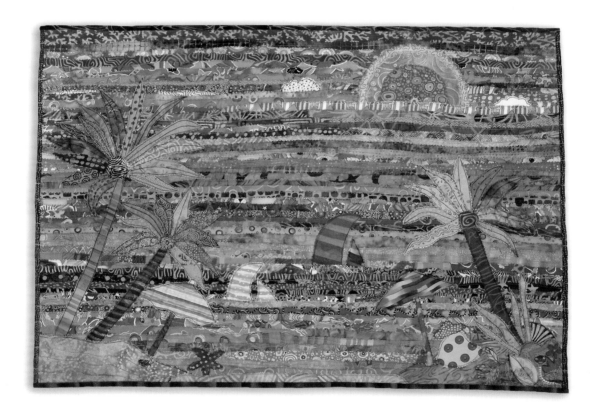

Tropical Moments

26 x 37 inches (66 x 94 cm) | 2012

landscape

Karen Rips

Thousand Oaks, California, USA

805-427-6050 | karenrips@gmail.com | www.karenrips.com

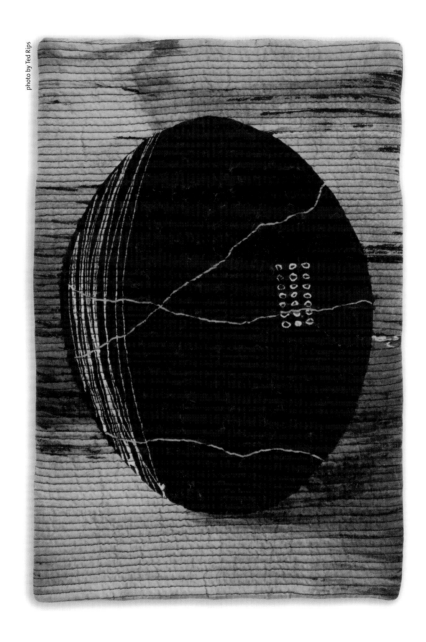

photo by Ted Rips

abstract

Quiet Alertness

17 x 11 inches (43 x 28 cm) | 2013

Lora Rocke

Lincoln, Nebraska, USA
402-450-1054 | lora.rocke@gmail.com | www.lorarockequilts.com

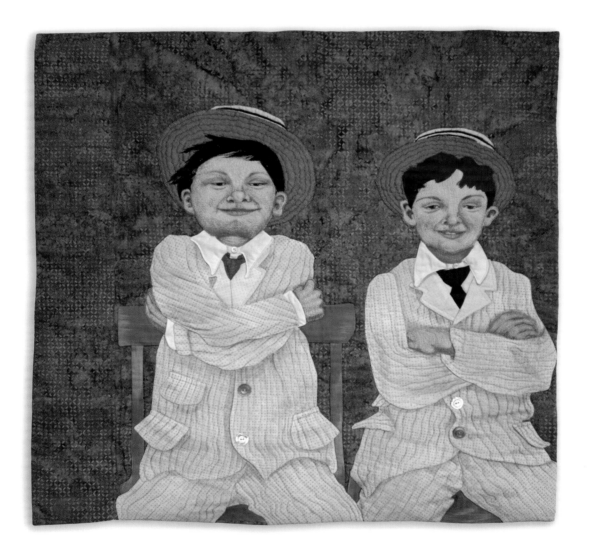

two boys in straw hats

29 x 29 inches (74 x 74 cm) | 2012

figurative

Judith Roderick

Placitas, New Mexico, USA

505-867-0067 | rainbowpaintr@comcast.net | www.judithroderick.com

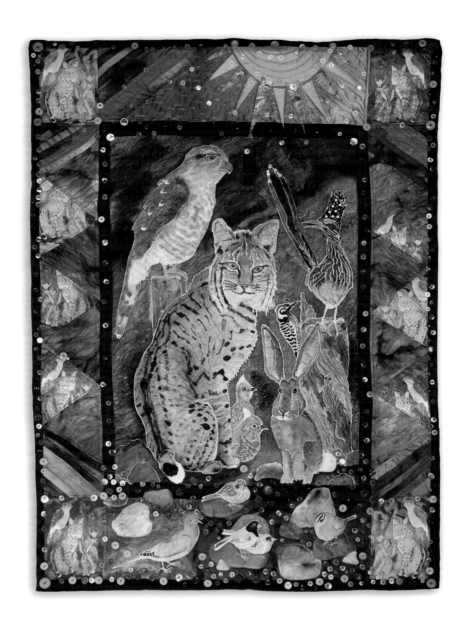

Peaceable Kingdom

58 x 41 inches (147 x 104 cm) | 2012

nature

Connie Rohman

Los Angeles, California, USA

323-225-3321 | crohman1@yahoo.com | www.connierohman.com

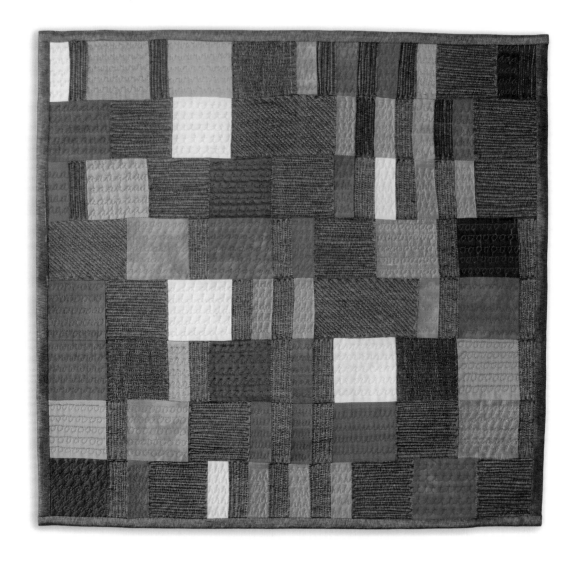

**The World's First Text Message (1844) -
"What Hath God Wrought?"**

24 x 24 inches (61 x 61 cm) | 2013

abstract

Bernie Rowell

Candler, North Carolina, USA

828-667-2479 | bernie@bernierowell.com | www.bernierowell.com

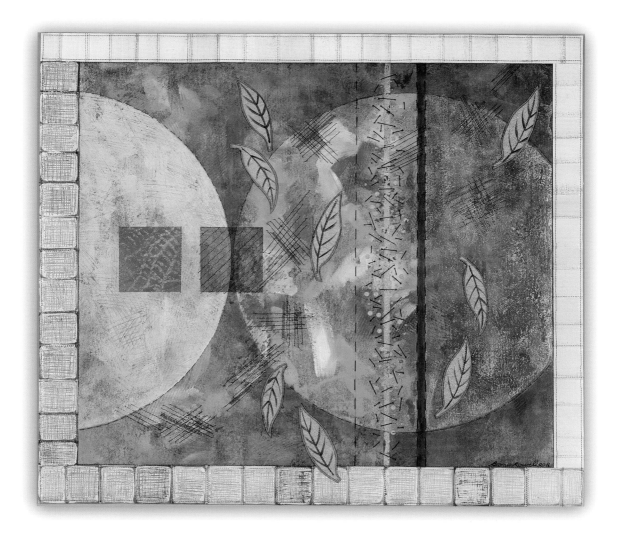

abstract

Moon Mending Meditation

25 x 28 inches (64 x 71 cm) | 2011

Pam RuBert

Springfield, Missouri, USA

417-862-3760 | pam@rubert.com | pamrubert.com

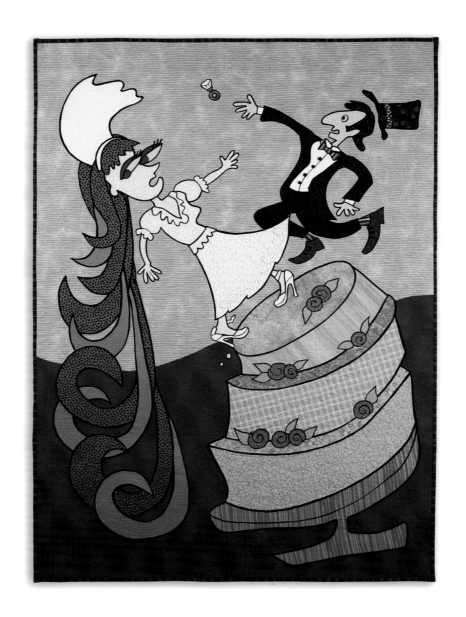

Niagra Falls – Wish You Were Hair

59 x 42 inches (150 x 107 cm) | 2012

figurative

Rose Rushbrooke

Safety Harbor, Florida, USA

813-335-1634 | rose@roserushbrooke.com | www.roserushbrooke.com

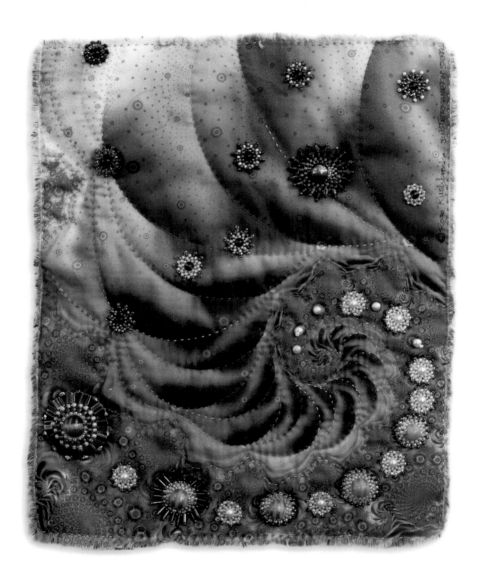

abstract

Subterranean Spiral

10 x 8 inches (25 x 20 cm) | 2012

Helena Scheffer

Beaconsfield, Quebec, Canada
514-695-8249 | helena@helenascheffer.ca | www.helenascheffer.ca

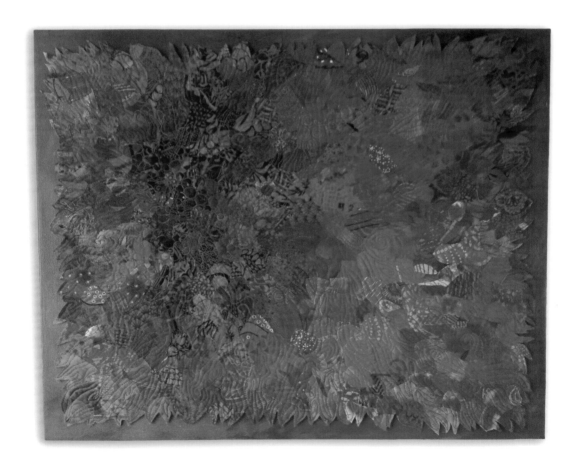

Crimson Fire
20 x 24 inches (51 x 61 cm) | 2013

abstract

Norma Schlager

Danbury, Connecticut, USA

203-798-0025 | nschlager11@comcast.net | notesfromnorma.blogspot.com

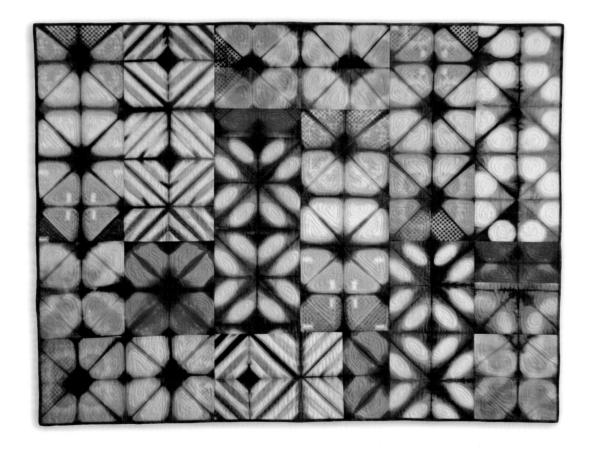

Itajime Surprise

44 x 56 inches (112 x 142 cm) | 2012

Barbara Schneider

Woodstock, Illinois, USA

815-337-9893 | bjsco@comcast.net | www.barbaraschneider-artist.com

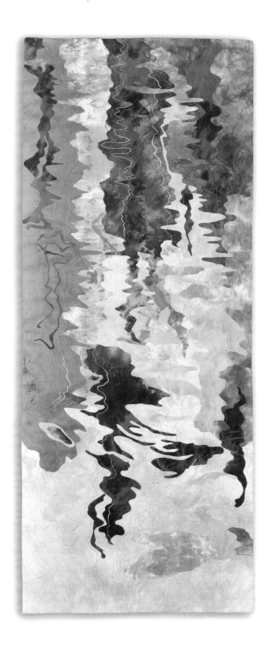

Reflections, var. 18

78 x 34 inches (198 x 86 cm) | 2012

abstract

Maya Schonenberger

Miami, Florida, USA

305-829-7698 | maya.schonenberger@gmail.com | www.mayaschonenberger.com

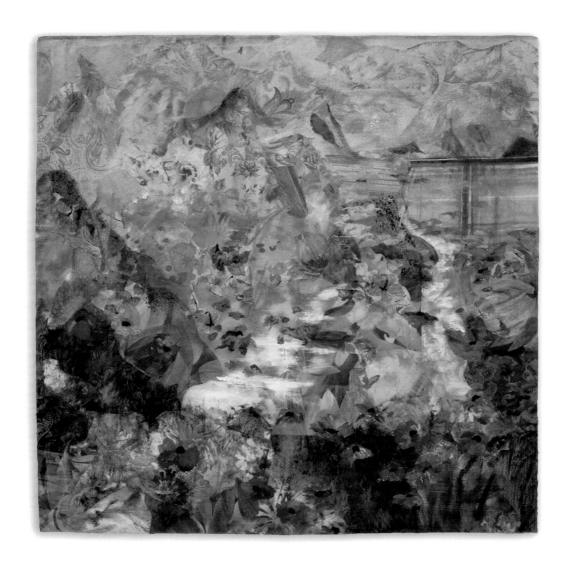

landscape

Miracle of Life

60 x 60 inches (152 x 152 cm) | 2012

Karen Schulz

Silver Spring, Maryland, USA

301-588-0427 | karenschulz@rcn.com | www.karen-schulz.com

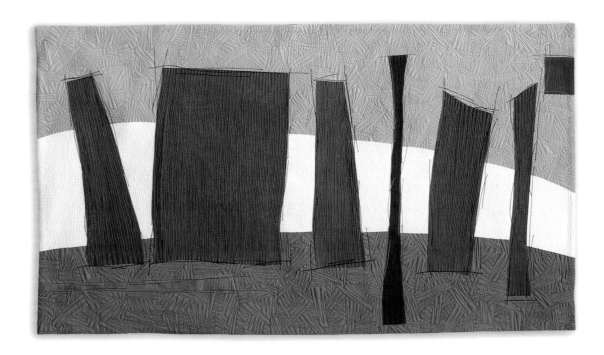

Stonehenge-ish

28 x 48 inches (71 x 121 cm) | 2012

abstract

Alison Schwabe

Montevideo, Uruguay

+ 598 9922 5026 | alison@alisonschwabe.com | www.alisonschwabe.com

photo by Eduardo Baldizan

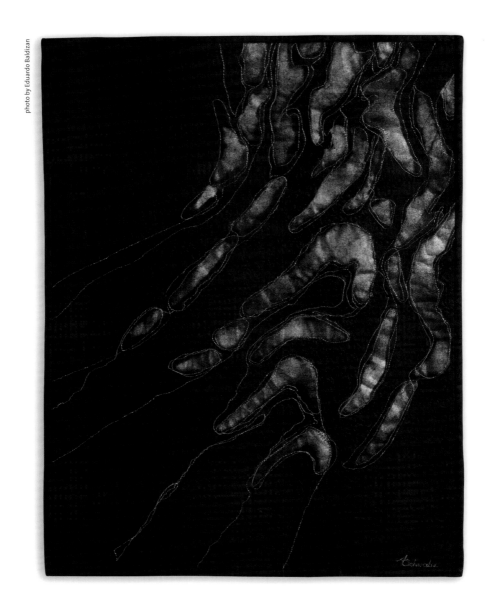

landscape

Tidelines #8

22 x 16 inches (55 x 41 cm) | 2012

Sandra Sider

Bronx, New York, USA

718-390-7473 | sandrasider@mac.com | www.sandrasider.com

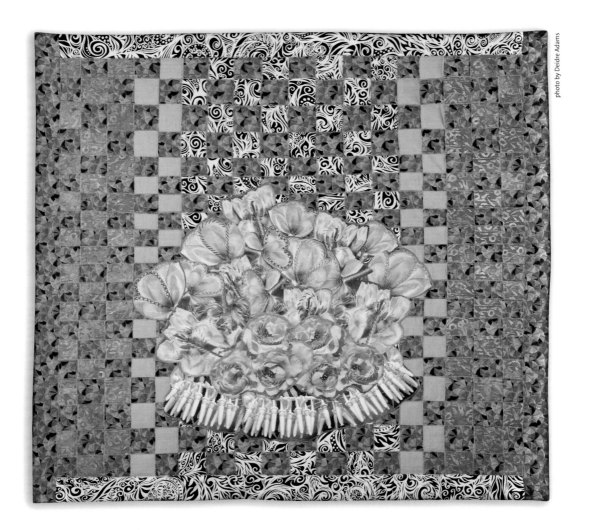

photo by Deidre Adams

Garden Grid #3

37 x 39 inches (93 x 99 cm) | 2011

nature

Bonnie J. Smith

San Jose, California, USA

408-298-7898 | bjs8934@aol.com | www.bonniejofiberarts.com

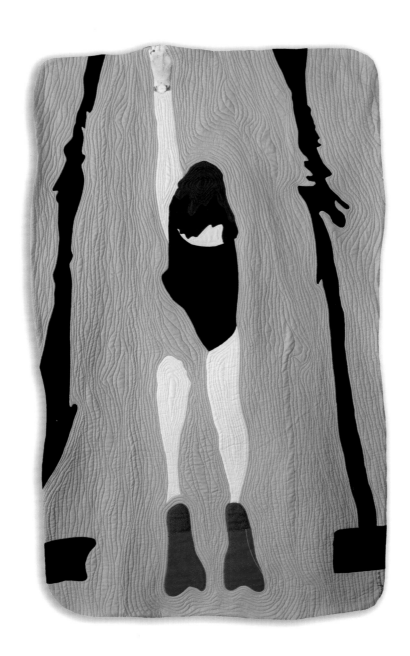

figurative

Swimming Upstream #1

65 x 35 inches (165 x 89 cm) | 2012

Lura Schwarz Smith

Coarsegold, California, USA
559-683-3060 | lura@lura-art.com | www.lura-art.com

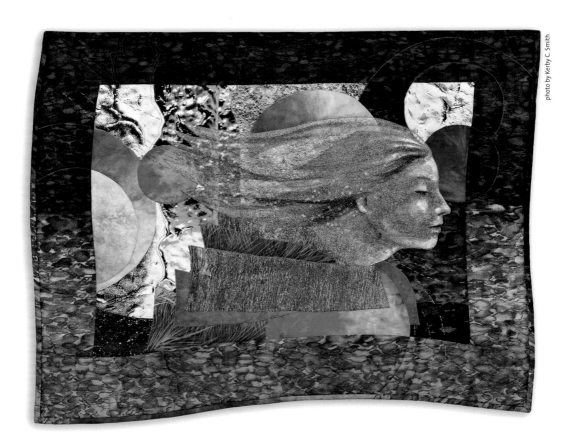

photo by Kerby C. Smith

Moonshadows

20 x 24 inches (51 x 61 cm) | 2013

figurative

Mary Ruth Smith

Waco, Texas, USA
254-296-9495 | mary_ruth_smith@baylor.edu

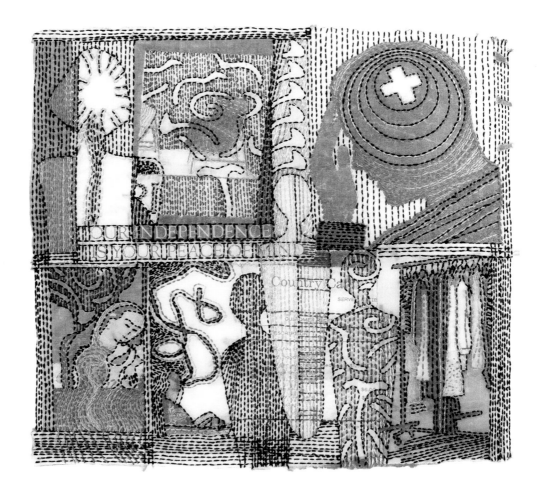

conceptual

Our Independence

10 x 11 inches (26 x 28 cm) | 2012

Sarah Ann Smith

Hope, Maine, USA
207-763-3565 | sarah@sarahannsmith.com | www.sarahannsmith.com

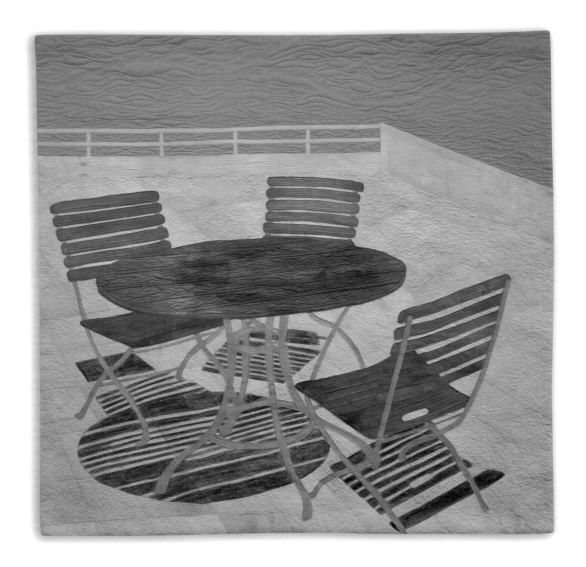

Conversations 1

36 x 36 inches (91 x 91 cm) | 2011

representational

Cyndi Zacheis Souder

Annandale, Virginia, USA

703-407-0916 | cyndi@moonlightingquilts.com | www.moonlightingquilts.com

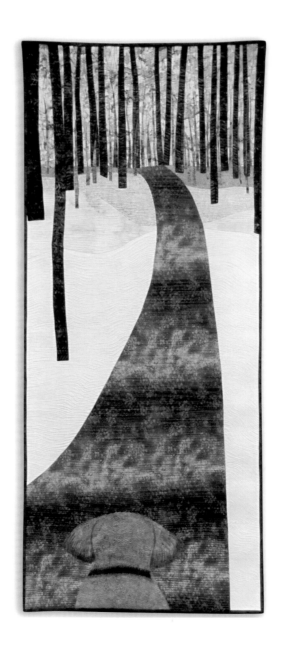

landscape

Let's Go!

59 x 24 inches (150 x 61 cm) | 2012

Joan Sowada

Gillette, Wyoming, USA

307-682-1657 | joansowada@gmail.com | joansowada.com

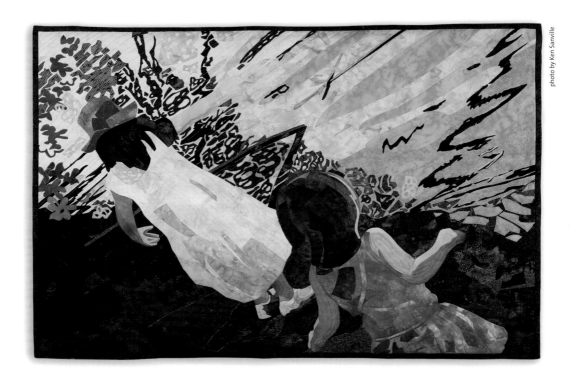

photo by Ken Sanville

Remembering When

31 x 46 inches (79 x 116 cm) | 2012

figurative

Virginia A. Spiegel

Byron, Illinois, USA

815-234-8342 | virginia@virginiaspiegel.com | www.virginiaspiegel.com

photo by Deidre Adams

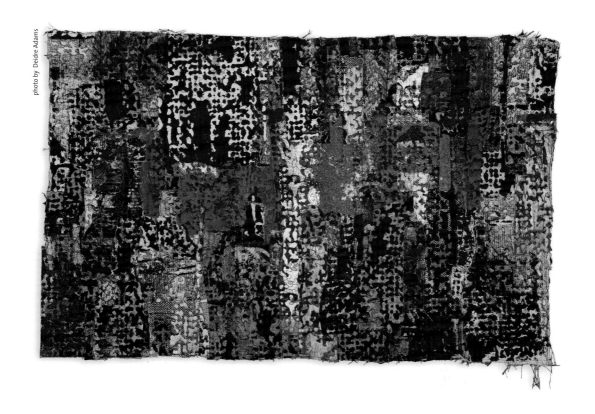

abstract

Formerly Present 7

24 x 37 inches (61 x 93 cm) | 2012

Marialuisa Sponga Archi

Colico, Lecco, Italy
00393334819516 | ml.sponga@gmail.com | www.sponga.com

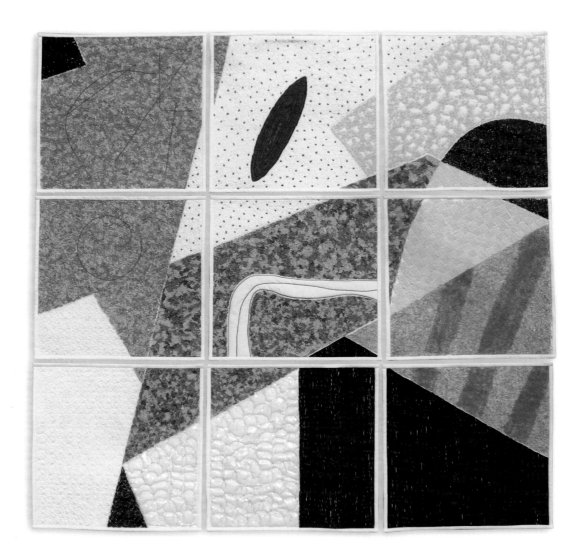

S-Composition n.4, from Thread to Thread

63 x 63 inches (160 x 160 cm) | 2011

abstract

Elena Stokes

Clinton, New Jersey, USA

908-285-8101 | elena@focusonfiberart.com | elenastokes.com

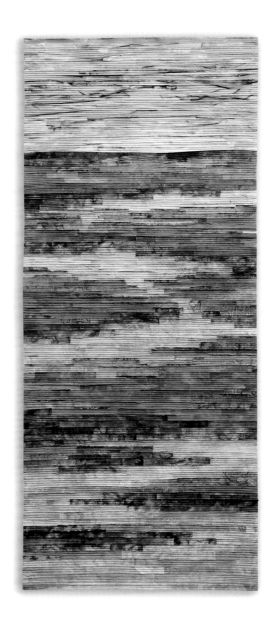

landscape

Tranquil Marsh – Wild Iris

78 x 32 inches (198 x 81 cm) | 2012

Priscilla Stultz

Fairfax, Virginia, USA

703-591-5630 | quilter73@hotmail.com | www.priscillastultz.com

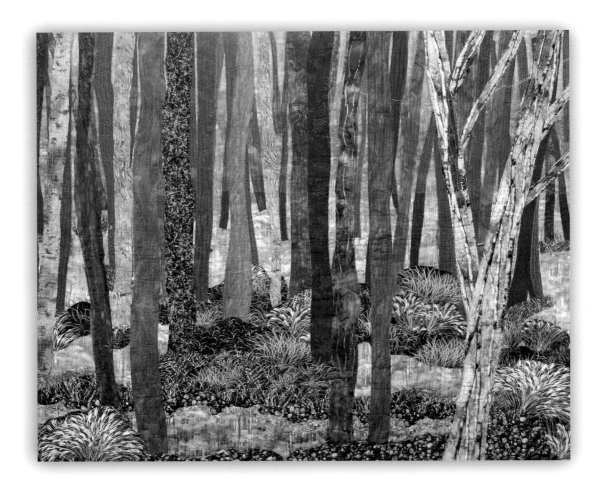

Morning Mist

28 x 32 inches (71 x 81 cm) | 2012

landscape

Mary Tabar

San Diego, California, USA
858-592-8828 | marytabar@gmail.com | www.marytabar.com

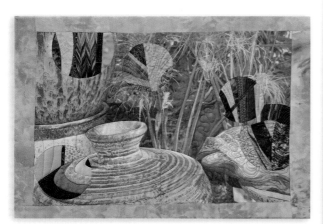

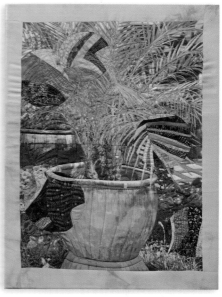

nature

Tunnel Vision Tan, Tunnel Vision Yellow (l-r)

28 x 58 inches (71 x 147 cm) | 2012

Tiziana Tateo

Vigevano, Pavia, Italy

+39 0381 690617 | vtateo@alice.it | www.tizianatateo.it

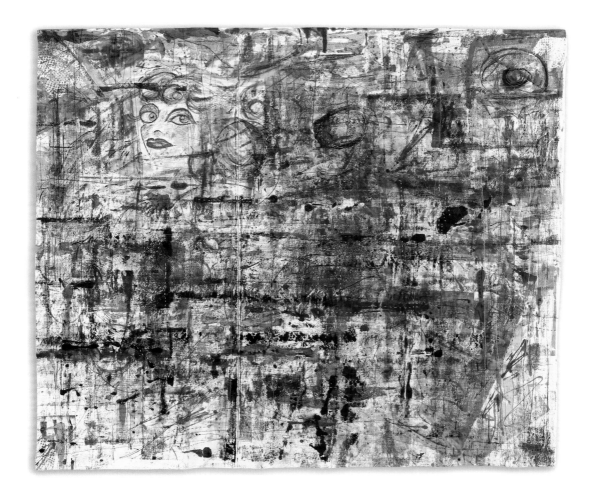

Flow of Consciousness

57 x 66 inches (146 x 168 cm) | 2012

abstract

Carol Taylor

Pittsford, New York, USA

585-381-4425 | ctquilts@rochester.rr.com | www.caroltaylorquilts.com

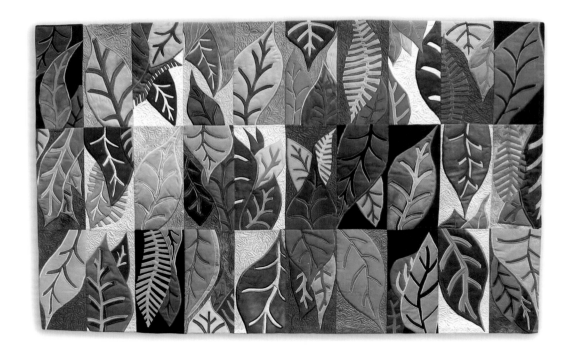

nature

Windfall II

34 x 53 inches (86 x 135 cm) | 2012

Kate Themel

Cheshire, Connecticut, USA

203-272-6171 | katethemel@gmail.com | www.katethemel.com

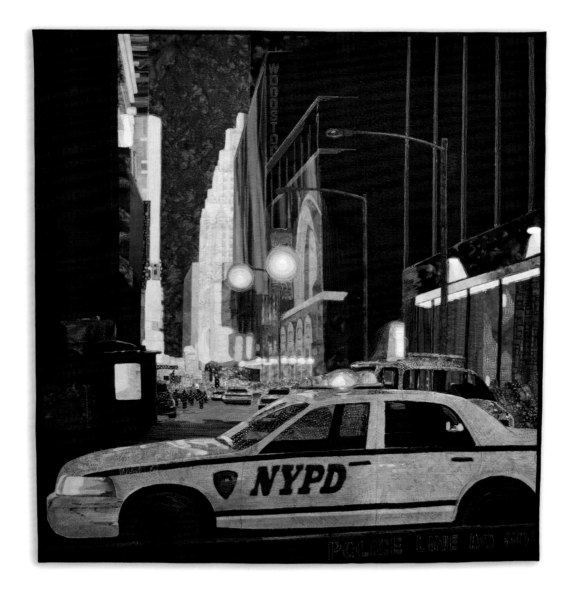

New Year's Eve

44 x 41 inches (112 x 104 cm) | 2012

representational

Catherine Timm

Westmeath, Ontario, Canada
613-281-1171 | catherine.timm@gmail.com | www.catherinetimm.com

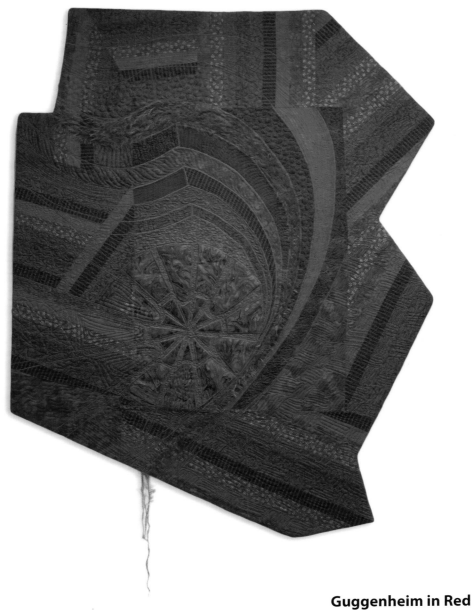

Guggenheim in Red
45 x 35 inches (114 x 89 cm) | 2011

Judith Trager

Boulder, Colorado, USA
720-242-7939 | judithtrager@gmail.com | www.judithtrager.com

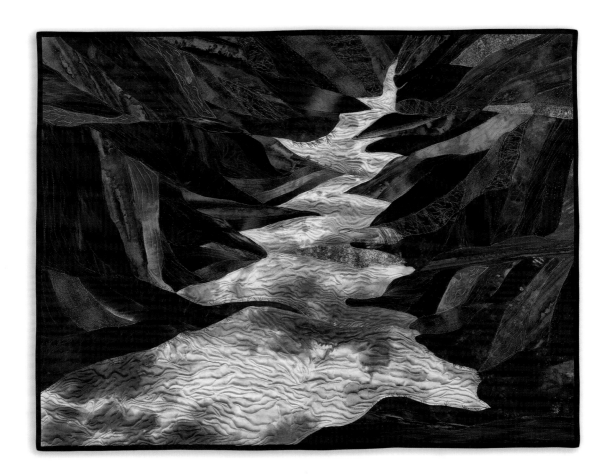

Nankoweap

32 x 42 inches (81 x 107 cm) | 2012

landscape

Gwyned Trefethen

Appleton, Wisconsin, USA

920-202-3933 | gwynedtrefethen@mac.com | www.gwynedtrefethen.com

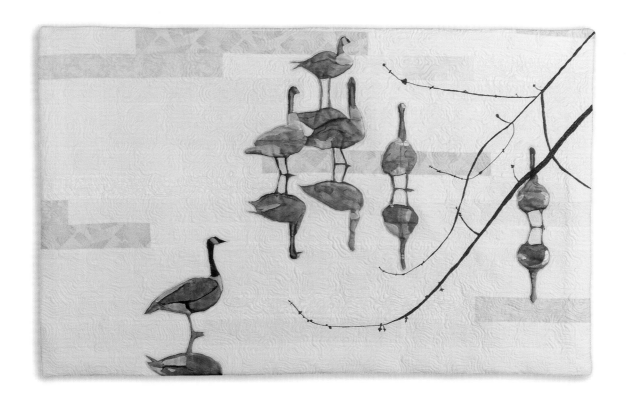

nature

Reflection

22 x 33 inches (56 x 84 cm) | 2013

Karen Reese Tunnell

Atlanta, Georgia, USA

404-401-2480 | karen@karentunnell.com | www.karentunnell.com

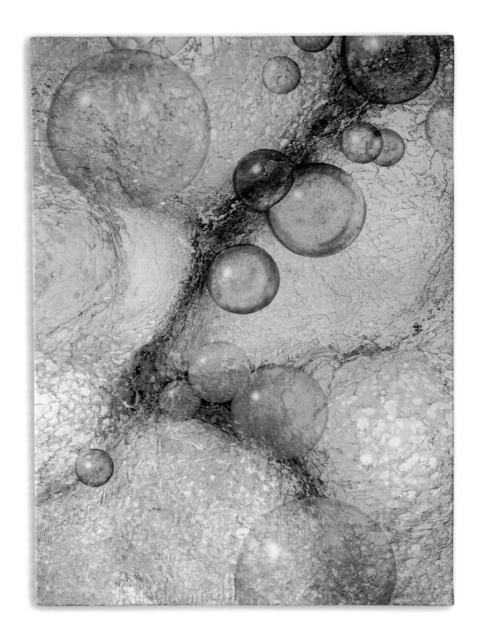

Bubbles

42 x 30 inches (106 x 76 cm) | 2012

abstract

K. Velis Turan

Earlton, New York, USA
518-731-8615 | kvelisturan@hotmail.com | kvelisturan.com

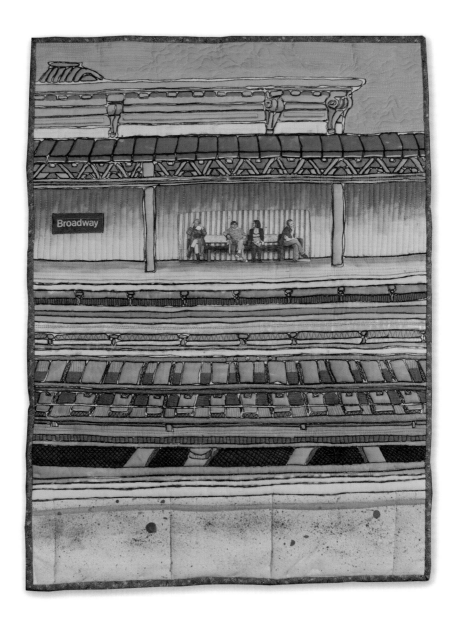

Broadway El
28 x 20 inches (71 x 51 cm) | 2011

VALYA

Oceanside, California, USA

760-433-4808 | valya@cox.net | www.valyaart.com

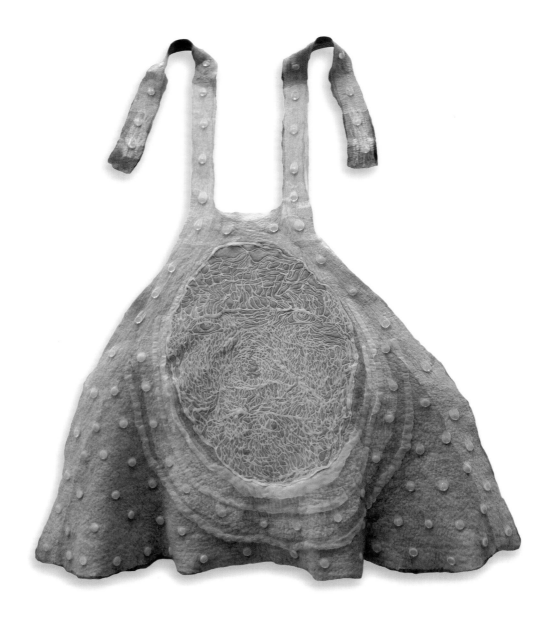

Apron.02

48 x 58 inches (122 x 147 cm) | 2012

representational

Grietje Van der Veen

Oberwil, Switzerland

0041614015655 | grietje@textileart.,ch | www.textileart.ch

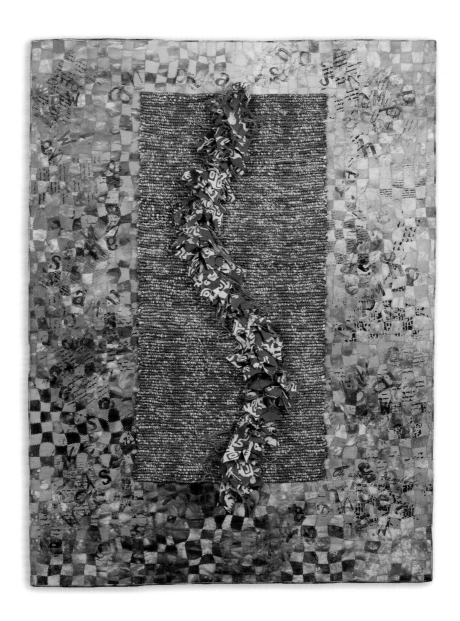

conceptual

Wrapped in Lies II

48 x 35 inches (121 x 88 cm) | 2012

Mary Vaneecke

Tucson, Arizona, USA

520-444-7149 | mary@maryvaneecke.com | www.maryvaneecke.com

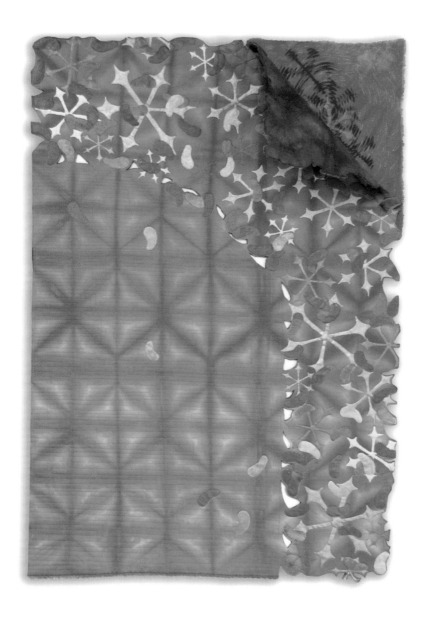

Off the Wall I

40 x 26 x 6 inches (100 x 66 x 15.2 cm) | 2013

abstract

Terry Waldron

Anaheim, California, USA

714-921-1143 | terryannwaldron@earthlink.net | www.terrywaldron.com

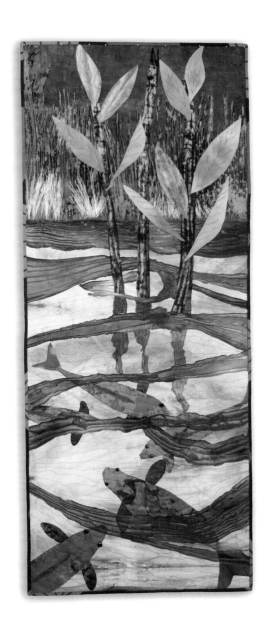

nature

Water Dance

60 x 24 inches (152 x 61 cm) | 2013

Lisa Walton

Sydney, New South Wales, Australia

+61 2 95607625 | lisa@dyedheaven.com | www.dyedheaven.com

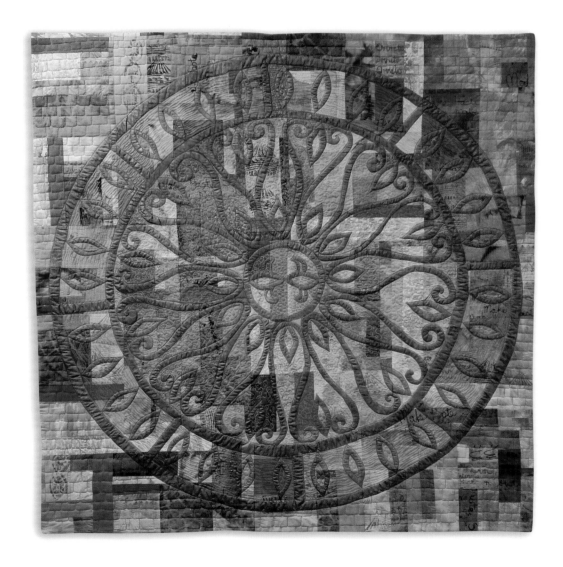

Orvieto Memories

51 x 49 inches (130 x 125 cm) | 2011

representational

Nelda Warkentin

Phillips, Maine, USA

207-639-3560 | nelda.art@hotmail.com | neldawarkentin.com

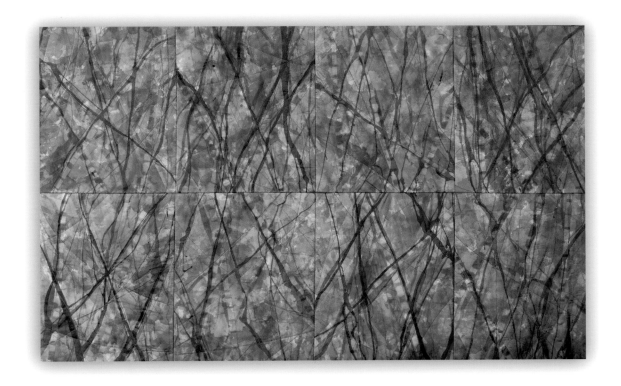

abstract

Bella Woods 2

30 x 48 inches (76 x 122 cm) | 2012

Laura Wasilowski

Elgin, Illinois, USA

847-931-7684 | laura@artfabrik.com | www.artfabrik.com

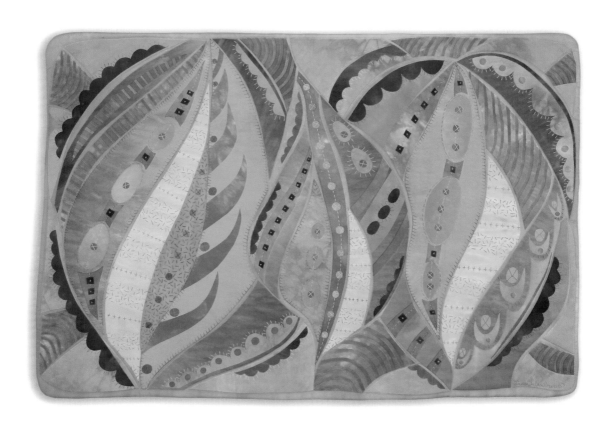

Seedpods #2

22 x 32 inches (56 x 81 cm) | 2011

nature

Carol Ann Waugh

Denver, Colorado, USA

303-408-7813 | carol@carolannwaugh.com | www.carolannwaugh.com

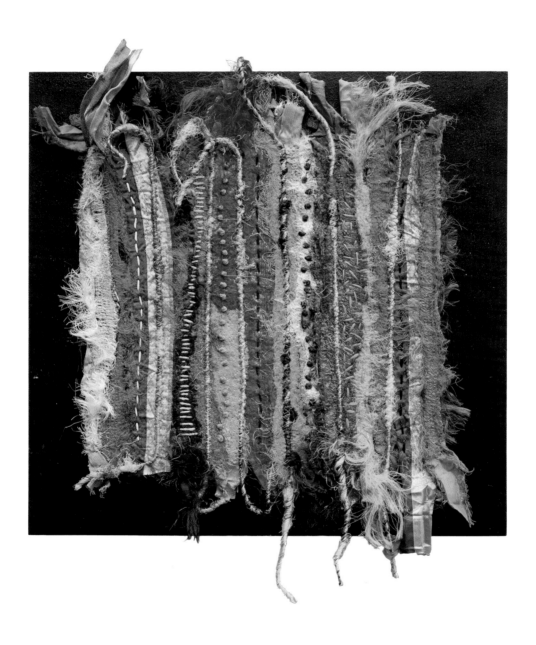

abstract

Silk Explosion

12 x 12 x 1.5 inches (31 x 31 x 3.8 cm) | 2013

Kathy Weaver

Highland Park, Illinois, USA
847-858-4758 | kathy@kweaverarts.com | www.kweaverarts.com

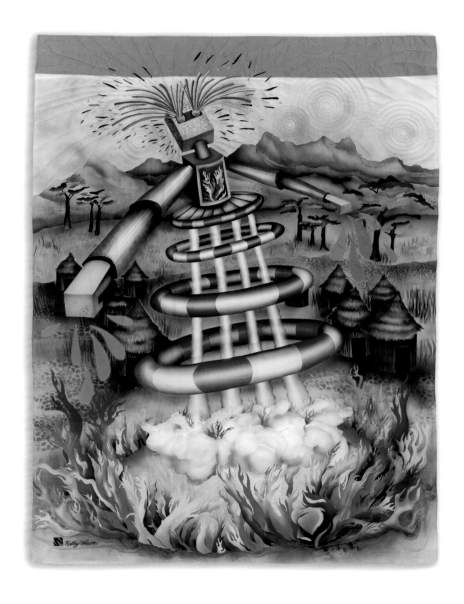

Destroying Angel

73 x 53 inches (185 x 135 cm) | 2012

figurative

Deborah Weir

Rolling Hills Estates, California, USA
310-325-1895 | fiberfly@cox.net | deborahweir.net

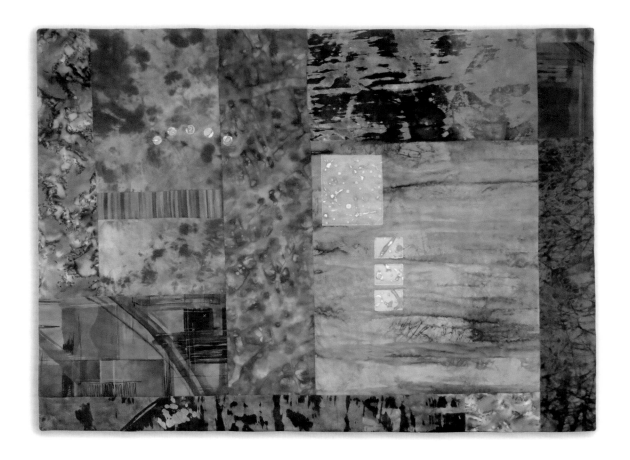

abstract

SeaGreen
26 x 38 inches (66 x 97 cm) | 2012

Sylvia Weir

Beaumont, Texas, USA

409-833-5217 | weir_sm@hotmail.com | sylviaweir.wordpress.com

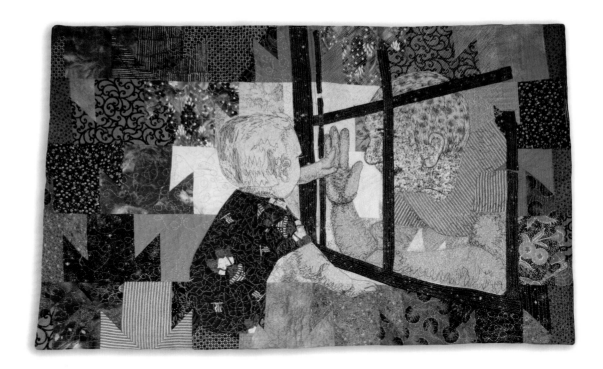

Father and Son II

20 x 40 inches (51 x 102 cm) | 2013

figurative

Grace Wever

Westcliffe, Colorado, USA

719-942-5061 | grace@realwest.com | www.weverart.net

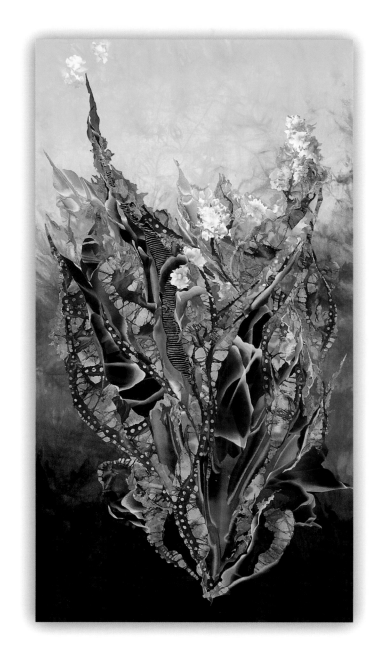

abstract

Enraptured I

34 x 18 inches (86 x 46 cm) | 2013

Nancy Whittington

Chapel Hill, North Carolina, USA
919-933-0624 | whittington@mindspring.com | www.nancywhittington.com

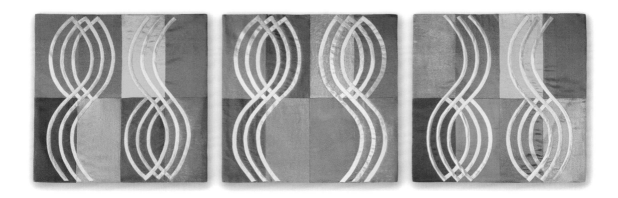

Three Vessels

24 x 76 inches (61 x 193 cm) | 2012

abstract

Leni Levenson Wiener

New Rochelle, New York, USA
914-654-0366 | leni@leniwiener.com | www.leniwiener.com

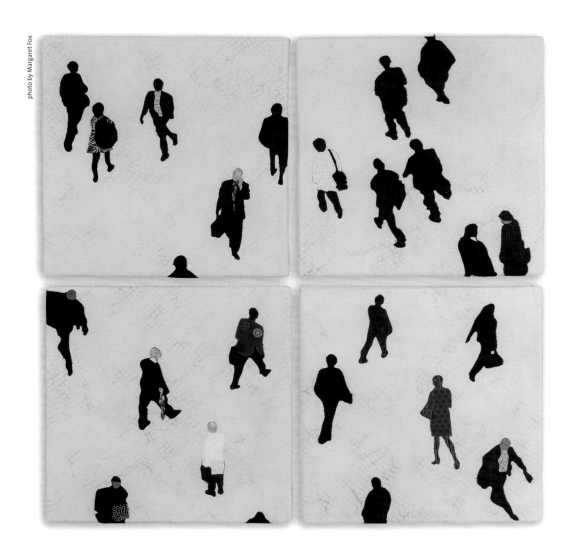

photo by Margaret Fox

RUSH

30 x 30 inches (76 x 76 cm) | 2012

Eileen Williams

Cedar Point, North Carolina, USA

252-723-2546 | eileenquilts@ec.rr.com | www.home.roadrunner.com/~eileenquilts

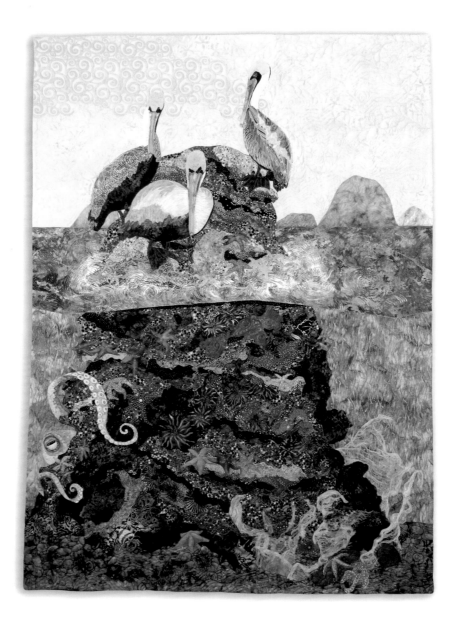

The Pelican Sisters

60 x 42 inches (152 x 107 cm) | 2013

nature